MAY STEVENS

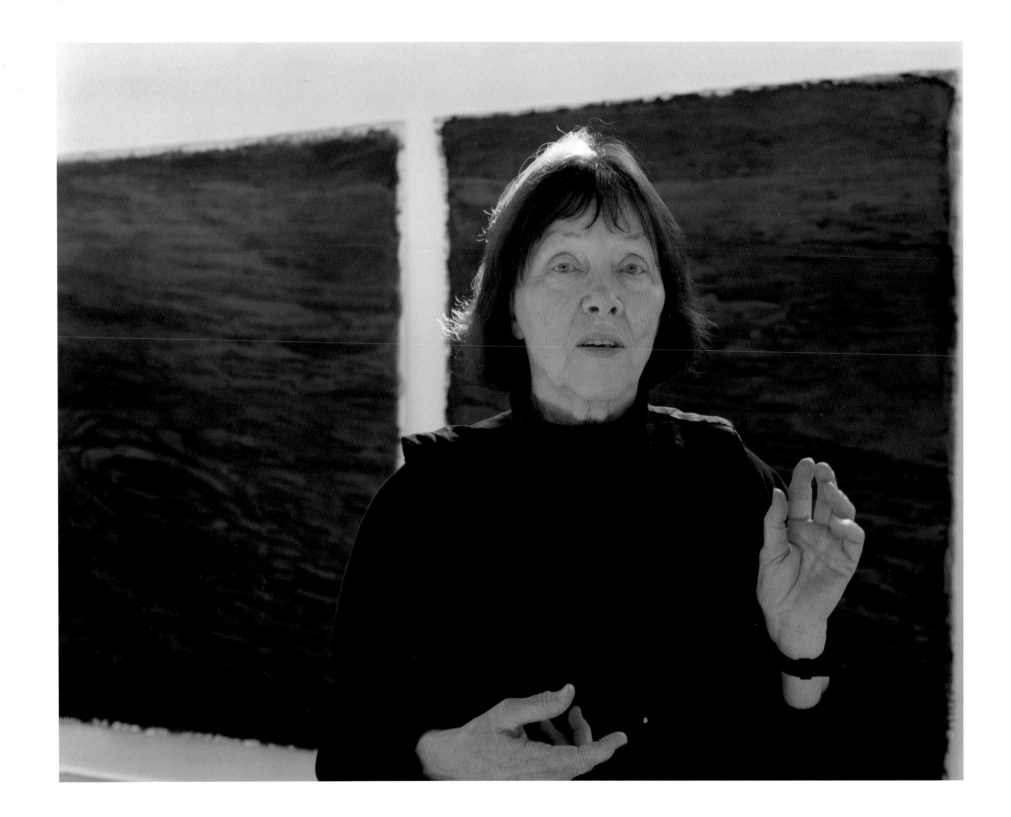

MAY STEVENS

PATRICIA HILLS

WITH AN APPRECIATION BY PHYLLIS ROSE

Pomegranate

SAN FRANCISCO

Published by Pomegranate Communications, Inc.

Box 808022, Petaluma CA 94975

800 227 1428; www.pomegranate.com

Pomegranate Europe Ltd.

Unit 1, Heathcote Business Centre

Hurlbutt Road, Warwick

Warwickshire CV34 6TD, UK

[+44] 0 1926 430111

sales@pomeurope.co.uk

Library of Congress Control Number: 2005900728

ISBN 0-7649-3323-X

Pomegranate Catalog No. A103

Design by Lynn Bell, Monroe Street Studios, Santa Rosa, California

COVER IMAGE: *Green Field,* 1988–1989. Acrylic on canvas, 84 x 144 in. Courtesy Mary Ryan Gallery, New York.

BACK COVER IMAGE: *Big Daddy Paper Doll,* 1970. Acrylic on canvas, 72 x 168 in. Brooklyn Museum, Brooklyn, NY.

FRONTISPIECE: May Stevens in her Santa Fe studio, 1999. Photograph by Gay Block.

ENDPAPERS: *Oxbow, Napa River* (detail), 2002. Acrylic on canvas, 72 x 118 in. Courtesy Mary Ryan Gallery, New York.

Photographs courtesy Gay Block, Cathy Carver, James Dee, Mary Beth Edelson, Maren and Reed Erskine, Brian Gilmartin, David Hamill, Virginia Lee Lierz, Adam Reich, Kevin Whitfield, Dorothy Zeidman, and Zindman/Freemont.

Printed in China

14 13 12 11 10 09 08 07 06 05 10 9 8 7 6 5 4 3 2 1

I have known May Stevens for more than thirty years. We met through mutual friends in the early 1970s. In 1976 Lawrence Alloway suggested I write an article about the three artists—May, Alice Neel, and Sylvia Sleigh—who were scheduled to have an exhibition at the Everson Museum of Art in Syracuse that September. I took the occasion to visit her studio to interview her and to study her art. Over the years, as we became friends, we attended meetings together, I visited her at her summer residences, and occasionally I taped my conversations with her and Rudolf Baranik. In the summer of 1990 I taped an interview for an article I was writing on her history paintings. Then in August 2002, at the time when Peter Briggs was planning the traveling exhibition of her recent work, May and I talked for nine hours on tape over a period of about a week. That session formed the basis of the present manuscript, with additional hours of conversation from September 2003 and August and October 2004 woven into the text.

From the start of this project the idea was paramount that the text "May Stevens: In Conversation" should read as a seamless conversation. My words, designated in boldface, are meant to clarify the contexts of her personal history but not to intrude. When the "Conversation" was completed May read it over, and we clarified several points. But she did not impose a written text on what is meant to be a dialogue between an "I" and a "you," although there are a few instances, always clearly marked, when written texts from a letter or from an interview have been included.

In conversation the voicing of the "I" is always present tense. That "I" exists in the present when speaking to the "you," also in the present. But when the "I" speaks of the past, we become alert to the negotiation that is occurring between the I's past and the I's present. In other words, the subjectivity of the speaker is constantly mediating between memories of the past and the rhetorical strategies needed to tell a story, to shape a memory for the present. The authenticity of the telling depends upon the successful mediation.

This is what May accomplishes. But she does more. Although embodying a highly tuned consciousness that desires precision in nuance and affect, May also speaks for a social and political conscience that demands attention be paid to past and present issues—of racism, gender inequalities, abuses of power. She will often switch from speaking in the past tense—about experiences she had in the past—to the present tense, as the emotion of memories takes hold of her. Recalling the literature, poetry, and anthropology from her past reading, she adapts the words of others that are useful for conveying her own feelings and ideas. She blends those words into an expressive whole, and they are not neutral.

ACKNOWLEDGMENTS

*M*y first acknowledgment is to May Stevens and to Rudolf Baranik, friends of my family for many years, with whom I discussed and debated many of the issues that thread through this book: the need to think politically, to attend to the craft of art, and not to compromise on either politics or art. I regret that Rudolf died before this book about May was published.

I especially want to thank Mary Ryan. Without her enthusiasm, support, and tireless efforts the book would not have come to fruition. Her staff at the Mary Ryan Gallery was very helpful: Jeffrey Lee, David Hamill, and especially Brian Gilmartin. Brian assisted with the preparation of the Bibliography, List of Exhibitions, and Chronology—lists originally assembled by Catherine Ryan. Brian tracked down photographs and transparencies and digitized them for the publisher. Peter Briggs deserves an enormous thanks for initiating the plans for the traveling exhibition, *The Water Remembers: Recent Paintings by May Stevens 1990–2004;* Jerry A. Berger, Director of the Springfield Art Museum in Springfield, Missouri, organized the travel arrangements of the exhibition to the Minneapolis Institute of Arts and the National Museum of Women in the Arts.

Those who facilitated our acquisition of reproductions of May's work include Jennifer Riley, Museum of Fine Arts, Boston; Paula Pineda, National Academy Museum; Kerry McBroom, Herbert F. Johnson Museum of Art; Linda Kulla, University of Missouri/St. Louis; Jane Rostov, National Museum of Women in the Arts; and Motrja Fedorko, Jersey City Museum. Mary Beth Edelson forwarded to me the photograph of the original *Heresies* group and provided us with a photograph of May. Donald Kuspit gave me permission to quote from the public dialogue he had with May one evening in 1984 at the Boston University Art Gallery.

I am grateful to Phyllis Rose, writer and professor of English, at Wesleyan University, who wrote "Writing on Water," an essay that expresses her thoughts when she first viewed May's painting *Oxbow* at the Mary Ryan Gallery.

Those who read early drafts of all or part of the manuscript "May Stevens: In Conversation" include Alan Wallach, Marianne Jackson, and Hannah Jones. I also benefited from the recollections of Joyce Kozloff and Leslie Epstein. Those who read my afterword, "May Stevens: The Dialectics of Painting, the Praxis of Painting," include Kim Sichel, my colleague at Boston University, and Lucy R. Lippard, another long-term friend; both made excellent editorial suggestions. I am also grateful to Becky Senf for transcribing the Stevens tapes, and to Elizabeth Berler and Melissa Renn for helping me track down necessary information and fact checking. At Pomegranate Communications, I was energized by the enthusiasm of publisher Katie Burke. Finally, my greatest debt is to Kevin Whitfield, who read the manuscripts numerous times and gave me his sage counsel.

Figure 1. *Lovely Appear Over the Mountains the Feet of Them That Preach and Bring Good News of Peace,* 1977. Silkscreen holiday card, 6⁷/₈ x 6¹/₂ in. Private collection.

CONTENTS

WRITING ON WATER

I spent a long time recently looking at May Stevens' painting *Oxbow,* trying to figure out why I am so strongly attracted to this canvas, which is, in many ways, typical of Stevens' work of the last fifteen years. A riverbank is painted in what I would call a loosely expressionistic style, and on the surface of the water, suggesting ripples, words are written in metallic ink. The painting is part of a series Stevens called *Women, Words, and Water,* and for me the luscious text, sometimes legible, more often not, is the heart of its magical appeal.

I know that Stevens' texts are from, among other writers, Virginia Woolf, who means a lot to me, and Julia Kristeva, who does not. In either case I do not care what the texts say. I don't even try to read them. I assume they have meaning for May Stevens, and that's all that counts. What moves me is the idea of the artist inscribing them as one might chant a mantra, patiently, lovingly, word after word, until the individual meaning of the words dissolves into the act of dedication itself. The repetitive task is a surrender and gift of the self. It strikes me that it is a distinctly female form of effort, akin to the effort it takes to raise a child or to run a household. A woman puts in day after day of unchanging, undramatic effort, cleaning houses that are immediately dirty and ready to be cleaned anew, cooking meals which are consumed and have to be prepared again the next day, soothing feelings which will need to be re-soothed and bucking up spirits which will never stay permanently bucked up. All these forms of female creativity are as selfless as sand paintings created and obliterated before the day is over. Only when you stand a long way back from these daily acts of devotion, only when the child has grown or the household tents have long been folded, can you see that something beautiful was created, like the luminous texts of May Stevens, floating on water.

In this painting, *Oxbow,* I see two different kinds of expressiveness. The painting of the riverbank, the water itself, and the reflections, while hardly an uncontrolled flinging of paint onto canvas, is akin to the assertive gesture of an abstract expressionist painter. I think of Jackson Pollock, in the famous Hans Namuth photographs, arcing lines of paint on the floor in gestures of pure temperament. For the sake of argument I will call this assertive kind of creativity male and the repeated task of self-suppression female. But the person who writes a text onto a painting needn't be female, nor need the activity be calligraphing words. Rocking a mezzotint plate is the same kind of repetitive activity in which an artist sinks into himself or herself and performs an act of devotion; so is, for an illustrator, penning the black line. For writers, re-typing the finished manuscript was a similar activity, enforcing minute scrutiny and intimate knowledge of surface. Since computers, this stage is now shrunken to a less physically demanding kind of editing. But even writers still stroke the skin of the work of art, claiming it inch by inch. Only metaphorically are these two kinds of activity—the outgoing and the ingathering, the intermittent and the persistent—male and female. They are really two parts of the soul.

John Keats' epitaph, in the Protestant cemetery in Rome, reads "Here lies one whose words were writ on water." Words on water usually signifies instability, insubstantiality, evanescence. May Stevens' words on water are just the opposite. How palpable they are! How they glow. How they emanate light. This is where their color and texture, the precious metallic ink, comes in. Being metallic, other than paint, the writing is there and not there, something from another world that has landed on the surface of the water, irradiating it, prayer made visible. Oddly enough, I never feel more grounded, more certain of the deep solidities of human life, of love and loyalty, than when I look at May Stevens' water paintings.

—PHYLLIS ROSE

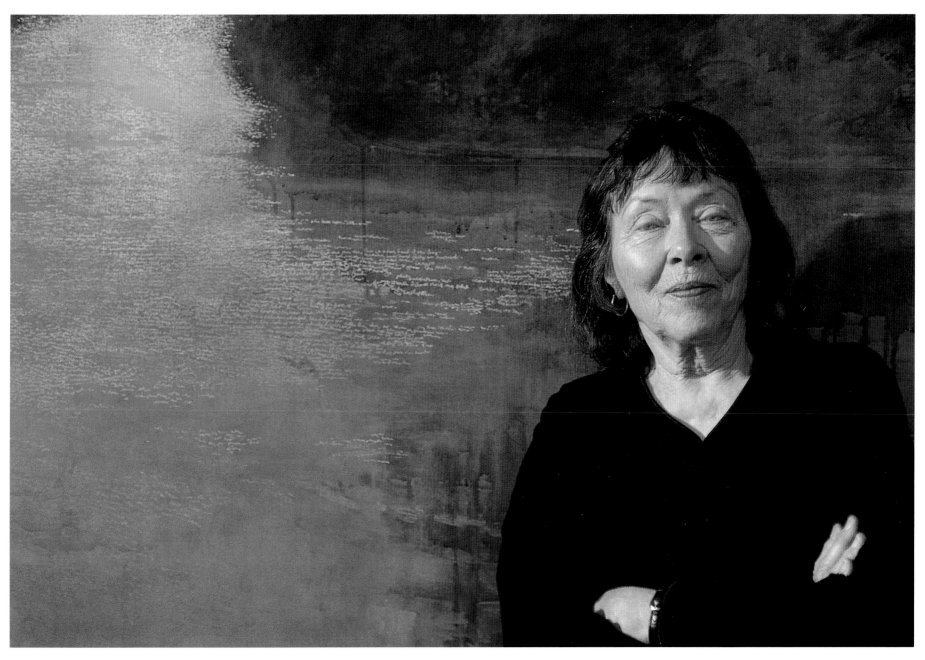

Figure 2. May Stevens in front of her painting, *Oxbow, Napa River,* California, 2002.

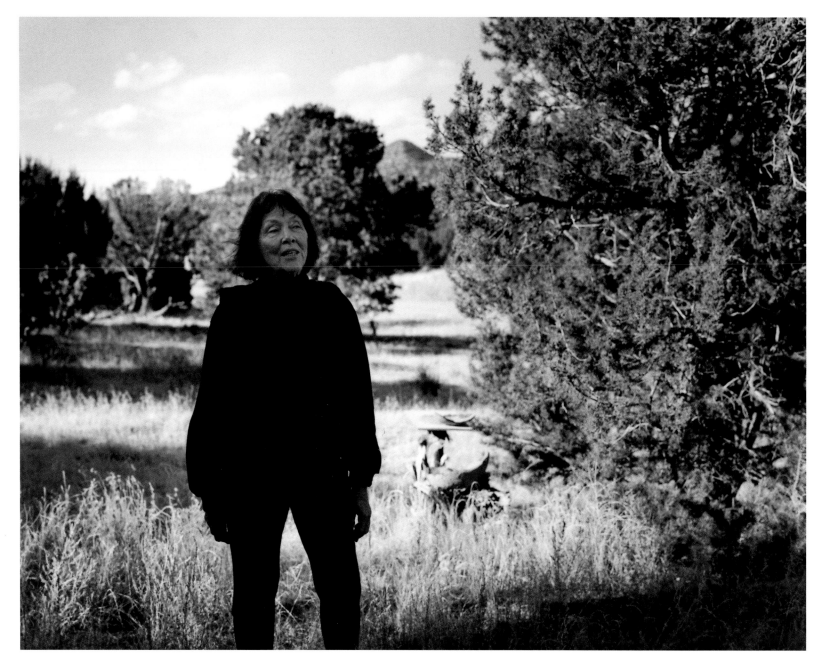

Figure 3. May Stevens in Santa Fe, 1998.

MAY STEVENS: IN CONVERSATION

I love story, I love narrative, I use it in my work. I tell stories. The stories are anecdotes about events. And they're selected because they mean something to me. I choose them because I see meaning in them.

✦ — ✦

There's an expression that I've used a lot, a quotation from William Butler Yeats, who said that you have to choose between "perfection of the life, or of the work."[1] I refuse to do that. I will not choose. I have always said I will not let the art dominate my life to the point where I damage my life—relationships, friends, love, all the things that make life worth living. On the other hand I've always said that the art is the most important thing in my life. I would say that to Rudolf, my husband for almost fifty years, and in one way it's true. But I also have always known that my life needs to have those things which make life bearable.

I have lived with Yeats' phrase. But at this point in my life, I have a different feeling about it.[2] I now feel that I don't have to worry about my life anymore or do the things that make one's life agreeable, separately from the art. I know how to make my life work for me. I have friends. I know how to have friends. I live alone. I know how to live alone. At this point I can focus only on the work. The goal that I have at this moment is to make the work better than it has ever been before and better than I have ever dreamed it could be. I want to go further than I have been able to go before. I'm free of any kind of worry. I have a gallery. I have an income. I have a beautiful place in Santa Fe with a beautiful garden. I travel. I have wonderful friends. I have a lover. I think that all of that can take care of itself, and I can focus entirely on the work, and that's my goal right now.

✦ — ✦

CHILDHOOD AND PARENTS

May Stevens was born in Dorchester, a suburb of Boston, Massachusetts, on June 9, 1924, to Alice Dick Stevens and Ralph Stanley Stevens. Her father's family hailed from Maine, of English and Scottish stock. Her mother, born in Canada, was Scotch Irish. A year and a half later, her brother, Stacey Dick Stevens, was born, and in 1928 the family moved to Quincy, Massachusetts, a city famous as the birthplaces and residences of John Adams and John Quincy Adams. Elegant nineteenth-century homes dot Quincy, and the architectural jewel of the city is the Romanesque-style Crane Memorial Public Library, designed by Boston's leading architect Henry Hobson Richardson and built from 1880 to 1883.

Since the early 1800s working-class Quincy men had found jobs in the granite quarries; in the early twentieth century Bethlehem Steel opened a shipyard. When Ralph Stevens got a job as a pipe fitter at Bethlehem, the family moved to 57 Lawn Avenue, a working-class neighborhood near the shipyard.

Stevens recalls growing up as a working-class girl, with teachers who recognized and encouraged her early talent for creating art.

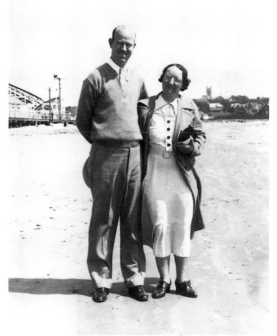

Figure 4. May Stevens' parents, Ralph and Alice, Newport, Rhode Island, 1937.

We lived the first four years of my life in Dorchester with my grandfather, True Nathaniel Stevens, whom I don't actually remember. He was a part owner of a grocery called Stevens and Greene. In a photograph that I've seen Stevens and Greene stand outside the grocery store with flat straw hats and long white aprons, the two proprietors of this little store.

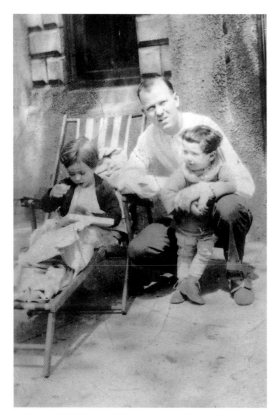

Figure 5. Ralph Stevens with May and her brother Stacey.

When I was four we moved to Quincy, because my father got a job in the Bethlehem Steel Shipyard nearby. I remember we moved on the Fourth of July, because when I heard the fireworks, I thought, "They're celebrating our arrival." My father had bought the house in Quincy with money my grandfather had left to him.

The house was at the very end of Quincy, called Quincy Point, where a bridge goes to the next town, North Weymouth. We rented out half of the house. It was an eight-room house divided down the middle—a duplex—with a kitchen and living room on the ground floor and two bedrooms upstairs, on both sides of the house. We didn't feel the effects of the Depression so much, because my father collected rent, he didn't have to pay rent himself, and he had a steady job. We didn't feel poor, but we were thrifty. We didn't waste money.

My mother was not a good cook. She had never really learned, even though she had worked as a waitress in a Chinese restaurant when they met. I'll speak about that. My father had come into the restaurant with his father, and my mother waited on them. When she gave them the check, she had signed her initials. It said "A.D.," and my father asked, "What does A. D. stand for?" and she answered, "After dinner." I love that. Because she was flirting. I think they were very much in love at one point. I spent a lot of my childhood trying to figure out how that love had gotten lost.

We would have, often for Sunday dinner, something called chicken fricassee, which as far as I can remember consisted of throwing a chicken, carrots, onions, and potatoes into a pot of water and cooking them until they fell apart. The only flavoring, other than the onion, was some salt. The apple pie was pretty good—probably my father made it. We might have leftover chicken fricassee on Monday and Tuesday, and maybe by midweek my mother would make meatloaf, which was bread and hamburger and chopped up onion and salt. So we'd eat that for a few days, and maybe on Saturday we'd have hotdogs and beans. The fruit and vegetables were awful. Everything was overcooked. But we had lots of cold milk. Since my father was a teetotaler, no alcohol came into the house. And he didn't smoke. But we loved root beer, which he made and stored in the cellar. Sometimes it would explode. And that was pretty much it. My parents' cooking traditions were English and Irish, which have never been great cuisines.

When I was five I fell—I have no idea how or why—on my left knee, which then would not straighten. I was hospitalized, and the doctors put a weight on my foot over the end of the hospital bed until the leg straightened out. Then they put it in a cast, and after a long time it was put into a brace. I wore that brace from the hip to the ankle to keep my leg straight for one year, from age five to six. That very much conditioned my life because ever after—in playing, jumping, running—when I fell or hurt myself, it would always be that same knee so that the knee became very fragile and battered over the years. The eventual result is that the right knee also became damaged, because I was sparing my left knee and overusing my right. So a physical problem of mine that continues today is bad knees.

From the very beginning I was a great student. I loved reading, and so the teachers loved me. In the first grade the back of the room had standing easels with pots of paint and a great big newsprint pad. If you finished your reading or your writing assignment you were allowed to go to the back of the room and paint. Which I was always doing.

I was the class artist. Kids would bring me little scraps of paper and ask me to draw a girl's head, or whatever. I also decorated the windows with tulips in the springtime and maybe holly at Christmastime. We mixed pigment with cleansers like Bon Ami, and then mixed it with water. We painted it on the windows. When you wanted to remove it, you rubbed it off and cleaned the windows at the same time.

One block from my home I swam in an inlet from the sea, called Fore River at some places and Town River in other places. It had tides, jellyfish, and horseshoe crabs, and even bloodsuckers. My river turned a corner and went into the Bethlehem Steel

Shipyard. Obviously the shipyard was built there because the river was there. But I thought all rivers had salt and tides, because that's what my river had.

As children in the summer we spent all day, every day, at a little beach a block from my home. It wasn't an elegant sandy beach. It was pebbly. But you got used to that. There were broken-down piers where small boats would be repaired, and many of those piers were falling apart. I'd go out on the pier, where you shouldn't go because the timber was hanging into the water. It was really kind of risky.

Unlike today, grade school children were on their own. There were no lifeguards, and we taught each other to swim. There were two rafts for children in close and two rafts farther out for adults. Neighborhood people came and swam there. They would bring big towels and lie on the beach. I would go up on the sidewalk and lie down without a towel. I would bake in the sun, stand up all covered with grime from the sidewalk, and go back into the water. All day long I did that.

On the other side of the beach there was a place we kids called Old Man's Field, where you could walk in knee-high grass or even taller grass. When my brother and I had rabbits we'd pick huge bags of grass for the rabbits from that field. But eventually it was bought by Socony—Standard Oil Company of New York. They built huge tanks there in the field, and they fenced off the piers. I would walk there all by myself, climbing over obstacles to get onto the piers. Huge tankers came in to fill up with oil from those tanks, and sometimes there would be oil slick on the beach.

There was a spit of land called Germantown that you could see across on the other side of the river. I always dreamed of crossing that river, of swimming to the green land on the other side, and at one point I did it all by myself. I don't think I told anybody. I had my dog with me—a black spaniel named Julie—and she swam with me. When we got over to that green sward, I climbed up and discovered that beautiful green land out there had the harshest toughest sea grass. You couldn't walk on that grass, because the blades were like spears. But from the beach on my side it looked like a perfect, beautiful place you'd want to go to and lie down on. It made me think of the old saying: "the grass is always greener. . . ."

<div align="center">✦ —— ✦</div>

I love words. I almost collect them. When I was a child, maybe I was ten or so, I received a huge, used, unabridged dictionary from a great aunt I never met, who lived in La Jolla, California. I read in it all the time.

I was writing poetry from the third grade on. I'd write a poem for Easter or for various holidays or events, and I'd show the poetry to my teachers. I had a notebook with the poems written down, and I tried to make them perfect. I remember writing a poem about an Easter lily. The last line was, "Of Madonna's beauty, she an heir." I had to have H-E-I-R, because it rhymed with something above, but I realized that "she" and "heir" don't match, because it should be "heiress." I did it anyway, even though I was aware that I was being grammatically incorrect. But I didn't change it.

In junior high school my teacher Miss Manchester read poems to the class with such vigor and excitement that she was almost acting them out. She would recite Alfred Noyes: "And the highwayman came riding—/ Riding—riding—/ The highway man came riding, up to the old inn-door." To me it was thrilling.

I would go home and stand on the second step of the thirteen-step flight of stairs that led from the first to the second floor. The second step would put me in the perfect position to see myself in the hall mirror. Into the mirror I would recite all the poems I liked, the poems I was writing, the poems I was reading in school.

I think that the way I speak developed out of my reciting to the mirror. I probably had in the back of my mind that I might become an actress. I'm writing poems, and I'm doing paintings and drawings, but I liked to act out the poem and watch myself and listen to my voice trying to pronounce everything beautifully and to give full value to all the vowels and consonants. This was probably Miss Manchester's influence. I think she may have been English.

I had another teacher in junior high named Mr. Evans, who loved Shakespeare, and the class acted out the roles. We also did a play called *The Little Match Girl* in which I wanted to be the little match girl, but they made me be the grandmother, probably because I was taller and not waif-like. So I regularly, constantly, recited poetry into the mirror. I memorized Tennyson, Longfellow, and W. E. Henley.[3] Henley was the poet who wrote: "I am the master of my fate:/I am the captain of my soul."

Words. I've always read and loved dictionaries and crossword puzzles, which I still do today. That dictionary my aunt gave me had many line engravings of all the ancient forms of armor, of all the animals and strange creatures. I loved looking at those drawings. I continued reading and writing poetry, and I knew which poets I liked. I liked Gerard Manley Hopkins.[4] Hopkins' poems are passionate about the beauty of the world, and about the language, which he used with extreme originality and invention. I loved John Donne. I loved many of the English poets. I loved nature and poems about nature.

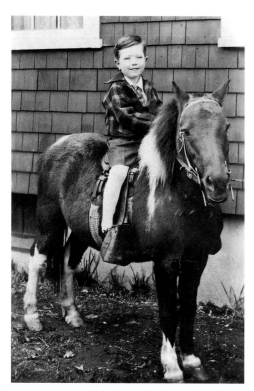

Figure 6. Stacey Stevens.

My brother, Stacey, had childhood diabetes. At the hospital my mother learned how to take care of him, to test his urine for blood sugar, and to give him insulin shots. That became a family affair. We took drops of his urine and put them into a test tube full of a blue liquid solution, which was then heated over the gas flame. If he had no sugar or a normal amount, it would stay blue, but sometimes it would turn green, yellow, orange, red. We had graph paper, and with crayons we'd mark down the date and color. He was on a restricted diet, and my mother had scales to measure the food. Sometimes if everything wasn't in balance, he would go into insulin shock. It was like being drunk. He'd become silly.

When he went to school he had a hard time, because he was one grade behind me. He would be in first grade when I was in second grade, and the teachers would say, "Oh, you're May Stevens' little brother. You'll be a good student." But he wasn't. That's already a negative for him. It also started off badly. He had to take a jar of orange juice with him to school because he needed to drink it at some point in the morning. When it spilled onto the floor, he was accused of having wet his pants. School didn't work for him. Part of it was probably because I had been so successful.

Stacey died in the hospital of pneumonia at the age of fifteen. The person who felt the loss most keenly was Stevens' mother Alice. Stevens describes her mother's gradual emotional withdrawal following Stacey's death.

I have often thought that when Stacey died, my mother lost it, because she had spent fifteen years totally concentrated on my brother. I took care of myself. I was a very successful student, and I loved school. My teachers and my father were very approving of me, because I was independent, strong, and relatively healthy. Because I had the bad knee, I would sometimes be incapacitated, on a couch in the living room reading books, making drawings, and getting a lot of attention. Even when I was laid up for a month or so—I think I was out of school one semester because of my knee—I would be very content. I loved reading, drawing, and listening to soap operas on the radio. I

had a chart that listed the soap operas that I liked. People would come and visit me and bring me things, and praise me because I was so cheerful. I felt my parents were pleased with me.

My brother, on the other hand, had difficulties. It seems totally unfair. I think that my father didn't approve of my brother. My brother was the boy, and he was not masculine or athletic, but sickly. And I'm afraid I adopted my father's opinion. The family divided into two categories: my father and I who were capable, and my mother and my brother who were not. It was an ugly division.

When I was sixteen I bought a black dress for dancing and for dates. I wanted to go out wearing it, to be an adult, and to be sophisticated. It was crepe, and it had tiny squares of pink and turquoise printed on it, with a tiny ruffle around the neck. I felt so grown up and thrilled owning that black dress. But the first time I wore it was to my brother's funeral. It became something else.

✢ —— ✦

In high school, and also in junior high, I had a girlfriend named Norma. I spent a lot of time at her house. Her house was closer to the high school and more centrally located. I would stop at her house, we'd do our homework together, and I'd stay for supper. I liked her suppers better. Sometimes I would even stay overnight with Norma. In a way, I was avoiding my own home, and making another home for myself. She had a mother who dressed well, who went out, who maybe was a member of clubs. Norma's mother was a normal person, and I felt my mother was not. My mother was a recluse after Stacey died.

Her father was a welder at the Bethlehem Steel Plant, where my father was a pipe fitter. What I recall about Norma's father is that when he came back from an excursion to Cape Cod, he said that he had refused to buy blueberries at stands along the road—because they were picked by the Portuguese. I knew even then that the reason for his prejudice against the Portuguese was self-protection, because he was also a foreigner and dark. He was French-Canadian and spoke with an accent. He didn't want to be mistaken for the Portuguese, who were also dark and spoke with an accent. I saw that and understood it to be racist.

The contradictions of racism in the working-class community in which she grew up have been constant themes in Stevens' writings and verbal dialogues. Her father had been raised as a Protestant Christian, but as an adult, he never practiced it. Her mother, a Roman Catholic, gave up her religion after she married.

My father was racist. He spoke against Jews, blacks, Italians. Italians drank too much and were Catholic. He didn't like Catholics. It wasn't a crusade, he wasn't part of a group, but he believed his own prejudices. He spoke against Jews, although he played poker on Saturday nights with a man called Max who was Jewish. He spoke against blacks constantly, and he spoke against communists. He was a member of the union at the shipyard, but it was a company union. I remember somebody moved next door to us, and my father said that the guy was trying to unionize the shipyard and that he was a communist. I remember that the communist's wife was different, because she wore housecoats down to her ankles, which nobody did in our neighborhood. She was probably more sophisticated or from someplace else.

My father had an expression he liked to use, which was: "You can become an American, but you have to be born a Yankee." He was very proud of being a Yankee. His people lived in Maine before they moved to Massachusetts, and he was a long time working-class Yankee. Early on I saw class difference, and I saw racism. I spent my college years trying to talk my father out of his racism—giving him books to read and arguing with him, because I knew he was wrong.

Still he was very supportive of me. He would bring cotton duck home from the shipyards, so I could paint on it. He never drank, he worked every day, he brought his pay home. He was very reliable, very responsible. And we were always taken care of. Stacey and I went to good doctors. On the other hand, he had no sympathy for my mother. I could not forgive him for that.

Stevens responded as follows when asked if she were aware of the way he was treating her mother, of his indifference to her mother's emotional needs.

I've described how I was close to my father and not to my mother. But at some point I began to hate my father because my mother fell apart. As a teenager, I didn't want to be seen with my mother. She was heavy, she was not well dressed, she was unhappy, she wasn't a good cook, she wasn't a good housekeeper. She had no energy; she didn't do anything. She was home all the time.

I did paintings of her sitting at the kitchen table in a housecoat playing solitaire. I liked the fact that she was always available for me to draw her, and to be a model.

And she knew how to comfort me. Sometimes I would come home from high school depressed—I mean something went wrong and I would come home unhappy, not because of schoolwork, but because of a social problem I had during the day. She would always be there. She would hold me in her lap and rock me, a big girl, maybe taller than she was. And then she'd make me cocoa and toast. She loved me. She had love to give. But I didn't want to be seen with her.

As I got older I could see her pain. And I began to do crossword puzzles with her. She was very good at crossword puzzles. She was a good reader, and she'd do cross-stitch embroidery. I took her to the movies one night a week.

At one point my father sent for a doctor to come to examine my mother. The doctor took my father and me out on the porch to talk about the results of his examination. He said she should be hospitalized, and I started to cry. He said, "She's not like your mother anymore." I said, "That's not true." Because I didn't know when she changed or how she changed. It happened too slowly. She had spent too much time taking care of my brother and never going out. She had no friends and didn't talk to anybody. She lost her own life. She shut down after my brother died. And we didn't do anything about it, because we knew nothing about psychology. I wept at the idea that she needed to be hospitalized.

She needed attention. My father had no attention to give her, and I became her only friend. I knew she needed me. I slept with her. This is another thing about our house. It had only two bedrooms, so until I was twelve my brother and I slept in the same bed. And when I was twelve it changed. I slept with my mother in one bedroom, and my brother slept with my father in the other bedroom. I would lie in the bed with my mother at night unable to sleep. A car would go down the narrow street, and the light comes through the window and travels through the whole room. My mother would say to me, "Did you see that? Did you see that? They're after us." She was paranoid. I would put my arms around her and comfort her. I would tell her that it was nothing and that I would never leave her. But I really wanted to go to New York and become an artist. They both begged me to stay. So I stayed for over a year after graduating from Mass College of Art.

In 1986 Stevens contributed to the volume of poetry, Fire Over Ice, edited by Reese Williams. Stevens included ten poems, four versions of a photograph of her son, Steven, running with his dog. She also included the following thoughts about her father and mother, titled "Class."

CLASS

My mother likes to dress up. When pleased with an elegant new outfit, mine or hers, she exclaims, "Some class." Class, to my mother, is an aspiration. She doesn't see anything wrong with lifting herself out of the commonplace to a look that shows the taste (education) and the leisure to dress with care. She knows that my father liked her better and would have liked me better when/if we got ourselves up in such a way as to show we wanted to please him and others who looked on us, not sexually as women, but in a class sense as women who respected ourselves, our neighbors, and the man who earned a living for us.

He wanted to be proud. He worked hard (sloughed off only to the extent that was conventional, permitted, in fact required by his co-workers) for his wages and used them for his own comfort and ours, to enhance his own standing in the community and ours. His sending me to college was the same kind of decision that rising in class was worth spending money on. He didn't expect, of course, that college would make me dress badly (jeans and shirts and long hair) even years after I graduated. Nor behave badly either (radical politics, peace marches, signing petitions and other intemperate behavior). He never imagined that lifting me out of his class would produce in me an allegiance to his class that *he* did not feel. He had swallowed the dream. But it's more than a dream because the books and the art that raise you from one class to another, to bourgeois life, are indeed capable of providing a better life—and also the means of critiquing that life.

Class aspiration never meant money to my mother nor to me. It did not mean household help, nor fur coats, nor holidays. It meant looking good (well-dressed, well-coiffed), like the minister's wife or Mrs. Lovejoy's daughter—the women who took pains with these things. I think that was what we admired most. People who did things with care and taste. Men who kept their cars shiny, women who kept their houses spotless, whose children showed that care had gone into their training. Men and women who raised flowers, mowed lawns; women who set a pretty table and placed a crocheted doily on the back and armrests of the upholstered chairs.

My mother ironed my dresses to starchy crispness. My favorite teacher touched my pleated blouse and said, "your mother must love you very much." Even now nothing pleases my mother like my fluffing her hair, pinning earrings to her soft old lobes, covering the wrinkled skin that hangs in folds about her neck and arms and thighs with fresh cloth and neat lapels. We tell her she looks like a college professor.

—1986

MASSACHUSETTS COLLEGE OF ART, THE MOVE TO NEW YORK, AND RUDOLF BARANIK

Following graduation from Quincy High School in 1942, Stevens commuted to the Massachusetts College of Art on the Fenway in Boston, a college established by the Massachusetts legislature in 1873 for the purpose of training teachers of art and design, the only college of its kind in the United States. On May 23, 1997, during graduation ceremonies, the Alumni Association honored Stevens as "a Distinguished Alumna of the College." The presentation document elaborated: "Widely acclaimed for her achievements in the visual arts, she has secured a place in history."

I have thought a little bit about the history of styles and the way it has conditioned me. I realized that at Mass Art the people that were held up to us were the Postimpressionists—Van Gogh and Gauguin. At some point Picasso, Matisse, and Cézanne were also included. But it was really Van Gogh that was the big thing, and Gauguin. I remember going to the Museum of Fine Arts in Boston to look at *Postman Joseph Roulin* by Van Gogh and being deeply influenced on a primal level—also by Gauguin's painting *Where Do We Come From? What Are We? Where Are We Going?* This kind of narrative painting that intends to speak philosophically about life itself was very important to my thinking, to the techniques that I used, and the way I put paint on canvas. I looked at how Van Gogh did it, and so did Nancy, who was my best friend in art school. On her waitress' salary she saved up enough money to buy a big, beautiful Van Gogh print of irises in a field. We painted those kinds of pictures in class, so what could be more natural than that I would want to go eventually to Paris?

I graduated with a certificate from Mass Art. I had been the editor of the school yearbook. I got mostly A's. My favorite teacher, my painting teacher, was Otis Philbrick, the acting president of the school. He liked my painting a lot, and he said he wanted me to promise him that I would never give up painting. I thought that was wonderful. It indicated that he understood how hard it was for a woman to go on, because they usually got married and had children. They don't become painters. But I promised him. He made me feel he believed in me, that he liked me, he liked my work, and that I could become a painter.

As I said, I stayed home for over a year after graduating in 1946. At first I got a job illustrating a book at D.C. Heath, a textbook publisher. D.C. Heath said that I

could either do it at home, or come in and work there. And of course I wanted to work there. I didn't want to be home. I illustrated a book called, *Clothes for Girls*. I did line drawings of girls in the clothes. And I loved doing it, I loved being there and talking with the other young women who were working in the company. My boyfriend, Bert, was overseas. I'd go to the USO and dance, and I had boyfriends that I met there. Nothing serious, since I was corresponding with Bert all the time and waiting for him to come home. After a year working at D.C. Heath, the book was finished, and the job was over. I then got a job at Remick's Department Store in Quincy working on ads. They gave me the previous year's ads, which I just altered for the current year. There was no creativity to it at all. I was very unhappy in this job. My great fear was that I might just earn a living and not lead an intellectually stimulating life.

My mother was totally lost, and all I could do was try to help her and be with her, and try to laugh with her and jolly her. I did this while I had a job I hated. My father was out of the house as much as possible, because there was nothing at home for him. No friends ever came. There was no social life at all. That had been the truth for a long, long time.

Then I got a phone call from my art school friend Nancy. She and her sister Elaine, who was a nurse, had taken a studio apartment together in New York, on the second floor of a building on East 62nd Street, between Park and Lexington. They said there was a little bedroom on the third floor, which shared a bath with another little bedroom. If I wanted to come I could live in the room upstairs and eat with them. In September 1947 I went.

When I left Quincy, I knew that my mother had nobody. My father couldn't deal with her. My brother was dead, and she had no friends. She had some relatives, but they weren't there for her. I left. I had to. I would have died if I had stayed.

I moved to New York to that little third floor bedroom and shared my life downstairs with Elaine and Nancy. I got a job working for a pattern company. All I did was draw the plan of the pattern as a diagram on the back of the envelope, but I could support myself.

Stevens' next project was to provide herself with a studio where she could paint. In January 1948 she began attending the Art Students League, a well-respected art school, founded by art students in 1875. The League accepts any students who want to enroll and grants no degrees. Students pay tuition by the month and are taught by well-known artists who work there part-time.

I needed to paint, so in January 1948 I joined the Art Students League. The first night I went there, the secretary told me to see the monitor to get a locker to leave my paints in. The monitor was Rudolf Baranik. When I saw him across the room, I thought: he's very good looking. He's intelligent and kind. And he has a sense of humor. I can see this in his face. He's a man not a boy, he's been in the army, he's wearing an olive drab army shirt with no insignia on it. And, I thought, no doubt he's married. I went over and I said, "I have to have a locker." He said, "There isn't any, but you can share mine." I never did get my own locker.

Rudolf Baranik (1920–1998) was born and raised in Lithuania. His parents were secular Jews and socialists. In 1938, sponsored by an uncle, he traveled to Chicago to study art. In June 1941 the Nazis invaded the Soviet Union. His parents and sister were murdered by Lithuanian fascists as the Germans were marching into Lithuania; his brother escaped to join the Soviet army. In 1942 Baranik joined the US Army and was sent to England. His regiment went to Normandy. When the war in Europe ended, he stayed on as an interpreter in the de-Nazification program. By 1946 he was back in Chicago and enrolled in the School of the Art Institute of Chicago. But eager to get on with his career, he moved to New York and enrolled in the Art Students League. Shortly thereafter, he met Stevens.[5]

My last year at Mass Art I had been terribly worried and preoccupied with Hitler. I knew about the camps and the madness in Europe. How could a madman be allowed to do these things, to control a whole nation? I had a dream in which I heard people crying in a foreign language. I interpreted it as my great fear and longing to be informed, wanting to know what was happening over there. During the war we were told to save fat and save metal. Some women didn't wear lipstick because you were using up needed materials. You did all kinds of things for the war effort. Everybody believed in the war and was horrified about what was going on, and so it was very natural, I think, that I would have this dream.

When I met Rudolf I didn't know he was Jewish, and I didn't know he'd lost his parents. But the more I knew about him the more he meant to me. I learned that he'd been in the American army and worked in a small village in Germany doing de-Nazification. He was so good-looking I thought he'd slept with every woman in Europe. But what he mainly offered me was a chance to understand the world better than I did—to become part of something larger than myself.

Rudolf later told me that he thought I was a New England upper-class WASP, because of the way I speak. And of course I thought he was the most suave European—sophisticated and knowledgeable about things I needed to know. He, meanwhile, thought of himself as a poor Jewish immigrant, and I knew that I was not an upper-class WASP. I was a working-class girl.

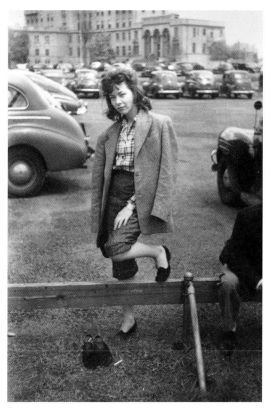

We began to go out. There were a couple of guys in the class who liked me besides Rudolf—one was a man in his fifties and the other was Chuck. Chuck was a very good-hearted, American klutzy guy, with hair hanging in his eyes, laughing all the time, very nice. He was a friend of Rudolf's so the three of us would go out together—but I liked Rudolf.

Rudolf and I would leave the Art Students League together, walking arm in arm. I used to make a test for myself. I wanted to see if we could pass by a newsstand without his stopping to read the headlines. He was totally wrapped up in world politics. Here we'd be holding each other, so much in love, and walking in the moonlight. But every time we came to a news kiosk, he would stop to look at all the newspapers. He needed to look at newspapers from different parts of the world, because he could read many languages.

Figure 7. May Stevens at the Massachusetts College of Art, Boston, c. 1946.

The first time Rudolf came to my room, which consisted of a cot, a chair, a bureau, and a window, he closed the door behind him and saw the subway map on the back of the door. I don't think he said anything. But the next time he came, he brought a map of the world. He took down the subway map and put up a map of the world.

I remember our wedding day. He was living with an elderly Lithuanian woman and her two daughters in Brooklyn. The morning of the wedding, he came to me with a bouquet of flowers from her garden. It was raining. She had sent him off saying a rainy wedding day means a fertile marriage. When he confided to this Lithuanian peasant woman that I was already pregnant, she told him (and of course she's Catholic, although she's also a member of his radical community of Lithuanians), "You should not ask her to have an abortion because she might never forgive you for it." So he didn't. He'd never thought about having children. Or being married even. I had always known I wanted children, but I never visualized it. I just assumed that I would marry and have children.

Rudolf and I got married on June 5, 1948. We decided to study art in Paris. That was going to the source, to the deep, wonderful place where Picasso, Matisse and Léger were still alive. We sailed for Paris in September. I was totally in love with Rudolf. I would have gone anywhere with him.

THE PARIS YEARS

Baranik secured official papers from the Army approving his application for benefits under the GI Bill, which included tuition in an art school and a monthly stipend. Thus when he and Stevens left the United States in September 1948, their objective was to enroll in one of the famous Parisian ateliers. Their son, Steven, was born on December 29, 1948. Their sojourn in Paris would last until Baranik's GI Bill benefits expired, in the fall of 1951.

There's a photograph showing me on the HMS *Queen Elizabeth* going to France in September 1948, wearing a gray two-piece maternity outfit and looking extremely happy, leaning on the rail. I took a photo of Rudolf wearing a tweed suit, which he never wore again. He, too, looks extremely happy and very sophisticated. The doctors had said it was okay for me to go Paris in my condition, but if I were any more pregnant than I was, the steamship would have had problems taking me to France. They wouldn't want to get involved in an emergency.

When the ship docked we went straight to Paris and stayed at a pension near Gare Saint-Lazare. I remember photographing the streets from our balcony there. I had to get a ration card for milk for the coming baby. Many things were rationed, since France was still recovering from the war.

It was only three years after the end of the war, and Paris was still trying to get back to normal. We were going to a Europe which had been torn apart—a place where thousands of Jews had been gassed. I was also pregnant, so that, too, was frightening.

But I was in Paris; the Louvre was there! And famous artists—Picasso, Braque, Matisse, and Léger—were there. These were called the "Big Four," the great artists and innovators. I saw my first Tamayo show in Paris, and my first show by sculptor Medardo Rosso and expressionist painter Nicholas DeStael. All these were new to us. Louis Aragon was there. Paul Eluard was there. So it was terribly exciting and overwhelming.

Figure 8. May Stevens on the HMS *Queen Elizabeth,* sailing for Europe, 1948.

We also found French artists who hadn't soared to the international level—artists like Edouard Pignon and Bernard Buffet. They were interesting to us—not on the same level as the "Big Four"—but they were alive and available. One could meet them, one could see their works constantly in galleries. That was the kind of world that we went into.

We both enrolled in the Académie Julian. I studied there along with Rudolf, until I grew too big to fit between the easels. We did charcoal drawings from the model. To erase the charcoal you took fresh bread, the baguette that you'd picked up in the morning, and you rolled the soft, moist center in your fingers to make a little piece of dough with which you removed the charcoal.

One of the teachers we had was named Cavaillez, who was a successful Impressionist painter. He said, "Il n'y pas de peinture sans violette." It was so surprising to me to hear that. But Cavaillez did sunlight, and if you do sunlight as an Impressionist you need a complement for the shadow, so violet shadows are necessary to create the Impressionist effect of sunlight.

At the Académie Julian, Rudolf became friendly with his professors, as he always did. We were invited to the home of his professor, Emile Sabouraud for dinner. I remember a fantastic meal. Madame Sabouraud served a beginning course made of mushrooms, some meat, and meat juices. Then she served lamb, the first time I had eaten lamb in France. She made it rare and juicy, and what I learned from Madame Sabouraud was to put little slits into the lamb flesh and insert slivers of garlic. I had never tasted meat like this—pink, juicy, and flavorful. It was superb.

We invited Professor and Madame Sabouraud to our home for a meal. We were then living outside Paris, in Ville d'Avray, on the way to Versailles and next to the Parc de Saint Cloud. I made dinner, and afterward I invited Monsieur Sabouraud into my studio to see my paintings. He looked at my work and said, "This is not honest." My mouth must have fallen open. I said, "What do you mean?" He replied, "It's too strong for a woman." I was amazed, deeply hurt, unable to speak. Actually, I didn't like his work either.

For three years we lived off the money from the GI Bill—Rudolf, myself, and Steven—and we managed. There was a strict procedure for Americans on the GI Bill, that came from the American Embassy. A sergeant or some official would show up to call roll, to make sure that the Americans who were being supported by the government were in school. Of course, many of them, once they'd appeared for roll call, would disappear from class, because Paris was tempting.

As I said, going to France at that particular time, being pregnant, and then having a baby was a really dangerous thing to do. The political situation was not yet settled. There were posters all over Paris about the Rassemblement du Peuple Français, which was the party of the right, the Gaullist party. Of course the Left was very afraid that de Gaulle would come to power, and in all the bakeries and meat stores, everywhere there were posters about the Rassemblement du Peuple Français, and also posters from the Communist labor union, the CGT—Confédération Générale du Travail.

One day, when I was still pregnant, we walked over to the Champs Elysees, where there was going to be a demonstration by the Left against the government. The Left was very powerful, because they had been active in the French Resistance and were much in favor in France. The CGT had planned a big march. At the time Rudolf was sending dispatches home to a New York Lithuanian newspaper, which was also on the left, and which paid him a little bit of money. So the marchers are going to come up the Champs Elysees, and I already see people tearing up the metal spikes which surround the trees along the boulevard. They're pulling them out of the ground, and they're also pulling up bricks from the pavement. They are arming themselves. On the side streets, off the Champs Elysees, you could see the French police vans lining up, and the gendarmes getting prepared for the oncoming battle between the people and the government, which wanted to stop the CGT from demonstrating. The government didn't want them to come to power. The vans were called Black Marias. We learned then that the capes of the gendarmerie have a chain sewn into the hem, so the capes can be twirled into weapons.

People are going inside the cafés along the Champs Elysees or going home. And they're setting up first aid stations at the tables outside these fancy restaurants to be ready for injuries. Rudolf insisted that I leave immediately and go back to the pension near Gare Saint Lazare, because I was pregnant. I left very reluctantly. I really wanted to see what would happen. So all I remember was the preparation for the demonstration. Things like this were happening all the time right after the war.

Later we saw Picasso marching in a May Day parade. He was short and wearing a kind of tweed suit with a vest and a cap. He looked to me like Charlie Chaplin, not the character from the film, but the person whom you would see sometimes when he was not in character. Picasso was short, with snapping black eyes, very lively. He painted the Peace dove, and he did a controversial drawing of Stalin. He gave Stalin a perfectly oval face, like the classical heads he always used, except he gave Stalin a big moustache and a big head of hair. The drawing looked like a sixteen-year-old Stalin. It was often reproduced in the newspapers. So there was this exciting art-Left life that we felt a part of. Although we were foreigners and students, we participated emotionally and got to know a lot of people on the art-Left.

I posed the question as to whether Stevens, Baranik, and the other Americans in Paris were affected by the currents of postwar existentialism, particularly the works of Jean-Paul Sartre and Albert Camus.

We were interested in the whole spectrum of literary thought. I think that we were particularly interested in the people on the Left, and in people known locally in Paris. I'd always known about, and always cared about, Sartre and Camus, but everybody knew about them in the States. They were like the background gods. But when you got to Paris, you read at a closer level and began to see Paul Eluard, Louis

Aragon, and other French writers who were not as well known in the States. I was interested in reading the poetry of Eluard and Aragon. I also discovered Baudelaire and remember being overwhelmed by *Les Fleurs du Mal.*

We were also interested in the very dramatic struggles going on that were reported in the press. There were tremendous numbers of newspapers and journals with only slight differences of political opinion that reported on, for example, the government of the Netherlands fighting in Indonesia. Some of the people we knew were young Dutch men who were in Paris to avoid being drafted and sent to Indonesia as soldiers. There were all kinds of crosscurrents of politics. It was very exciting.

I think we all accepted the idea of existentialism as an interesting idea, really quite important in the current political situation, so Camus and Sartre were somehow like background.

We always knew that one's ordinary existence doesn't transcend the effort of simply earning a living. So the idea was to make your own life by taking action and going beyond ordinary existence. Just earning a living, not living a mental life, and not trying to change things was a life that was frightening to me. I remember when I graduated from art school being terrified by the idea that I might go from art school to ordinary life, the life of my parents, a life that didn't have action and excitement and struggle and trying to change things and trying to reach for things. I was afraid of slipping into what I saw as a trap of just getting caught in earning one's daily bread and not having the time, or the energy, space, the physical health to go beyond that level of existence. You become human only when you make this great struggle for realizing your life and making it count. That was very much part of our thinking.

Figure 9. May Stevens and her husband, Rudolf Baranik, strolling down the street, Paris, c. 1949.

I asked whether she and Baranik responded to that aspect of existentialism that dwelled on the hopelessness and despair of "the human condition."

I know people talk about the pessimism of Simone de Beauvoir and Sartre, and of course, Camus. Camus had lots of reasons to be a pessimist. Look at his political position. He was in such a bind. Camus was intelligent and concerned with people, but at the same time couldn't rise above his background. He was unable to transcend that, unable to be pro-Algerian, because he was a Frenchman born in Algiers. He simply described that terrible tension, because his allegiance to his own people and background was too strong for him to rise into a rational and deeply human position. He couldn't make the existential leap.

But he wrote some wonderful works that are very important. I remember being interested in his use of Sisyphus—the fascinating idea of the struggle which keeps going on and on and never moves forward. It's like Camus himself. He was on the Left but unable to speak for Algerian freedom, because he was part of the French elite that controlled and benefited from the subjugation of the Algerian people.

I go along with the Gramsci idea, which seems self-evident. Antonio Gramsci said that what he admired is "pessimism of the intellect and optimism of the will."[6] In other words, I can't stand to say everything is lovely or everything is getting better or whatever it is, when I don't see that. I hate that falseness. On the other hand I think that you have to live to struggle and take joy in it. But that doesn't mean you think that you're going to make it, or that things are going to necessarily be better. But you're going to try it anyway, there's no other way, but to make that effort, with good spirit and good grace.

Rudolf left the Académie Julian, which was too traditional. He said it was oppressive, with Impressionist teachers insisting that you could not use black, the obligatory color being violet. Rudolf then began studying with Léger, where many Americans were enrolled. Léger was a Communist like Picasso, and the two of them had a rivalry between them that was quite evident and, from a

distance, amusing. I would go to Léger's studio on Fridays to hear Léger's critique. He would sit in a chair and the paintings would be brought forward to him. If he saw a painting which looked at all influenced by Picasso he would say, "Enlevez!" Take it away! "Enlevez, c'est du Picasso!" It looks like Picasso. Out!

The first time I walked into the Léger studio it was amazing because up on the model stand were three or four models dressed with flat straw hats, in shorts, and striped T-shirts, leaning on bicycles, and above there was a big rope draped around the scene, so it looked like a living Léger. You were expected to use that as your subject and to use Léger's color. Léger used to talk about how he liked to draw and paint the trousers of a workingman, because it had folds and bumps. What he didn't like were the creased trousers of a businessman because that was of no interest. He preferred the lumpy quality of a worn, used, trouser leg.

Léger was doing paintings of construction workers—paintings showing men working on buildings. Léger told the story that one day he was mistaken for a construction worker, when he went to look at what they were doing. He was very proud of being taken for a laboring man. He was a very down-to-earth person.

In Léger's studio Rudolf used black. He was still a beginning painter and he loved blacks, grays, and whites. They became characteristic of his mature paintings, but even then he was using them, and Léger objected. He would look at Rudolf's paintings—he liked Rudolf and his work—he'd look at the color and say, "C'est du cirage." Cirage is shoe wax, black shoe wax. Rudolf was using thick blacks and grays in his painting. But at the end, when Rudolf left, Léger signed a book for Rudolf with his best congratulations and best wishes and told him how he admired him and his work. Léger also made a little drawing of a toy choo-choo train in the book.

We read many of the French newspapers. There were about eight dailies, *L'Humanité* was Communist, and there was one called *Le Franc-Tireur*, and *Le Monde*, and all kinds of newspapers. When you had an exhibition many of them reviewed you. I had a show at Galerie Huit, a gallery that American GIs put together on the Left Bank, on rue St. Julien le Pauvre, which was reviewed in several of the French newspapers. The review I remember best was in the *New York Herald Tribune International* edition. The reviewer, Peter Karegeannes, said that it was a fine show but there was one painting which was scarred or marred by its title. That painting was called *The Martinsville Seven,* and represented seven black men who had been accused of rape in the American South. It was a small horizontal painting, simplified and semiabstract. They were wearing white T-shirts and blue jeans, and they were just lined up—seven black men. I don't know where it is now. My reaction was: nobody tells me what to paint. The reason I'm an artist is because it's a place where you can be totally free. No one is going to prevent me from doing political work when I want to, and no one's going to make me do it, if I don't want to. I am free in this one area of my life. I'm totally free. That's why I'm here. I can be myself and do what I want to do.

In Paris I submitted work to the famous French "salons," annual exhibitions of various categories, and was accepted. The most famous and important was the Salon d'Automne. I showed there and at the Salon de Mai. I also entered the Salon des Femmes Peintres and the Salon des Jeunes Peintres. I had works reproduced in newspapers. Can you imagine eight newspapers, with maybe eight reviews of all the shows going on? I was showing with Picasso in the Salon d'Automne, where my work was placed in the gallery with other political art. It was a huge exhibition.

In one of the reviews of my work, probably for my solo exhibition at Galerie Huit, they described me as "May Stevens, a young American come to Paris to perfect herself." Isn't that wonderful? They're slapping themselves on the back. Come to Paris to perfect herself! But it worked very well for me because they thought how smart I am to come to Paris to perfect myself. When I got back to the United States, Americans thought, "She's been educated in Paris. How smart she is." Right? It worked in my favor both ways. And, of course, Rudolf was showing and doing work as well, and he sold some work.

While I was getting all that glory from showing in all these salons, I was at home with baby Steven, but painting all the time. Rudolf and I were unaware of what was happening in the art world of the United States in the late 1940s and early 1950s. We were in for a surprise when we came home in 1951.

We socialized with many American ex-GIs in our community at the Galerie Huit and with students at Fernand Léger's school, many of whom were American. One of the enterprising young ex-GIs, also a Léger student, started a diaper service. Rudolf would go into Paris on the train from Ville d'Avray, where we were living, with a backpack full of soiled diapers wrapped in newspaper, and he would give them to this guy who had a diaper service. American ingenuity, right? The next day the guy would bring them in clean, and Rudolf would bring them back.

We met interesting people in Paris. Two of our friends were Jehangir Sabavala and his wife. He was a Parsee, which means his origins were Persian, and his wife was Indian. They were very interesting people, well educated and sophisticated, and it was great to be with them. Peter Mattheson, the writer, was there, and he and his wife came out to Ville D'Avray where we made dinner. Other artists in Paris when we were there included Ellsworth Kelly, Haywood Rivers, and Sam Francis, but we didn't know them.

We hired a *femme de ménage,* a housekeeper, when I got arthritis after Steven was born. I could hardly walk around the room without becoming totally fatigued, and I'd have to go back to bed. Her name was Marguerite, a large, heavy woman from Alsace. She was quite homely, with missing teeth, stringy gray hair—and she was quite wonderful. She would take Steven for a walk in the woods, the Parc de Saint Cloud, and she'd come back with mushrooms she'd picked, and sticks she picked up for the fireplace. I would look at the mushrooms and say, "My god, you bring home food from the forest!" And she'd say that in France they ate "tous ce que se mange." Everything that can be eaten, we eat.

We went to England for a week, leaving Steven with Marguerite. We needed a break. We needed a change, and it was so wonderful to be in London where people spoke English. I remember being in a movie theater, and I'm moving into the row of seats. I say, "Excuse me." And they understand me! When we came home, Steven, who was learning to talk, sounded just like Marguerite. He had imitated her accent and her French in a week.

We came home to New York when the GI Bill ran out.

RETURN TO NEW YORK

In the fall of 1951, Stevens and Baranik returned to New York with Steven, then almost three years old. Stevens' father met the family at the dock and then drove Stevens and her son back to his home in Quincy to stay, while Baranik scouted for an apartment in New York.

We stayed with my father and his housekeeper. My mother had been placed in the Medfield State Mental Hospital two years after we had gone to Paris. But since my father didn't want to live alone, he persuaded a widow, Mrs. Rogers, to keep house for him. She was Scottish and very attractive with wavy, gray hair. She lived with him along with her adult son.

What bothered me most is that when we would go to visit my mother in the mental hospital, Mrs. Rogers would sit in the front seat of the car. My mother and I would sit in the back. Mrs. Rogers would have made sandwiches, we'd all have a lovely picnic, and I was miserable. I thought my mother was being dishonored, because she was so displaced by the housekeeper. The front seat should have been my mother's. She was Mrs. Stevens, his wife. My father would tell me that he would never divorce her, and I would think, "What do you mean, you'd never divorce her? You divorced her in truth, by never talking to her, and only paying attention to her basic necessities." When

she needed a doctor, he got a doctor. When she needed food, he got food. She had a roof over her head. If she needed a dress, he bought her a dress, but he didn't talk to her. But I'm quite sure that they loved each other at the beginning of their marriage.

<div align="center">✦ —— ✦</div>

Rudolf found a place to live in the damp basement of a house in Queens. The landlord was part of the Lithuanian community that Rudolf knew. Later we moved to South Ozone Park, where we rented the first floor and basement. We also lived in Flushing, near Queens College, at one time. By then Steven was in elementary school.

Shortly after we returned, I got sick again, as I had been in Paris. I could hardly move, with a low-grade fever and aches and pains all over, a kind of arthritis. I was hospitalized, first at Mount Sinai hospital and then moved to another hospital. It was the same arthritis I had right after Steven was born. I kept being tested for rheumatoid arthritis, but they couldn't figure out exactly what it was. They never gave me anything but aspirin, and sometimes I took up to sixteen aspirin a day, less when I felt better. I also got tintinitis, which is ringing in the ears, from taking so many aspirin.

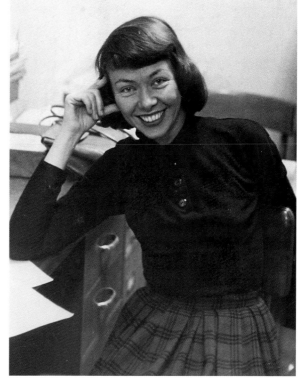

The two artists held part-time jobs in 1952. Baranik worked for a Lithuanian newspaper published in New York. Stevens went to work, first as a clerical assistant with a market research firm, and then at the Museum of Modern Art, which hired her on the recommendation of her Massachusetts College of Art teacher Lawrence Kupferman. She worked in the publicity department as a clerk-typist, a job for which she admitted she had little talent or enthusiasm. In the two years she worked at MOMA, the most significant experience she recalled was: "I got my ass pinched by Edward Steichen."

During the 1950s Stevens and Baranik struggled to make enough at their jobs so that they could live both as artists and as a family raising Steven. When they moved to Dalewood Gardens in Hartsdale, near White Plains, it was to a one-bedroom apartment in a complex that included a swimming pool, grassy areas, and woods nearby where Steven could play and be somewhat independent. They turned the bedroom over to Steven and used the living room as their painting studio, with Baranik using one wall and Stevens the other.

Baranik also rented a space over a store in White Plains and taught painting there. He would invite well-known New York artists, such as his friends Alice Neel and Ad Reinhardt, whose parents were Lithuanian, to come to his studio and speak to his class. Many of the students Baranik taught, such as Nilufer Reddy and Sandra Gold, became friends and collectors of the work of both Baranik and Stevens. Sandra Gold's husband, Philip Gold, a dentist, exchanged dental care for paintings.

Baranik, then in his early thirties, began to exhibit in New York shortly after their return. He was invited by the ACA Gallery, a gallery known for its promotion of figurative art of social issues, to show in their 1952 exhibition Five Artists—Four Media. *Baranik's paintings were singled out for special notice by art critics Lawrence Campbell of* ARTnews, *Stuart Preston of* The New York Times, *and Emily Genauer of the* New York Herald Tribune. *He then joined the ACA, which mounted a solo exhibition of his work in spring 1953. Curators from the Museum of Modern Art came to his studio and selected some of his work for a 1954 traveling exhibition,* Recent Work by Young Americans,

Figure 10. May Stevens at her desk in the publicity office, Museum of Modern Art, New York, mid-1950s.

which included artists Conrad Marca-Relli, Grace Hartigan, Alfred Leslie, and Kenzo Okada.[7] Baranik had his second and last ACA solo show in 1955. In his "Autobiographical Notes" he describes his art as moving more toward an art of mood, a style he would later call "socialist formalism." In 1958 he moved to the Roko Gallery. By this time he was teaching at Pratt Institute. He would also teach at the Art Students League.

Stevens was included in an ACA Gallery exhibition in 1957 and began to show regularly in other group exhibitions after that. In 1961 she had her first solo exhibition in New York at the Roland de Aenlle Gallery.

One of the reasons that made Baranik and Stevens eager to return to the United States in 1951 was to see the new art done by the abstract expressionists gaining prominence in New York, whom they had read about in Paris. Before they left Paris, Robert Vrinat, the editor of Actualité Artistique Internationale, *had asked Baranik to write a regular "Letter from New York." Baranik admitted later that "some of these early [Letters] show me now how retrograde ideas connected with the School of Paris still had a hold on me, for example, my contention that Rothko 'lacks plastic qualities,' meaning, that what I found lacking was the French sense of matière. But a year or two later Rothko emerged to me as one of the best artists in the US. (Pollock and deKooning were clear to me from the start.)" Baranik wrote for only a few issues of the publication.[8] Stevens had a similar response when she saw exhibitions of the New York School, such as* Fifteen Americans, *curated by Dorothy Miller for the Museum of Modern Art in 1952.*

We came back to New York, having been away for three years, having gone to what we felt was the heart of art. Then we came back and found out that abstract expressionism was happening in New York. We saw Pollock, Mark Rothko, Willem deKooning, and Franz Kline's works for the first time. We saw the show *Fifteen Americans* with these strange paintings of Jackson Pollock's, of allover patterns, like fabric. When I first looked at Pollock, I said, "Wallpaper!" This new American painting had happened while we were away, so we were stunned.

Things were not immediately accessible to us because we were so used to looking with French eyes. In France we were learning about making a beautiful painting, *à la francaise,* in the French style. We had learned from Picasso and Matisse and absorbed all the things that were happening in Paris. So when we came home, we were overwhelmed and skeptical.

At first I thought that Pollock's paintings didn't have any structure, they didn't have any rationale. The French spoke about Jackson Pollock as this wild man from the West, who was like a savage and primitive, who slashed at canvases and threw things. The French sensibility seemed to me concentrated on construction, on building a very firm, formally constructed work, with everything interlocked. There was a scaffolding for how to put a picture together, and then you saw Pollock. He wasn't doing it. At first you thought, there's no logic. There's no rationale here. It's just paint flowing. It could go on forever. It doesn't need any boundaries. You could cut a swatch anywhere, because it doesn't have any inner coherence. When I began to see his work with my own eyes, I realized this is utterly untrue. Pollock has great delicacy, great control, and great organization. But I saw it as a French person when I came back, because I'd been away for three years.

TEACHING DURING THE 1960s AND 1970s

Stevens discovered that she could easily obtain a BFA degree by taking additional college courses. With these credentials in hand, Stevens began teaching art, first at Long Island City High School for about two years, and then at the High School for Music and Art, which she left in 1961 because of her frustrations over not having enough time to paint and develop an active exhibiting career.

When I was in Paris, I had received a letter from the Massachusetts College of Art, where I had graduated with a certificate, the only diploma they gave at the time. The letter said that for the year of my graduation I needed only six additional credits of English in order to get a BFA diploma. So I set about going to school—first at Long Island University and then at Queens College, near where we lived. One of the two English courses I took was the Bible as Literature. But when I got sick, I couldn't finish the classes. So Rudolf went to my classes, listened to the lectures, and took notes. He would return and tell me what was going on. I went in and took the final examination and got an A.

My first teaching job at Long Island City High School in Astoria, Queens, was very stressful for me. It was hard, partly because, if you want to be a good teacher, you cannot do it halfway. You throw yourself into it. You wear yourself out. I was a brand new teacher. I'd never taught before. I was still completing courses, but they needed teachers. Long Island City High was supposed to be a very tough school. The other teachers talked about the movie *Blackboard Jungle,* which came out in 1955, and showed a school similar to theirs.

In the beginning I was so frightened that I never sat. I always stood. I walked around the room, because I wanted the students' eyes to follow me, I wanted to feel that I had some sort of control over the students. There were other young teachers who had spitballs thrown at them. I chose three or four women teachers, who were really good and successful, to go to for help. I asked to have lunch with them—each one, individually—and I told them I wanted to get some pointers from them. Audrey, an art teacher, was a bleached blonde lesbian, heavyset, wore bright red lipstick, and was tough. She told me: "Get your paperwork in on time, get all your forms filled out, and nobody will ever bother you." Another was named Josephine, who had brown hair pulled back in a big bun and wore long skirts. She was very gentle, sweet, and efficient, and made a home of her classroom with fish tanks and pretty pictures. The best person that I talked with was Lucille, who was a black woman who taught science. She was a very sensible person, not flamboyant, but smart. I told her, "I'm scared of the kids. I don't know what to do. I don't feel I have control." Then I told her about my life, how I'd come back from Paris where I'd been for three years. How I had a child born in France and had exhibitions at the Salon des Jeunes Peintres, the Salon d'Automne, and the Salon des Femmes Peintres. When I finished, she said, "You know what you have to do? Tell the students who you are." Wasn't that brilliant? So I went into the classroom, and I told them. And it made a difference. I became a real person to them rather than just an ineffectual teacher.

Figure 11. May Stevens, her son Steven, and May's mother, Alice, c. 1952.

One day they gave me cafeteria patrol, which is what they give to new teachers. I'm down in the basement lunchroom, the room is full of tables of raucous students. The noise is blinding. The bell rings to end the period, and I'm standing next to a table full of teenage boys, who are hulks. I say," It's time to go upstairs. The bell rang." The nearest boy looked up and said, "Fuck you." I nearly fell over. Nobody had ever said that to me before. I didn't say a word. I was just devastated. I go to my teacher friends and tell them about this boy. They say, "Oh that's Frank Talini. He's one of the Talini boys. We always have Talini boys in the school. It's a big Italian family. The boys don't do any harm to anybody. They just can't read, so they make noise, you know. They're all right. Don't worry about them." Later I was teaching art to students who wanted to become artists, but also teaching art appreciation for those who didn't want to become artists. I had Frank Talini in my art class. He did the most beautiful delicate watercolors in the world, and we became buddies.

I then went to teach at the High School of Music and Art in upper Manhattan. I had students painting on large sheets of paper. I would go home with stacks of these paintings, sit down on the floor, and make three piles: the ones I liked, the ones I didn't, and the ones in between. I'd mark the piles A, B, and C.

I was planning an exhibition in the fall at the Roland de Aenlle Gallery, next to the Museum of Modern Art. But I haven't been able to get my artwork done, because I'm so involved with teaching these talented kids. I go to bed at night worrying about some kid's painting, not my own. I tell the Music and Art administration that I must take a semester off. They say I can, if I go to school for six credits, or if I am pregnant or if I have some disease. Otherwise I can't take the semester off. We were a sister school with the High School of Performing Arts. Their teachers, who were musicians, singers, and actors, had provisions made for them if they had to go on tour. I said, "I'm having a show, I have this career thing I've got to do." They say, "You can't do it, unless you have, for instance, lower back pain." On principle I couldn't say that. I told them I need the time off, so I quit. I wasn't going to let them control me or limit me. I was an artist. I immediately looked for other teaching jobs, and got a job at the School of Visual Arts.

Stevens taught part-time at the School of Visual Arts from 1961 to 1996, when she and Baranik moved to Santa Fe. She also taught briefly at Queens College during the 1970s, but her steady job was at Visual Arts. Frequently she took visiting artist positions at other universities.

At the School of Visual Arts I had some talented students. You love them and you care for them, especially those who have real talent or interest in art. Strangely, some students were very talented, but they didn't care. I would say, "You know this is great. You really have to pursue this," and they would say, "Yeah, whatever."

I taught a class called Women and the Arts, and another called Art and Politics. I had some graduate students in it, who took the courses as electives, such as English-born artist Jenny Polak and Johann Grimonprez, a Belgian, who made a film about the Papua New Guineans. Lorna Simpson, who brought in photographs that she had done, took my Women and the Arts course. I also became close to Rudolf's students from Pratt and the Art Students League, especially Abdelali Dahrouch, a Moroccan who grew up in France, and Alex Villar, a Brazilian.

I taught a course at Queens College in an evening program for returning adults, along with two other teachers: the novelist Leslie Epstein taught English, the musician Michael Oldbaum taught music, and I taught art. We tried to coordinate. For example, when Leslie taught *Lolita,* I showed Balthus paintings. Leslie and I became good friends, which we still are.

For their English course students read short stories that were amazing to me. One was called "A Simple Heart," by Flaubert, "Le Coeur Simple" in French. It was about Felicity, a maid who spent her life in a bourgeois French household. The story takes her from her first entry into their service to her death. During all that period she is totally devoted to the family, she raises their children, she does everything that they need, and she lives in a little room at the top of the house. She has no outside life. At one point she has a little fling, an affair with somebody, who leaves her. It's not terribly significant. And when the children grow up and leave home, they never get in touch with her. She has been used—she's not useful anymore. She has one friend in her attic room. It's a parrot whom she adores, her only friend and companion. When she gets old, still living in this house, with nobody paying any attention to her, she dies. And as she passes over, she sees God. God is a huge parrot. It's a story I have never forgotten—the narrowness of her life and the dream she had of something beautiful and better realized in her final fantasy.

Another was "The Hunger Artist" by Franz Kafka, about a man who had a job in the circus of not eating. He would lie on hay in a fenced enclosure. A sign would declare how many days he had fasted. People would come and say, "Look at him, look at how thin he is." Then maybe they would come back the next day or a week later and exclaim, "My God, he's much thinner. How can he hold out?" So this

was the great excitement, the freak in the circus. He didn't eat. And when the circus closed and moved on, he'd go to another circus stop and start in all over again. Well, the fad or fashion of being interested in this ended. People stopped coming. So eventually he just gets too weak to recover, and he lies limp on the straw. He's dying because he hasn't eaten for so long. And he gave up caring because nobody came. As he's dying he says his last words to those who are still there: "To tell you the truth I never found anything I liked to eat," which I found absolutely wonderful. Funny, sad, and I think profound on some level. He never found anything he liked to eat.

Words I remember that have become important to me are: "If the book we are reading does not take a pickax to the seas of pity that lie frozen within us, then why are we reading it."[9] Literature is meant to deepen, release, enrich. We all close down, we protect ourselves, and we try not to feel too much. We become preoccupied with our own affairs and not the affairs of other people who are in pain or trouble. Kafka says if we lose that ability to feel for others, we have lost a lot. I believe it was Adrienne Rich who once asked—I think this was in a footnote in an essay she wrote about lesbianism—how do we decide at what point we draw the line, where we say beyond this line I will not feel for people.[10] She is saying, I will have sympathy and compassion and be involved with all kinds of people up to this point. Beyond that they're outside my ability to handle. I cannot feel for them.

We all do that. We don't have pity for the homeless, or not much. We decide whatever or wherever we will place that line. Otherwise, it's too much; you can't handle it. Of course, it's self-protection, and it's necessary to some degree. The best of literature or art or music makes us feel.

$$\rightarrow\!\!-\!\!\leftarrow$$

As I've said, my father was always a racist. He spoke against blacks, Jews, Italians, and Catholics, which I heard throughout my childhood. I knew it was wrong, and it infuriated me because I loved my father. We were very close and I wanted him to be better than that. I began to give him things to read. I argued with him. He would listen to me, but he never changed his mind. Otherwise, I think he was actually quite a good man, but certainly not a very profound thinker. The result was that I was always aware of racism, as was Rudolf, of course.

When Rudolf was a member of the ACA Gallery, he became friends with Charles White, the black artist who was both draughtsman and printmaker. One day at the end of a conversation in the ACA Gallery, White said, "Well, I've got to go get a haircut." Thinking that White would go in the neighborhood nearby on 57th Street, maybe over to Lexington Avenue where there might be a barbershop, Rudolf offered to walk with him. White looked Rudolf in the eye and said, "Are you kidding, I've got to go to Harlem to get a haircut." We learned from White a little more of the day-to-day consequences of racism. Rudolf and I shared these feelings against racism and felt ourselves to be part of the black civil rights movement.

We went to Washington every year to protest. Rudolf, Steven, who was a teenager at the time, and I heard Martin Luther King Jr. deliver his "I Have a Dream" speech in August 1963. We had taken off our shoes and had put our feet in the reflecting pool on the mall in front of the Lincoln Memorial on that hot summer day. There was a hush during the "I Have a Dream" speech. The silence of thousands of people listening was terribly moving. At that moment we were all envisioning the kind of future that he envisioned, where all children would be equal. His conviction, his vision, was like manna to starving souls.

In April 1963 I had a show called *Freedom Riders* at the Roko Gallery in New York. Rudolf and I had not gone South. I wasn't personally involved in the movement, since I had a child at home, and was teaching regularly as was Rudolf. But I followed the news very closely and was extremely interested in learning about the freedom fighters. In my show I had images of black people, and sometimes black and white people. One painting, *Make Way,* showed a group of black people facing a mob. Another, *Proposal for a Monument,* was

FREEDOM RIDERS,
MARTIN LUTHER KING
JR., MALCOLM X

taken from a photograph of black people kneeling down and praying in the center of the square in Albany, Georgia. Another black-and-white gouache in the series, probably done later, showed black people being driven back with a water hose, as happened in May 1963 in Birmingham, Alabama.

The exhibition had a small catalog with a preface signed by Dr. King. Rudolf had suggested to me and the Roko Gallery director, Michael Freilich, that we might get Dr. King to write something for the catalog. Rudolf's idea was to write something on the idea of the show and take it to the people at King's offices and see whether King would be interested. So Rudolf wrote a paragraph and the King people said, "Well, we'll see." When King himself saw it, he said he would like to sign it. So that paragraph appeared in the catalog over the signature of Dr. Martin Luther King, Jr.

> The men and women who rode the freedom buses through Alabama, who
> walked in Montgomery, who knelt in prayer in Albany, who hold and sing
> We Shall Overcome Some Day in the face of hostile mobs—their acts cry
> out for songs to be sung about them and pictures to be painted of them.

✦ — ✦

Recently a show traveled the country called *In the Spirit of Martin: The Legacy of Dr. Martin Luther King, Jr.* with a wonderful book accompanying it with many photographs and reproductions, including two of mine. One is *White Only,* which shows a black man facing a glass door that has the lettering "White Only" in reverse, because he is on the outside and the viewer is on the inside looking out. The other is *Freedom Riders,* that small painting from the 1963 show, which shows a group of people in a bus heading South.[11] They are very tense, expecting the worst, knowing that they might well be attacked on their trip into the South. It's a very powerful painting, which we wanted to put in the traveling exhibition, but it wasn't available. I have sold many of those works with civil rights subjects, but the people who bought them were not always easy to locate. I always thought *Freedom Riders* had a particularly strong composition. It reminded me of Daumier's *Third Class Railway Carriage,* where you see people on the inside of a bus or carriage, set against brightly lit rectangles of windows. We went every year to Washington to take part in the civil rights demonstrations. It was a great joy to do, and something we felt very passionately about. Later it turned into the antiwar movement, and we went every year to join in the struggle against the Vietnam War.

When Malcolm X, the militant black leader, was assassinated in Harlem on February 21, 1965, he had recently broken ties with the Nation of Islam, and was launching his new Organization of African-American Unity. After he was pronounced dead, his body was taken to the Unity Funeral Home, where he was wrapped in traditional Muslim sheets and placed on view to the public. On the day of the funeral about 20,000 people lined the procession from the church to the burial grounds.

When Malcolm X was killed, we were very moved by it and upset. He was laid out in a funeral home in Harlem, not very far from where we lived on Riverside Drive at 157th Street. I went to see him. I did two gouache drawings of his body—one on parchment of

just his head. The other one was the whole body laid out on a litter. I took the images from newspaper photographs, as I had with my civil rights imagery.

Patrice Lumumba, the first Prime Minister of the Republic of Congo, was pursuing a policy of decolonialization, a policy in conflict with the Belgian government, when he was tortured and assassinated by a firing squad of military men on January 17, 1961.

Earlier, when Patrice Lumumba was killed in Africa, I was very disturbed by the way that he was assassinated. I had been following the progress of his life and activities, as had many of my friends. I wanted to respond to it, and so using a newspaper photograph I made an enlarged head on a sheet of paper. It was a profile in black ink of Lumumba with an expression of necessary endurance on his face and a rope around his neck. I gave this to my friend E. S. Reddy, from India, who later became Assistant Secretary General of the United Nations and Director of the UN's Center Against Apartheid. The United Nations was building sanctions to try to bring South Africa into line, and Reddy was the person in charge. He knew most of the Civil Rights leaders in the United States and followed all of the activities relating to civil rights. Lumumba meant a great deal to him.

During 1967–1968 Stevens and Baranik moved to 97 Wooster Street, south of Houston Street, an area that was to become the center for artists in New York. Their son, Steven, who had gone to the State University of New York in Binghamton, had transferred to City College of New York and was living in the Riverside Drive apartment. The move to Soho (as the area south of Houston was called) meant that Stevens and Baranik developed closer and daily relationships with other like-minded artists and writers.

THE PEACE MOVEMENT AND PROTESTS

Writer Grace Paley was the head of the Greenwich Village Peace Center. She was a person who could be in authority without ever being bossy—practical and sensible without any question of rank or status. She always had very good ideas, probably better than anybody else's. But if one had another idea, she would certainly include it. We fell in love with her immediately.

In 1966 Rudolf and I began working with Paley and with the War Resisters League, of which she was also a member. When Steven was planning to resist the draft, he went to Karl Bissinger, a photographer, of the War Resisters League for draft counseling. Karl helped him fill out forms and write a conscientious objector statement. But because Steven was a student at that time, he was never called up. We did not want him to fight, and he didn't want to fight. It never crossed my mind that he might have to go to jail. Jail was a very dangerous place to go. You would never know what would happen to people there, how they might be abused. But it never happened.

We stood in Sheep Meadow, in Central Park, in a circle of parents, friends, and supporters around young men who burned their draft cards together. Paley said she would never forget seeing my face across the circle. I wanted to support Steven in this act but was terrified for him. We were also putting ourselves in jeopardy by aiding and abetting this act, which was against the law. But he wanted publicly to burn his draft card in Sheep Meadow with other people. Our feeling about the war was that we did not want our son to go and do these horrible things. I never thought about him getting killed. I didn't want him to kill other people.

At that time Mitch Goodman, a poet and writer married to poet Denise Levertov, headed a group of writers who wanted to protest the war. They had already gathered and started to organize. They decided to try to expand the group by inviting artists to join them. They called Rudolf for advice. Everybody relied on Rudolf for help in these things. Joan Snyder, for example, said that when she got requests in the mail to support some cause, she asked them whether Rudolf Baranik supported it. She trusted him, as people did, because he was

extremely honest; he would support anybody he believed in and would never have anything to do with somebody whom he was suspicious of, no matter what they said. So Rudolf invited Leon Golub and Nancy Spero, Jack Sonenberg and Phoebe Hellman, and of course me. Irving Petlin, a friend of Golub's from Chicago, joined us. There were about seven of us. We seldom had big meetings. It was all done on the phone. We called friends and fellow artists and asked for support, for ideas, for participation on many levels.

From January 29 to February 5, 1967, "Angry Arts Week" occurred in New York—a weeklong program of performances, concerts, demonstrations, art shows, public poetry readings, and a leaderless midnight concert in Town Hall. Baranik did a poster publicizing the "Angry Arts" (Figure 12). The group raised funds from artists and writers and placed an ad protesting the Vietnam War in The New York Times, *on January 29, and in the* Village Voice, *on January 26. The exhibition* Collage of Indignation *was held at the Loeb Student Center of New York University.[12]*

Figure 12. Rudolf Baranik's poster for Angry Arts Week, New York, 1967.

The first big thing Artists and Writers Protest Against the War in Vietnam did was to buy a full-page ad in *The New York Times*—I believe for $6000. We had six hundred artists and writers, each giving $10. Their names were listed with the statement called "End Your Silence." It was very successful and quite sensational—with all these well-known people expressing their passionate disagreement against the war.

Then came Angry Arts Week. Everybody we knew wanted to be in on it. It became very exciting. Floats went around and flatbed trucks held performances. People would listen to speeches, poetry was read, and plays were performed. I remember one play by a group called Burning City Theater.

All kinds of things were happening. Everybody we knew wanted to stop the Vietnam War. One skit consisted of two women. One woman would go into a laundromat, take out the other woman's laundry, and put in her own. They would start screaming at each other, "You're acting just like the Americans in Vietnam."

In Soho we were in the middle of it. An effective event was planned by Petlin, who called up the army and told them he needed body bags for a theatrical performance. They loaned him the body bags, which were carried through the streets into Central Park, to make people think about the bodies that were coming back from Vietnam. That would be good to do now, with American soldiers still dying in Iraq.

Then there was the huge exhibition at Loeb Student Center called *The Collage of Indignation.* Leon Golub turned his loft over to artists, each of whom could take a 2 x 2 foot piece of Masonite and paint an antiwar statement. Both abstract and realist artists did these panels—Raphael Soyer, Ad Reinhardt, and others. I recall Nancy Graves putting two camel humps, made of camel fur, and writing "Hump War." James Rosenquist had a piece of shiny bright barbed wire on another panel. I took a cloth instead, and I painted the words, "Morrison shall never die." Norman Morrison was an American Quaker who set himself on fire in Hanoi. He was following the example of Buddhist monks who had been immolating themselves to protest the war. The show at Loeb Student Center got a tremendous amount of attention. Max Kozloff, the art critic and later an editor of *Artforum,* was very much against the war. He called the whole thing a Wailing Wall. Posters announcing the events were pasted up all over town. Max, Rudolf, and I went out one night to put up posters in the Columbus Circle area. Rudolf waited in the car, while Max and I did the postering. A police car came circling around, but they didn't see us.

In 1971, Rudolf, acting for Artists and Writers Protest Against the War in Vietnam, and Benny Andrews, representing the Black Emergency Cultural Coalition, put together the Attica Book, *which included poetry by prisoners and reproductions of paintings, drawings, and collages by forty-eight artists, including works by Stevens, Jacob Lawrence, Romare Bearden, Nancy Spero, Alice Neel, Carl Andre, Faith Ringgold, Robert Morris, and Antonio Frasconi. Andrews and Cliff Joseph also organized artists, including Baranik and Camille Billops, to go into the Rikers Island prison to teach art to inmates.*

Rudolf was the first white person, maybe the only white person, to be invited by Benny and Cliff to join them in teaching prisoners on Rikers Island, who tended to be largely black. Rudolf loved telling stories about Camille and her experiences teaching. Camille would bring in things like incense and all kinds of wonderful things to make treats for the prisoners, to make their lives more livable and to make prison a less sense-deprived environment for them. She'd have to fight with the guards who didn't want her to take in anything special. One guard asked, "What's the incense for?" And she said, "For mood, man." Camille was unstoppable.

I did three paintings of Benny Andrews: a portrait of Benny Andrews in profile, with *Big Daddy* wrapped in a flag behind him, one of Benny with his wife Mary Ellen, and another of Benny with me. They are all about 5 feet square, quite handsome.

Between 1967 and 1976 Stevens did a series of paintings, Big Daddy, *that were frequently exhibited in both solo and group exhibitions. The figure—middle-aged, bespectacled, faintly grinning, bald, and naked with a bulldog in his lap—evolved from a photograph of her father. Stevens paired that image with a photographic image of her mother, to create* The Family, *1967 (Plate 2) and* The Living Room, *1967 (Plate 3). Recent critics have referred to these Big Daddy paintings as "political Pop," because of their affinities with the flat, cartoon-like Pop Art paintings Roy Lichtenstein and Andy Warhol were creating in the 1960s and 1970s.*

ORIGIN OF
BIG DADDY

When we lived in Dalewood Gardens in Westchester County in the late 1950s and early 1960s my mother occasionally visited us for an extended stay. My father would come down from Quincy to drive her back to Medfield State Mental Hospital. Once while they were both there, Steven took a photo of my mother seated at the dining table and another of my father on the other side of the table. They were just casual snapshots, but they were very distressing photos to me. My mother looked totally defeated, a picture of despair. My father on the other side of the table is wearing an undershirt with a deep U and his arms are folded across his chest. While she looked abject, he looks defiant. It looks like he's saying, "It's not my fault." They were devastating photographs, and it hurt me to look at them. There was no communication between them. That one photograph evolved into Big Daddy. The picture of Alice became the source of the Alice paintings and drawings.

In the first painting I did, *The Family,* 1967, my mother and father are seated in front of enlarged photographs pinned to the wall—of my brother sitting on a pony and myself next to my mother. In the second work, *The Living Room,* painted later in 1967, I put the two together, seated in a darkened living room, with a TV set between them. The image on the TV screen was the memory of a time when we were more of a family. In it I'm sitting in a chair and reading a book. My father is crouching next to me and holding my little brother. The painting is about isolation and lost intimacy. After we moved to Wooster Street, in Soho in 1967, I began the *Big Daddy* paintings. At that time I was involved in the antiwar movement nonstop.

Big Daddy Paper Doll, now owned by the Brooklyn Museum, is the key image. It shows a fat, white, self-satisfied smug man who is totally naked, and with a big bald head. Lucy Lippard said the head is phallic, which I had not thought of before. I wasn't conscious of its

being phallic. I don't really believe that everything that's vertical and skinny looks phallic, but when she said this to me, I thought, well, it does look that way.

He has a big bulldog in his lap. The reason for the bulldog is because I didn't know how to draw a naked man. If you thought Rudolf would pose for me, you're wrong, and if you thought he wanted me to get somebody else to pose for me, you're also wrong. So I put a bulldog there—a big fat wrinkled bulldog.

The bulldog came from a book I had on the army. There was a unit called the "Big Red Four." Their mascot was a bulldog, which was reproduced in the book. I also did some research on army uniforms. Big Daddy sits in the middle, naked, white, and drawn with a thin red outline. On one side of him is a soldier; on the other, a policeman in a dark, blue uniform with a big, blue, shiny helmet for riot gear. Then there is the black-clothed, hooded hangman. At the end is the butcher. Both the butcher and his bulldog wear white aprons stained with blood. The butcher and the hangman are allegorical, but the police and the military are genuine.

In some versions I put little tabs on the uniforms, so you could cut them out and put them on the naked man; in other versions I wrote "Big Daddy Paper Doll" across the top. The Brooklyn Museum version is a 12-foot painting with no tabs and no writing. I made a hundred silkscreen prints, and twenty-five were with "Big Daddy Paper Doll" written in green on the cobalt blue of the background, but in so close a value that the words almost vibrate like optical art. I did many versions with Big Daddy wrapped in a flag.

I was still doing the Big Daddies in 1976, and some people thought the paintings were patriotic—to celebrate the 200th anniversary of this country. Someone called the Herbert F. Johnson Museum of Art at Cornell University to ask that. I was having a show there. I said, "Of course they're patriotic, they're very patriotic, they believe in the values our country was founded on." Several museums acquired the Big Daddy paintings.

THE WOMEN ARTISTS' MOVEMENT AND HERESIES

As protests against the war in Vietnam continued into the 1970s, some of the earlier activist groups began to merge with other groups. The organization Artists and Writers Protest Against the War in Vietnam, for which Rudolf Baranik and Stevens had done organizing, was folded into the Art Workers Coalition (AWC), a large umbrella coalition. Eventually, by 1971, the viability of the AWC waned, but other groups were emerging, such as the Black Emergency Cultural Coalition, the Guerrilla Art Action Group, and, in 1976, Artists Meeting for Cultural Change.[13]

Galvanized by the women's movement that was sweeping the United States in the late 1960s and 1970s, women artists and critics organized their own groups, such as Women Artists in Revolution (WAR), the Ad Hoc Women Artists Committee, and the Women's Caucus for Art.[14] Women artists, critics, art historians, and students were becoming aware of the inequities in the art world in terms of getting teaching jobs, of gaining access to art galleries, and of publishing. More importantly, they wanted their voices to be heard in professional circles.

Stevens and her activist friends began to redirect their skills in organizing meetings and mounting street actions toward an analysis of their own status as women artworkers. They created "consciousness-raising" groups that provided women with forums where they shared experiences, built self-esteem, and rethought their professional lives. The slogan "the personal is the political" stirred women to consider the ways they shared similar circumstances. "Political" meant being aware of the structures of power and of the social conventions that had kept women subordinate to men. To Stevens and her circle to be a feminist meant not just questioning patriarchal authority but engaging in social change.

Theory combined with practice was the ideal. New York women artists joined together to create their own cooperative galleries, such as AIR (Artists in Residence), which rented space in 1971 at 97 Wooster Street, where Baranik and Stevens lived. Another New York women artists' cooperative, started in 1973, was Soho 20, in which Stevens participated and had a solo exhibition in 1974. Stevens also participated in the exhibition Women Choose Women, *organized by Women in the Arts (WIA) and mounted at the New York Cultural Center in January 1973.[15]*

Although opportunities to exhibit were most welcomed by individual artists, more needed to be done to effect the kinds of social changes that would affect future thinking about art practice. Many women artists and critics saw two avenues to bring about lasting change and to convert feminist theory into practice: an art school with art instruction focusing on feminist issues, and publications by, of, and for women. It was these concerns that propelled women to gather in Joyce Kozloff's loft in November 1975 to hammer out their strategies for changing the world. Among those present were Kozloff, Stevens, Lucy Lippard, Miriam Schapiro, Mary Beth Edelson, Ellen Lanyon, Joan Semmel, Nancy Spero, Michelle Stuart, and Susana Torre.[16]

Stevens recalls the readings, the meetings, and the actions.

When we returned from Paris, I read Simone de Beauvoir's *La Vieillesse,* which in English was called *Coming of Age.* I also read *The Second Sex,* which came out in 1949 and was extremely important. I was always a feminist in some sense. When Steven was small, we would play a game at the dinner table that was like a Twenty Questions game. You chose a character to be, and other players asked you questions trying to figure out who you were. I was always a famous woman, because I wanted my son to know there were such.

There were many meetings in New York in which we discussed feminist issues. I remember a panel discussion in AIR. Four or five male critics were invited to address the women's movement. Blythe Bohnen, one of the members of AIR, chaired the meeting. She was very graceful and tactful. The issue was: How did these important male critics see what we were doing and how did they talk about it and rate it? What were their opinions? It was a wonderful evening with Max Kozloff, Richard Martin, Lawrence Alloway, and others. Max said, "It's not a style," which is true. So how was he going to judge it when it's not a style? Lawrence said, "I write about women all the time," which was also true, because he wrote about his wife, Sylvia Sleigh, and her friends. But how could they write about the women's movement, which was coming up all around and was totally different from anything that ever happened before? At that meeting, Lucy Lippard was in the audience. She got up and walked out in disgust, because the men had no idea what to say, and she was writing about us all the time. But we had wanted to know what the men thought. Joan Semmel was there and was very outspoken. We finally left together and decided, we've got to do our own criticism because the men haven't a clue on how to critique our work.

Another meeting was at the Central Park West apartment of Dorothy Seiberling, a friend of Miriam Schapiro. Schapiro had been out in California working with Judy Chicago, and the two of them were developing a theory that women's work, if it's truly women's work, has round or oval forms in it, which had been suppressed in the male art world. But I'm thinking, I don't like round forms necessarily. Although Big Daddy was very voluptuous, I'm not going to do round forms. I don't do abstractions. I was furious, and I thought, I don't want these women putting me in a bind, telling me what to do. Men were telling us what to do. Are women also going to tell us what to do?

At another meeting Lucy was there, along with Miriam, Joyce Kozloff, Joan Semmel, and others. Joyce said, "We have to do it ourselves, we have to do everything ourselves. We better write about it, we have to do our thinking and develop it." Other people had other ideas, so on the floor various suggestions were made: a magazine, a school, but not exhibitions. We wanted something that would last.

There were many suggestions. Miriam very much wanted a school, because she wanted to do what she had done in California. Lucy wanted a magazine. Both happened. A school opened on the West Side, and there was the magazine, which we eventually called *Heresies*.

So there were many meetings where we finally decided how to do it and what to do with it. Twenty women were dedicated to the idea of making a fantastic magazine that was going to help to change the world. It was not about becoming stars in the art world. It was about spreading the word of feminism. It was the beginning of the most exciting period of our lives. We were changing our lives, people were leaving their marriages, or redefining them, or going into new or different relationships. All kinds of things were happening. Lesbian relationships were developing and/or failing. For the young lesbians among us, this group was the hospitable world they were looking for.

Miriam Shapiro and I were fifty-two, with husbands, and we each had a child, a man-child. It wasn't going to change our lives to that degree, because we had family, we already had galleries, we were showing, we had reputations. The youngest people in our group were two twenty-four-year olds: one was Marty Pottenger, a carpenter, a beginning performance artist, and a friend of Harmony Hammond, who was already a well-known sculptor. The other was Betsy Hess, coming into her own as an art critic and writer.

Designing the magazine was a fantastic, no-holds-barred situation, where we would think of the wildest ideas and let the chips fall where they might. Eventually, when it came down to what we would actually do and to raise money, we had to become practical. But in the beginning we dreamed huge, so as not to cut off anything.

We fought all the time, all the time. To decide on the title of the magazine, everybody would come in with a list of twenty names, and we would sit there and read the names. Everybody in the room would go, "Ohhh, ohhh, awful." One of them was *A&P*, which was for Art and Politics, a takeoff on the grocery store. Another name that actually won out for a while was *Pink*, which Lucy pushed very strongly because it was political to choose pink—a color for women who are held in contempt because they wear pink, and they are pink and delicate. *Emma* was a lovely name, but there was a German magazine called *Emma*. So we called it *Pink*. Joan Braderman was not there the night we selected the name. When she came to the next meeting she said, "I can't stand it. I'm ashamed to tell my friends that I'm in a magazine called *Pink*." Then somebody came up with the information that there was a London magazine called *Pink* for teenagers, about sleepover parties and the like. So we discarded it and then we came up with *Heresies*.

It was to be a national and international magazine not about success in the art world, but about enlarging the world for women. We reproduced four posters from China, one of which was titled *Women Hold Up Half the Sky*. We were pasting up the issue to get it ready in a mad hurry for the CAA conference in January in California. Lucy asked me if we could use my loft as a central gathering place to paste it up. I gave all the women keys to my loft so they could come in and work at any time of the day or night, seven flights to the top floor, and touch up photographs, finish articles, whatever.

Rudolf volunteered to be a gofer and said he'd get coffee if they needed it. Lucy had the idea that it should look different from any other magazine. It

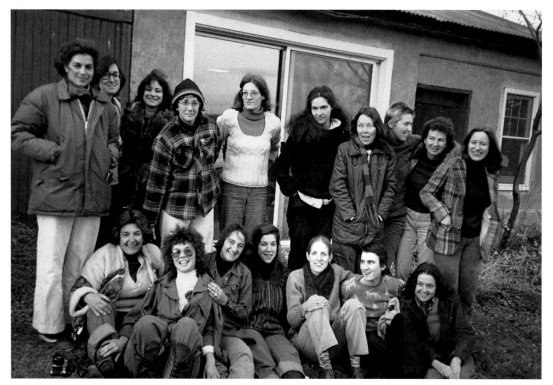

Figure 13. Group portrait of the members of the *Heresies* group, at Joan Snyder's farm in Pennsylvania, 1976. Photograph © Mary Beth Edelson.

should look feminine or feminist, with decorative borders between articles. We all thought, "What a terrible idea," but she wanted it to be extreme and different. She talked us into it, and then asked Rudolf to go out and get typeface borders, like patterns from an Indian culture, or hearts or diamonds. Rudolf hated the idea, and he said, "No way. I'll get you all the coffee you want, but I won't get borders."

The first issue of **Heresies** *came out in January 1977 in time for the College Art Association meetings in Los Angeles. Members contributed articles, poems, and artwork and gathered articles from well-known feminists, such as Barbara Ehrenreich, Adrienne Rich, Carol Duncan, Ruth Iskin, and Susan Saxe. The twenty members of* **Heresies** *were Patsy Beckert, Joan Braderman, Mary Beth Edelson, Harmony Hammond, Elizabeth Hess, Joyce Kozloff, Arlene Ladden, Lucy Lippard, Mary Miss, Marty Pottenger, Miriam Schapiro, Joan Snyder, Elke Solomon, Pat Steir, May Stevens, Michelle Stuart, Susanna Torre, Elizabeth Weatherford, Sally Webster, and Nina Yankowitz (Figure 13). The smaller collective within the membership that organized the first issue included Braderman, Hammond, Hess, Ladden, Lippard, and Stevens. The graphic borders are minimal in this first issue; the most noticeable border frames a box in which acknowledgments are made, including thanks to Rudolf Baranik. Stevens had a two-page spread of reproductions of collages that celebrated the lives of the Polish-born Marxist and cofounder of the German Communist Party, Rosa Luxemburg, and her own mother, Alice Stevens:* Tribute to Rosa Luxemburg, *1976, and* Two Women, *1976 (Figure 17, page 43). From these collages Stevens developed the series* **Ordinary/Extraordinary**, *which occupied her for more than ten years. Each of the six women who made up the first editorial collective published personal statements. Stevens' statement is to the right.*

<p style="text-align:center">✧ —— ✦</p>

During her years working with **Heresies**, *Stevens developed a friendship with Vivian E. Browne, a black artist who died in 1993, who also explored subject matter dealing with the Vietnam War.*

In the 1970s I became friends with Vivian Browne, who worked with me in the women's movement and whom I invited to join *Heresies*. She was very instrumental in seeing that *Heresies* did an issue on race.[17] We went to Cuba together. We roomed together when we went to Washington, DC, to the College Art Association. When I started to be close friends with Vivian I was conscious of the fact that I might say the wrong thing, I might do the wrong thing, I might offend her without meaning to. Because it seems to me that if you do not live among black people, then you don't always know how they are thinking and what their needs are, or their thoughts, their sensibilities, and their sensitivities. So as Vivian and I began to get closer, I said, "You know, Vivian, I am sure I will say the wrong thing sometime and I will do or say something which could hurt you and you have to tell me, because I can't imagine all the things I could do

WHAT KIND OF SOCIALIST-FEMINIST-ARTIST AM I?

What kind of socialist artist loves Corot as well as Courbet and forgives oil painting its bourgeois origins and abstract expressionism its heraldry of U.S. imperialism?

What kind of feminist artist sees pink as a private color to be sparingly used?

To the women's movement I would like to bring, as to art, the subtlest perceptions. To political action, I would like to bring, as to art, a precise and delicate imagination.

The personal is the political only if you make it so. The connections have to be drawn. Feminism without socialism can create only utopian pockets. And the lifespan of a collective is approximately two years.

Socialism without feminism is still patriarchy. But more smug. Try to imagine a classless society run by men.

Trying to be part of a collective is a little like being a chameleon set on plaid. I may split apart before I get the pattern right. But somehow it seems worth the pain because I believe community is the highest goal.

I believe every woman's life is a little better because of what we are doing.

—M. S.

that would be wrong. I'm asking you to be aware of the fact in advance. I'm apologizing for the stupidities which may come out of me, or the things that I may say which you may take the wrong way. You have to tell me, and we can work it out." And it did happen. If she lives in a different world or culture than I, then when we try to become close we're going to have miscommunications. We worked together on the *Heresies* issue called "Racism is the Issue."

When Lucy Lippard's book *Mixed Blessings* came out, it helped a lot. Lucy worked very carefully in the field in order to include all the different groups. She had the book checked out by many people before she published it, and actually knows the people whose work she included. She writes from knowledge of their intentions and the complexity of their situations.

It's really exciting to work in these fields. However, you can make mistakes. You can tread on people's feelings and mismanage the whole thing. Because there's no way you can understand the whole thing. It's too complicated. That's why it can't be done by us. It has to be done with everybody.

Issue no. 9 of Heresies, *published in 1980, focused on the theme "Women: Organized/ Divided—Power, Propaganda and Backlash." Stevens' essay, titled "Taking Art to the Revolution," points out the constant dialectic between art and history, between theory and intuition, between the need for structure and the desire for experience. What she wants most to see in other artists and her students is active engagement—with art and with life. Stevens' essay touches on many of the themes that she had discussed over the years with her students at the School of Visual Arts. Brief excerpts from that essay are on the facing page.*

<div align="center">✥ —— ✤</div>

HISTORY AND HISTORY PAINTING

In three paintings, The Artist's Studio (After Courbet), *1974 (Plate 21),* Soho Women Artists, *1977–1978 (Plate 22), and* Mysteries and Politics, *1978 (Plate 23), Stevens painted herself and her friends in large, almost life-size paintings that project a similar gravitas as that found in the large group portraits of Rembrandt. The works were shown as* Three History Paintings *at Lerner-Heller Gallery, New York, in October 1978. The three, along with* Artemisia Gentileschi *(Plate 17), were also exhibited at Franklin and Marshall College in February 1979.*

*The paintings marked the beginning of Stevens' ambitious project of presenting both a personal and a revisionist history that spanned over twenty years. In 1993, writing to the author, she reflected back on the project: "History painting is as problematic today as the sculptural tradition of the monument. As history is suspect so is the art that confirms it, solidifies [it] into irrefutable symbol—propaganda for the winning side. In my 'history paintings' . . .—*Artist's Studio, Soho Women Artists, Mysteries and Politics, *. . .* Ordinary/Extraordinary *(the series),* One Plus or Minus One—*official versions of history are deconstructed in favor of hearing silenced voices and unrecorded lives."[18]*

Before I was political, and maybe in some sense more deeply than I am political, I was interested in the historical. I sometimes attribute that to the fact that I am basically a New Englander, and New England is loaded with history, with Thanksgiving, Pilgrims, and Indians. So to me history is a fact of life. The past is here. Maybe if you live in California, it's not the same. I'm sure there are places where you can live where there is a newness and a rawness in terms of the atmosphere. My atmosphere, however, was loaded with the past, which I don't think makes it less alive. I think it adds richness.

TAKING ART TO THE REVOLUTION, 1980

ART AS PROPAGANDA All art can be placed somewhere along a political spectrum, supporting one set of class interests or another, actively or passively, at the very least supporting existing conditions by ignoring other possibilities, silence giving consent.

ART AS NOT PROPAGANDA The meaning of art cannot be reduced to propaganda; it deals with many other things in addition to those revealed by class and sociological analysis. Both definitions are true; they are not opposites, but ways of measuring different properties.

ART is that which functions as aesthetic experience, for you. If a certain art works that way for enough people, there is consensus; that becomes art. For a while.

THEORY A proposed pattern to understand the world by. We look for patterns (meaning) in the world. When we think we see one that works (fits our experience), we apply it for as long as it holds up. But when it begins not to fit, we re-examine the pattern, correct it, refine it—if it is salvageable. Mystification of theory prevents its organic development; anti-individualism prevents users of mystified theory from matching it to their own experience. Theory is for us, not the other way round. Example: The Women's Liberation Movement causes socialists to re-think the words liberation, class, family, sexuality. Socialist theory must meet the feminist challenge or give way to a fuller theory, a fairer practice. Similarly, feminists must meet the challenge of the economic theory of class.

INDIVIDUALISM The society we want to build will be composed of politically sophisticated women and men, conscious of history, of their own needs, of social responsibility, and of sharing, learning and growing together. We can become that kind of human by practicing and developing those skills along the way. The pluralism of the "hundred Flowers" impulse, the patience to go slow and not force compliance, the concern for process and feeling—these are the things women can bring to socialist practice, attitudes so badly needed, so shockingly absent.

FEELING The touchstone. Our theory must fit our feeling. Puritanism, "should" and "ought" won't work, won't—ultimately—help. We have to deal with the individual and with feeling, sensitively, not condescendingly. If we are not attuned to feeling, our own and others', the theory will not hold. It will not have taken into account powerful forces that will drag it down and eventually defeat it—as indeed it must be when it is one-sided (indifferent to women, indifferent to individual conscience, to personal feeling.)

RELATION BETWEEN FEELING AND THEORY Theory cuts off its roots, loses it connection to reality when it ignores feeling; feeling needs structuring, a means of evaluating between conflicting feelings. A balancing act where contempt has no place since it is not theoretical and is not a feeling that can exist between equals.

Art as propaganda must help to bring about the conditions under which it can achieve its fullest propaganda function. This means propagation of respect for art, respect which can help bridge the gap between art of the highest order and working-class experience. When Mary Kelly makes art out of baby nappies and documents her child's development with Lacanian theory, she attempts to integrate the artifacts of a woman's daily reality, charged with complex emotional affect (Marxist/feminist/artist/mother raising a male child on the edge of the working class), with the keenest contemporary intellectual analysis she can bring to bear. This art swings between the nursery and the tower and shows again the way we are split—worker from knowledge, woman from science.

Art is political. But one also has to understand that the uses to which it is put are not its meaning. Its status as object and commodity is not its meaning: there are many objects and commodities. They are not all art. What makes art different? Exactly the ways in which it is not an object, can never in its nature be a commodity. (Humans can be sold as slaves: to be human is essentially not to be a slave, in one's nature.)

A socialist and feminist analysis of culture must be as careful as it is angry—fierce and responsible.

That's very much my thinking about my own work, and about what I see as history and the progress of ideas. I tend not to be a rejecter but someone who wants to reconcile, to take from the past that which is useful. I want to keep the past in the storeroom because it may become interesting. However, I am sometimes overcome with the idea of historical clutter and really want to throw a lot of things out. But those things can be useful in the future, because something there can be reinterpreted.

My use of the term "history painting" stems directly from Gustave Courbet and his *Burial at Ornans* (1849–1850), in which the entire village comes together to celebrate, I was told, the death of Courbet's grandfather. Instead of honoring an emperor or some member of the aristocracy, this huge gathering of people celebrates the death of a peasant. When we think back to the past and our ancestry—historically where people have come from—we always think of the knights and the ladies, and not necessarily those who tilled the soil and turned the earth, which is where most of us come from. But that we drop out from our consciousness.

One of the things that interests me a great deal is simply the idea of time—the approaches to time and the uses of time. You spoke about my showing Alice, my mother, and Rosa Luxemburg at different periods in their lives, and I think one of the most interesting things that I've tried to work with is crossing time—by using women of different times and finding their commonalities. There is a dialectical process—throwing things out but keeping things—sorting, rejecting and not rejecting. It's important to do both in some way, and not necessarily in a fixed position, but in a shifting position with time. When we look at any period, we're aware that the thinking and concepts of the earlier period were very different from today's. It's very important to realize you cannot bring a twentieth-century consciousness to the past and expect that those people had a twentieth-century consciousness. At the same time, there is a commonality which I think we have to acknowledge as well, so you don't throw the whole thing out, as though your thinking has nothing to do with their thinking, because it does. So when I look at Alice and Rosa, I'm searching for what they had in common and what was different. Of course, it's one thing to do this in painting, and another to do it in criticism or theoretical writing, because these similarities and differences in my work have got to be done visually—in a suggestive way. This applies also to my different series and their sequence, with their omissions, inclusions, juxtapositions, and their empty spaces.

Figure 14. *Drawing Big Daddy*, 1973. Ink and gouache on paper, 8 x 7 in. Courtesy Mary Ryan Gallery, New York.

A lot of it has to do with a kind of poetic imagination and a kind of openness where you feel a relationship that cannot be diagrammed or envisioned in any way except through these gaps and suggestions. That's what I find fascinating. I feel that I can speak in my art through the exact values of two tones, through the degrees of texture, or the lack of texture, through the slash of a stroke, or the flow of an area of paint. Those things can say something about my topic, about my feeling, which cannot be translated into words. To express what I want, I have to use an art form that is as subtle and as sensuous as painting.

This is very different from the way that some artists who are more didactic, and perhaps more activist than I am, who speak through a much more spelled out, easily translatable, easily available, and accessible medium—such as words.

But even then, words don't give the voice quality, or the temperature of those who speak. With words alone, you're missing something. All kinds of ironies and subtleties exist in the tone in which something is said, or the facial expression or gesture of those who say it. A straight recording of words doesn't have that. So visual work and aural work contain these more sensual things. That's what those arts can give you.

My notion of history, simply put, is the fact that I am part of history, that you are part of history, that we are all part history. History is not separate from us. As I participated in the women's movement, I learned that I was making history and that a great, major, ideological change in thinking for everybody was taking place. I was one of the people helping to make that happen. I did that because of my own history, and my own life, the things that I had met, felt about, and worried about. These things energized me to become part of that movement and to help make that movement happen.

When we know that history is made by everybody, that it is not external to those people involved, painting about these historical issues should then become closer to those of us who are experiencing the meaning of history. So painting becomes something out there that you look at, but also something that you can get into.

Film, of course, is the thing that you can really get into. Now I'm fully aware of the fact that all of these things are often suspect. That art, with its seductiveness, can draw you in and then mislead you. But everything can mislead. It's not a reason to avoid using the powers that these fields, these disciplines, and these knowledges give us. The fact that emotion can overcome you, and make you do things that you wouldn't do if you were more rational, is not a reason to dispense with emotion. Laura Mulvey's idea that visual pleasure in film is what misleads us doesn't mean that visual pleasure should not be used.[19] Pleasure is not something we can dispense with. If you do, you lose everybody except those who are operating on this attenuated level of theory. And that's a loss. Pleasure does not necessarily have to be seduction.

Mulvey's proposal that visual pleasure is a danger had its usefulness, but I think that everybody's rethinking that. Pleasure is something which I'm not giving up for anybody. I love movies, and I want them to seduce me if they can. When you make films that withhold visual pleasure, you're not making a film that anybody wants to look at. She now knows, as everybody else knows, that you've got to use pleasure, and you have to use it intelligently. Pleasure is life enhancing. It can be misused, but beauty and sensuous experience are in themselves worthwhile. What you do with it is important, but it is a value, not just a weapon or a tool.

A while ago there was an exhibition at the Metropolitan Museum of Art—I believe it was called *Masterpieces from the Louvre.* The paintings were great big "machines," and all of them had narratives, for example, the king stops to bless the peasant outside the peasant hut. They were really fascinating for the historical and sociological value as well as the painting value. One of the things I remember from that show was seeing a portrait of Napoleon by Ingres. It was the most ridiculous painting of this baldish man, sitting straight in the middle of the painting with his scepter and his ermine and his wreath around his head. It was an image to laugh at—an image that was utterly campy. But the quality of the paint absolutely took your breath away. There was then this fascinating contradiction of a painting that I thought was pure camp, sheer fakery, sheer pretense but also painted in a way to make you absolutely drool. It was gorgeous. It was not a question of thick paint, it was just so elegantly painted.

There is the contradiction: the seduction of paint and the beauty of paint. All these formal aspects—texture, color, and almost scent—that you use in a painting can sometimes promote something which is questionable. The image that is being made with those formal qualities—

Figure 15. *John Erlichman Confers with Lawyer,* 1973. Ink on paper, 8 x 9 in. Courtesy Mary Ryan Gallery, New York.

whether they fit, how they fit, whether they fit well, whether they are mocking—can become very interesting. I don't think that what happens is always a conscious result of the artist's intention. Sometimes the viewer brings a position, a vantage point, which the painter didn't have, but is viable.

That's what criticism can do, and what "art appreciation" can do. Look for the fit, look for the meaning of the fit, or the lack of fit, and analyze the disjuncture. I think sometimes, without even being terribly interested in historical issues, such as the relationship of church and state, or whatever was going on at the time, that content comes through in the disjuncture. You need to think about that complexity, as in my own work—what is given and what is missing, from work to work, and from the series as a whole. Then think about the junctures and disjunctures—between the ways something is made and what is being said, and how what is made and what is said alters the other, back and forth. That's the liveliness of it, the life of it. It is more complex than just executing something.

ROSA LUXEMBURG

The subject of Rosa Luxemburg occupied Stevens from 1977 to 1991; in 2001 the artist worked again on earlier watercolors of Luxemburg (Plates 28 and 29).

Luxemburg was born in Zamosc, Poland, in 1871, to a middle-class Jewish family. A childhood illness left her with a lifelong limp. She attended the Warsaw Gimnazium and was active in radical politics. In 1889 she moved to Switzerland and attended the University of Zurich, studying natural sciences, political economy, and law. In 1898 she completed her doctorate with her dissertation, The Industrial Development of Poland. *She was a prolific journalist, a writer of polemical texts, a theoretician, and a Marxist activist within the Social Democratic Party (SPD) of Germany. In 1916 with Karl Liebknecht she founded the radical Spartacus League, which became the German Communist Party. Because of their resistance to the German government, both Luxemburg and Liebknecht were jailed for most of World War I. Shortly after their release, they were rearrested and then murdered by German Freikorps soldiers on the night of January 15, 1919.[20] (Freikorps soldiers were the private armies recruited by former German World War I officers to fight against the Red Army and to quell communist revolution.)*

Figure 16. *Ordinary/Extraordinary,* 1977. Collage and mixed media, 17 1/8 x 21 1/2 in. Private collection.

I first heard about Rosa Luxemburg from two friends who were talking about her all the time—Lucy Lippard and Alan Wallach, an art historian. Lucy gave me a biography of Rosa Luxemburg to read, probably because I expressed some interest and regretted my lack of knowledge of her. I fell immediately in love with Rosa and read everything I could on her. I read J. P. Nettl's biography, *Rosa Luxemburg,* and all the other biographies I could find, but I did not read *Accumulation of Capital.* I read her letters and became really enamored.

Some of her contemporaries said that Rosa Luxemburg had the best mind in Europe, second only to Karl Marx. She was internationally known for her writings and her political activism. She was outspoken, cowed by nobody, and also known to be cantankerous and feisty. She was an important figure in a male-dominated world, which she enjoyed. She was confident, she was funny, and she scared them. I also was very pleased and proud of her for arguing with Lenin.

I read her letters to Leo Jogiches, who was a Lithuanian activist and socialist whom she met in Zurich, where she got her doctorate. Afterward she left immediately for Germany, where she married a German in order to become a citizen there and be politically active. It was a marriage of convenience that was not meant to last. Jogiches constantly corresponded with her and gave her advice on

what to do. He never finished his doctorate, and remained in Zurich for years, long after she had gone to Germany. He came from a wealthy Lithuanian family, and he would send her money along with advice.

The letters between them are wonderful. She would say things like, "You don't have to tell me everything that I must do, I can think for myself." She would also say, "If you would only hurry up and get your degree and come and join me, we could get married, we would love each other, we would do all our political work together, and we would have a little tiny baby, just a tiny baby." She was in every sense a real human being, a woman who wanted to marry, was in love, wanted to have a child, and wanted to combine it with a very active political life.

When she was in prison during World War II, she had great sympathy for the other women who were there. She would call them, "my poor dear prostitutes and thieves," and she would write how sad they were when she was finally released at the end of the war.

When I saw the Margarethe von Trotta movie, *Rosa Luxemburg,* in 1986, I did not like the ending, which showed Rosa's murder by the German Freikorps soldiers. Earlier, when I did my painting *Voices,* which is one of the paintings about the funeral of Rosa Luxemburg and Karl Liebknecht, I wanted not to contradict the tragic ending, but to bring something else into play. So I ended up adding these words of Rosa: "Ich war, ich bin, ich werde sein," ("I was, I am, I will be") above the coffins. If I had done just the funeral, it seems to me I would have done what von Trotta did, which was to let the story end. I didn't want it just to end. I wanted it to bounce back, to ricochet, to indicate that this is not an ending, and there's more. I mean we're looking at this movie. We're reading these books. We're talking about her life. So it hasn't ended.

Figure 17. Page spread from *Heresies: A Feminist Publication on Art and Politics,* no. 1 (January 1977). Left: *Tribute to Rosa Luxemburg,* 1976, mixed media. Right: *Two Women,* 1976, mixed media.

✣ — ✣

I created many, many collages of Alice and Rosa and made them into the book, *Ordinary/Extraordinary,* the first and only artist's book that I've ever made. I had received an NEA grant of $1000, and with that money I could make the book rather simply. There was no typesetting; I hand-lettered all of the text. The book consisted of photographs and book illustrations which were Xeroxed with a lot of negative and positive variations. The images would be enlarged and re-Xeroxed with a consequent degradation of the integrity of the photograph. Odd things would happen because of the repetitive Xeroxing to the images of Rosa Luxemburg and Alice Stevens.

It was important to me that people realize that both words, "ordinary" and "extraordinary," referred to both women. I wanted to make Alice Stevens understood as a woman of a certain character, who was quite unique and impressive in her own way. Rosa Luxemburg, the brilliant theoretician, was also a very ordinary human being. I worked with those ideas. The text in the book consisted of extracts from Rosa Luxemburg's letters and a few lines from her political writings, and the text for Alice was also lines from letters she wrote and postcards she wrote to me, plus a tissue of narrative that was necessary because I didn't have such rich written material from my mother. What I wanted from the book, from its visual impact, was a certain flow so that from page to page you were moving through a design that was not just on a page or on a two-page spread, but a design with a flowing movement throughout. The book has white covers with my handwriting, extracted from some of the material inside and blown up.

ARTIST'S
BOOK, 1980

I took it to Ingrid Sischy, who was then editor of *Artforum,* to ask for her help in finalizing the book because I had so many collages and there were so many possibilities. I had never done a book before, and making a book seemed to me more difficult than making a painting. I think that was because to me a book was a sacred thing, a book was holy. Paintings I knew how to do. I knew all about paintings. Ingrid helped me make final difficult selections among so much material. We met at the publishing company that published *Artforum,* a Chinese firm on Greene Street, very close to where I lived. We spread out all my collages and text pages. I didn't know whether to make the back and front covers with white writing on black, which would be the negative, or black writing on white. She said the book is very dark. There are lots of black in the pages, so I think you should make the covers white. I agreed. Then there were certain lines or juxtapositions of photographs that resulted in a crooked or broken line which I had left because I liked the look of it. Ingrid said we have to tell the printers here, that nothing is to be changed, because printers have a tendency to correct and reorganize things and make things look neater or better in their terms. The reason the book turned out the way I wanted it is because she helped me, by speaking to the printers.

I also spoke to Janet Koenig, who was an artist friend on the left, and Janet went through the book and told me which of the collages she thought might be better. I remember Reese Williams looking at the finished book and saying, "It's rough but very thoughtful," which I thought was really accurate, because I really fussed with it—trying all the variations until I could get the feel of what I wanted. Those collages in the book served as a basis for some of the large paintings that I made later on.

THE DEATH OF STEVEN

Stevens' and Baranik's son, Steven, committed suicide in October 1981 when he jumped from the George Washington Bridge, landing on the banks of the Hudson River. Both parents deeply mourned their loss. They memorialized Steven by creating a book of his photographs, Burning Horses.

After Steven died we found photographs he'd been taking, most of which we'd never seen before. One of them was a group of toy horses, plastic animals, which he set fire to, out of doors, on the shores of the Hudson. He also burned them indoors. As they melted and fell or lost limbs or heads or tails, he photographed them. They were beautiful, terrible, very moving, and extreme, like an Ingmar Bergman movie. They were strange, surreal, and amazing black-and-white photographs. I have no idea of the quality of the printing or technical kinds of things, I just know that they were terribly moving, not only to me but to everybody who saw them.

Rudolf and I sequenced them, and we got someone to print them in duotone, two different blacks—one over the other that gave them an additional richness. We called the book *Burning Horses* with one of the photographs on the cover, his name "Steven Baranik" underneath, and a one-page text on the last page. I wrote the text—a brief story of Steven's life. It was very restrained and ended by talking about the suicide note he left, in which he said, "Thanks, Earth, namaste." Rudolf's and my names do not appear in the book. Rudolf was very conscious of the fact that the book should not be seen as exploiting Steven and his work, so we included just the photographs, his name, and the unsigned text.

✦ —— ✦

After her son's death Stevens set aside the painting of her mother she had been working on, Go Gentle, *to work on several small works based on contemporary photographs of Luxemburg and her political friends (Plates 24 to 27) and also three large paintings focused on the subject of Luxemburg's funeral:* Demonstration *(Plate 30),* Voices *(Plate 31), and* Procession *(Plate 32). Interviewed in 1993 by Judith Pierce Rosenberg for* Sojourner: The Women's Forum, *Stevens recalled the connection of these paintings to her loss.*

I had heard that it isn't until about two years later [that] you really have the full impact [of the loss] and that's the way it was with me. By the time I got to '83, when these three large paintings were done, I had full access to all of my feelings; I was all the way home. There were friends who saw my Rosa Luxemburg funeral paintings for the first time and put their arms around me and wept with me because they understood the genesis of the powerful feeling that made them.[21]

In 1983, Stevens returned to the subject of her mother, Alice Stevens. She finished Go Gentle, *1983 (Plate 34) and painted* Fore River, *1983 (Plate 35) and* A Life, *1984 (Plate 36), all of which were based on photographs that Stevens herself took at the nursing home when she visited Alice. In 1984 Stevens painted* Forming the Fifth International *(Plate 37), which pairs the two together— both subjects sit together in a green field as if engaged in conversation. These works of Luxemburg and her mother constituted the series* Ordinary/Extraordinary.

In *Ordinary/Extraordinary* it isn't just clash of cultures that I'm dealing with. I'm dealing with the lives of Rosa Luxemburg and Alice Stevens. Alice Stevens was born in Canada in 1895. Rosa Luxemburg was born in Poland in 1871. These two women who are important to me were juxtaposed by me because of the differences in their lives and because as a part of the women's movement I was very interested in the range, the span, the diversity, the problems, and the possibilities of women's lives. So here I placed a woman who was a Polish Jew and became an international theoretician, organizer, and actual world-changer and juxtaposed her with my own mother, who was a housewife, had two children, and ended up in hospitals and nursing homes. Whereas Rosa, of course, was killed for her activities, assassinated in Germany in 1919.

I met a friend on the street one day in Soho, and she said, "How's your mother?" I said, "She died last February." She gasped, "Oh, gee. I'm sorry. I felt like I knew her." And then she said, "But everybody did." I thought about that, you know, the way my mother had said everybody knows me. Yeah. For me I think it means that I want her to be known, even for the individual person that she is, but it also means that I want people like that not to be forgotten. For me she's not just a single person, because we all know this person. We all know her, and we may become her. She's a problem, as aging is a problem, as illness is a problem, as being a woman who does not fulfill herself is a problem.

I know people who don't want to look at her, don't want to hear about it, don't think she should be in art. And I understand the feelings, while at the same time it makes me angry. These images of Alice are not portraits. It's not autobiographical, because the intention is to go beyond that. The aim is to say something that's more than personal. But the only way to go to something larger is through the personal.

I don't like things which start in the big generalization and in the universal. I hate that which seems pretentious, pompous, and generalized. It has a kind of flabbiness and ponderousness. For me, through the very specific, one can go deep enough to come out to that which is very, very meaningful on a very broad and deep scale. So, you know, her wrinkles and her veins and so on, for me are very large.

Go Gentle is one of my best and most memorable paintings, with several images of Alice Stevens who is somewhat larger than life in the paintings. There are two figures of Alice in the foreground in which she seems to be leaping out of the painting. She's seated, her arms are raised, and she's gesticulating. I painted the background in an iridescent pewter and silver. Alice, in two images in the foreground, wears a white dress and has regular flesh tones, but the modeling of the dress and some of the tones on the body go into hues of lavender and brown, with a little bit of rust around her fingers as she gesticulates. Lucy Lippard spoke about these browns, purples, blues, and ochers in my paintings—she was referring to *Procession* and *Voices*—and called them "bruise-like colors."[22] I thought that was a very perceptive notion. One always remembers the way the colors of a bruise change and go from their blue-purples to brown and yellow before they eventually vanish.

BU ART GALLERY EXHIBITION, 1984

In 1982, when I was Director of the Boston University Art Gallery, I began to have conversations with Stevens about organizing an exhibition of her Rosa/Alice *series. In February 1984 the exhibition* May Stevens: Ordinary/Extraordinary: A Summation 1977–1984, *opened at the BU Art Gallery and then traveled to the Art Gallery at the University of Maryland, College Park, and to the Frederick S. Wight Gallery at the University of California, Los Angeles. For the catalog, the printing of which Stevens herself designed and supervised, original essays were written by Donald Kuspit and Lucy Lippard, and previously published essays were included by Moira Roth and Lisa Tickner. I wrote the foreword. On March 15, 1984, Stevens and Kuspit held a public discussion at the Art Gallery.*

The catalog was marvelous. It had a series of essays and many illustrations. A few weeks after the opening, we invited Donald Kuspit, an internationally known critic and supporter of my work and Rudolf's, to discuss the work with me in the gallery. We flew in together from New York. He said something interesting: whether or not my work will last depends upon what happens to Socialism and Feminism. If they remain important, my work will be important. If they fail, then my work won't be important. I was infuriated when he said that, so I argued with him. I got so angry that I lost my cool. I said, "You can't understand, because you're a man." Of course, with that remark, I had spoiled the conversation. Because if he can't understand it because he's a man, there's no point in his talking anymore. But my fury about his remark is justified, I think, because the religious paintings of the Renaissance have lasted, and it doesn't matter that we don't necessarily believe in Catholicism. You don't have to be a Catholic or even religious to think Michelangelo and Hieronymus Bosch are great. Of course Feminism can't fail, and I don't think Socialism can fail. They can go up and down but they cannot fail. They will not disappear.

Rudolf was so angry when he heard what I'd done. "How could you argue that way? How could you do that?" Anyway, Donald has remained a friend. He likes to challenge and to be provocative. And I guess I probably do, too. But during the evening's panel discussion, he talked in general about his theories on criticism and was challenged by people in the audience.

Donald Kuspit had been working on a collection of essays, The Critic as Artist, *and during the evening he restated his belief that the critic "not only completes the work of art, but finally gives it its enduring identity." To Kuspit, it is the critic who mediates between the work of art and the "horizon of expectations" of the audience. Kuspit suggested that to socialists and feminists, Stevens would meet those expectations. Donald Kuspit's remarks were tape recorded at the event; excerpts specifically focused on what he saw as unique features of her art are included here.*

Kuspit: "What interests me about these paintings, but also about the earlier group of large public scale feminist paintings that May made, is that they really have an old master ambition [and she is] trying to satisfy this ambition under modern conditions, which is partly impossible. . . . What May is trying to do is to take more or less familiar contemporary reality and mythologize it. The problem is there is no larger framing mythology to locate it in. If you think of Rembrandt looking at contemporary figures and then setting them in biblical themes, we see that there was a problem solved. . . . If you think of Caravaggio taking contemporary, observed figures, setting them theatrically within a updated biblical context, again you see the solution to the problem ready made. This is one of the things the old masters have done. I remind you that all the figures that we see in Renaissance paintings were contemporary figures in those days, dressed in biblical clothing and mythological garb, etc. We have this in Titian, etc. Today we don't have any ready-made universal myths. One of the problems of making a feminist oriented painting is that part of what feminism has achieved through its criticality is to destroy all the conventional myths of what it is to be a woman. You cannot show Gloria Steinem as Venus. You cannot show Bella Abzug as Athena. It just won't work in our day and age. . . . Woman today is in a critical situation. . . . There is uncertainty about what it means to be a woman now. So the question, if you want to mythologize . . . in the deepest sense of creating a profound myth, a profound concentration, and summary of a certain kind of complex psycho-social/political/personal experience, how do you do it?

"What Stevens tries to do, it strikes me, is to do it partly by taking basic photographic source material, documentary material and then bringing to bear various kinds of modernist or near-modernist strategies, which include utilization of flatness, and various kinds of painterliness. She uses what have become traditional methods of making a picture in the contemporary period . . . what Harold Rosenberg called 'the tradition of the new.' She uses these methods applied to a 'problematic content,' namely woman's identity and achieves a certain kind of effective grandeur through that. . . . May is offering us a discontinuous narrative of modern experience through partial allegorical means—in the figures of Rosa Luxemburg and Alice Stevens and also Karl Liebknecht. The crowds themselves have allegorical status. What doesn't have allegorical status is the kind of truncated modernism, the abbreviated modernism, that she uses, and which gives a very curious kind of carrying power to images that have a certain kind of news-worthy, nostalgic news-worthy carrying power in themselves. So that is it."

✦ —— ✦

In 1988, Bill Olander, curator at the New Museum of Contemporary Art in New York, offered me a show. I had the entire main gallery, a huge space. I enlarged an image of Rosa Luxemburg attending the Second International and an image of Luxemburg's murderers—assassins celebrating both her death and the death of Karl Liebknecht, who founded the German Communist Party with her. The murderers were celebrating in the Eden Hotel in Berlin where they were quartered.

ONE PLUS OR
MINUS ONE

 I made these as collages on a small scale and then had them blown up to 11 feet high and 18 feet long. Each was made of four strips pasted to the wall like billboards. (See Figure 18.)

 These two images, which filled the long entrance gallery, were accompanied by blown-up texts that gave you the background of each of the two images, with another text that summed up the whole situation from my point of view. Carol Jacobsen wrote an article for *Art in America* on these works and on my Rosa Luxemburg and Alice Stevens work. She said that the reason that I could make these images

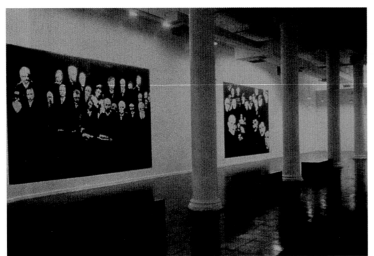

Figure 18. May Stevens' exhibition, *One Plus or Minus One,* New Museum of Contemporary Art, New York, 1988. Each panel is 11 x 18 feet. Left panel: *The Second International.* Right panel: *Eden Hotel.*

knowing they would be destroyed—there was no way of taking them down intact after they'd been pasted on—was because these images were so powerful that they would be committed to the mind.

My Chilean friend Cecilia Vicuña and her husband, Cesar Paternosto, were very moved by these works because of their own political positions and the memory of the terrible things that happened in both Chile and Argentina. Political assassinations were one of the most common events in those Latin American countries. I think the show was very successful. I had again hurt my leg, and I attended the opening with Bill Olander pushing me around the gallery in a wheelchair. The works were severe and very powerful.

I called the exhibition *One Plus or Minus One,* because in each image there is one woman. In the first image of Rosa attending the Second International, she's centrally located, and the only woman at the conference. At the age of thirty-three years she was already an international figure. She translated a speech made by Jean Jaurès, the French delegate, who had spoken in French while attacking her position. She translated that and then proceeded to respond to his attack. I'm sure she stood out at that conference in many ways and for many reasons.

The second image has a waitress also centrally located. She brings a tray of drinks for the members of the Freikorps who killed Rosa. One of the men is known to have hit Rosa over the head with a rifle butt as he took her from the hotel room in which she had been quartered that January 1919. When she got to the vehicle in which they were taking her away, the officer in charge shot her. She was then driven to the bridge over the Landwehr Canal, and thrown into the canal. The waitress in the painting brings the wine to this circle of men at a table as they celebrate their accomplishment. They have fulfilled their mission. They have gotten rid of Red Rosa, the Polish Jew who had come to Germany to join the Socialist party and to make a revolution and who had spent four years in prison protesting the First World War.

One person at the opening looked at the image of the waitress in the hotel serving the wine and said, "She is complicit with these murderers." I said, "She's not complicit. She's a working girl who is doing her job. She has no choice. And it's wrong, when you say 'complicit,' for that implies a political allegiance, a sympathy, a solidarity with these men. We have no way of knowing whether this woman was aware of what was going on, whether she cared, and what her position was." I thought that he was totally wrong. I was struck by the fact that in the first photograph of Rosa with a huge group of men, who are politicians, socialists from all over the world attending a conference, we had one woman who was with them, for them, one of them, equal to them, and more outstanding and powerful than perhaps any of them. The second picture of the waitress surrounded by the murderers is a companion piece in which one woman does not have, in this situation, any power or any weight at all. The waitress is a woman who is paid to bring the wine, and she does it because she needs to live and eat. Hence, One Plus or Minus One. One is gone and another one is brought in who has no power—she's acceptable, she's okay.

BUNTING FELLOWSHIP, 1988–1989

The Mary Ingraham Bunting Institute of Radcliffe College was founded in 1960 as a postgraduate fellowship program for women in the arts, humanities, and sciences. Each year the Bunting (as it was called) usually accepted two or three artists along with poets, writers, and academics in the humanities, social sciences, and sciences, bringing the total to about thirty. In 1999 Radcliffe College officially merged with Harvard University and reorganized the institute. The newly formed Radcliffe Institute for Advanced Study accepted men as well as women and expanded the number of scholars to fifty.

My good friend, the poet Jane Cooper, and I applied to the Bunting Institute together, and we both were accepted. I called you, Pat Hills, who now lives in Cambridge, and I said that I've been accepted at the Bunting. They want me to come to see the studios. I told them I couldn't do that very well, since I had a broken leg and was on crutches. So you went to the Bunting for me and saw immediately that the studios were too small for my work—little rooms with slanted roofs. I do paintings that are 12 feet long and 6 feet high and usually tacked to the wall. You suggested a large room, then empty, that was slated for renovation and they agreed. So I had a room with a 30-foot-long wall. They put up boards to cover the windows, and I made a 30-foot painting when I got there. I came on crutches, but I managed.

The Fellows would all attend the once-a-year presentation of each Fellow. In that way you could really see what was being worked on. For artists, it would be a show. For those working on books or projects, there would be a lecture. The day after the lectures, we would gather for a brown bag lunch, and everyone would discuss what had been presented, which means you would listen to a physicist from India such as Abha Sur, a feminist theorist such as Mary Russo, a poet such as Jane Cooper, and a medical doctor and civil rights activist from South Africa such as Mamphela Ramphele. Mamphela came with her two boys, one of whom was the child of Steve Biko, who was killed by the South Africa apartheid regime. She later had a very important position at a university in Capetown.

The frankness with which a Fellow would talk about her work within our small group was different from the way she would respond when she was making her public presentation. With just us it would be more feminist, open, and vulnerable. I felt that we were a wonderful group and could learn so much from each other. Frictions did happen, but it was one of the moments of my life that I shall always remember.

The Bunting administration gave me an apartment in Cambridge near the Bunting, and Rudolf spent quite a bit of time with me. On Thanksgiving of that year, November 1988, Rudolf came to visit, and we went to an art opening and to dinner. During the night he had an episode with his heart. We called the ambulance and were taken to Mount Auburn Hospital. The cardiologist said that Rudolf would have to have bypass surgery. He'd already had one, but it was eight years previous to that. He stayed with me in my apartment until they could schedule the surgery. After the operation they put him in a room with John Kenneth Galbraith. They enjoyed each other's company. Rudolf spent his recovery with me in my Cambridge apartment.

At that time I was in the middle of working on a great big painting for my show scheduled in the spring. I called the show *The Canal and the Garden.* Those two geographical terms were the stand-ins for the two women, Rosa and Alice. The Landwehr Canal was the specific place where Rosa Luxemburg was thrown, after her assassination. The canal goes through Berlin and is active, like a river. The Garden was an ideal place for my mother, as it is a more static and enclosed space. My mother occurs in four different images in the 24-foot painting, *Alice in the Garden.* In another 12-foot-wide painting, *Green Field,* she is a small figure in the distance within an emerald green field. In another painting Rosa has been thrown into the canal, and you see the purple blossom of her skirt billowing in the water. I wrote on that painting, because I wanted its message to be clear, "But that was in another country." I realized how difficult it is to make this image clear and important to people who live in another country and in another time. *The Canal,* 10 feet long and 6 feet high, represented the actual canal. The center is painted silver, and on either side is black vegetation that glows in a subtle way and activates the silver void. *The Canal* had been in the Boston University show, but I brought it in for this show.

Stevens and Baranik spent the spring semester of 1990 in Long Beach, California. Stevens had been invited to be a Visiting Artist at the State University of California, Long Beach. A studio was provided for her at Angel's Gate in San Pedro, on the water. It was the first time the two artists had spent a considerable time in California.

COLLABORATION

Figure 19. The artist's favorite photograph of herself and Rudolf. Here they're squaring off in conversation, Thanksgiving, 1997.

During the late 1980s and early 1990s, when she was less involved with Heresies, Stevens continued to collaborate with women, especially on projects that they conceived together. She admired the collaborative and action-oriented Guerrilla Girls, founded in New York in 1985 to protest sexism in the art world. During the mid-1990s Stevens attended the large meetings of the Women's Action Committee, an organization that protested ongoing sexism in many aspects of American social life, including the judicial system.

I have collaborated throughout my work in various times with various people. I collaborated with Cecilia Vicuña on a work about the Selk'nam people who lived at the bottom of South America on Tierra del Fuego and became extinct in 1967. I painted an image of them, and Cecilia told their story in Spanish, which I translated into English. The work consists of two pieces; one pictures three Selk'nam women and the second is my hand-lettered version, in both Spanish and English, of Cecilia's story describing the people and what happened to them. I did a collaboration in 1989 with the performance artist Betsy Damon.

Actually, I made Rosa and Alice collaborate. I wanted Alice Stevens to be an historical figure, like Rosa, not only because she is my mother, but because people like her should be in history. Like Courbet, who painted *Burial at Ornans,* I want my mother to be a part of our history as Courbet's grandfather became a part of French history by being in his painting.

I like the notion of collaboration, although collaboration is not necessarily two people getting together and melding their ideas into a more standardized way. My idea is playing with others' ideas, checking it out with them. It's like a kind of stew. Each can have separate elements that are aligned with the ideas of the other and that mean something when put together. I like that kind of collaboration, and I often suggest that to other artists.

Parallel experiences became the catalyst for Stevens' collaboration with Boston sculptor Civia Rosenberg, who was a Fellow at the Bunting Institute during 1988–1989. Rosenberg's son, Daniel, a student in photography at New York University, had died by his own hand the previous May. Civia's mourning reminded Stevens of her own loss when Steven died.

In 1991 I did collaborative work with Civia Rosenberg. She and I were both fellows at the Bunting Institute, and she almost didn't come. When I got there in the fall of 1988, I learned about her son, Daniel. The assistant director, Anne Bookman, whose own father had died, encouraged Civia to come, because the Bunting fellows could be a support group for her. And they were. She and I were in a weekly group with two or three others who shared our feeling of loss.

In the spring Civia did a show about her son's death, which was one of the rawest and most naked shows I can ever imagine seeing. Civia's husband, the young man's father, could hardly stand being in the room. Many of the people who saw it had difficulties responding, because it was so direct. Civia used some of his diaries. She built a boat to represent a symbolic journey. I thought it was very beautiful, and I liked it very much, but many others did not relate to it as strongly as I did.

About a year later, when I was back in New York, I proposed to Civia that we do a collaborative show. She had seen my artist's book *Ordinary/Extraordinary* and also the book of Steven's photographs, which Rudolf and I had published after his death. Later Civia did a book of her son's photographs, which was similar in format to my son's book.

For this reason, when I was in New York I thought that Civia and I could do something together about our two photographer sons—do an exhibition or an artwork. My idea was that we would each take these books and incorporate the images of both photographers in our own paintings or drawing or whatever we wanted to do. Maybe we could use both young men in one work, or I could use her son's photographs and she could use my son's. I also thought that we would send each other the works and perhaps add to them so that we'd both be working on the same work. That did not materialize. We didn't work on each other's works, but we did see what each other was doing.

The collaboration resulted in the exhibition Crossings: A Collaboration Between Civia Rosenberg and May Stevens, *held at the DeCordova Museum and Sculpture Park in Lincoln, Massachusetts, in the fall of 1991. The show included individual drawings and paintings by them both that focused on the iconography of their sons' work and even incorporated collaged photocopies of their sons' photographic works in their own individual works.*

Eventually we decided to show these "collaborative works" in Boston. Rachel Lafo, the curator at the DeCordova Museum, liked the idea of our showing them there. Civia included some sculpture that she had made of beautiful hands. I brought deer bones that Steven had found in the woods at Bear Mountain, a park in upstate New York. He had found a small dead deer in the woods and had brought it home. He called the Museum of Natural History to find out how to clean the bones. He cleaned them and eventually brought the bones with the hoofs to me. I loved them; they were so beautiful. Over time I gave the hoofs away to four friends whom I cared about. But for the show I put the bones in a couple of wooden bowls and set them on the floor of the gallery. That was my collaboration with Civia, who remains a close friend.

Christine Temin, reviewed the exhibition for The Boston Globe *(September 17, 1991), and described the results. Stevens and Rosenberg "have also transcended the personal. 'Crossings' is not therapy for two bereaved women, but a universal statement about the mystery of death, one that will speak to anyone ready to listen. . . . [The work of the sons] is filled with allusions to death. So, in this show, is the work of the mothers. Animals stand in for human souls in many of the drawings, paintings and photo collages, just as they did for ancient hunters."*

✢ —— ✦

WOMEN, WORDS
AND WATER

In my painting, *But That was in Another Country,* I tried to show the death of Rosa, her murder, her assassination, and the drowning of the corpse. I know that it can't be done, but I think it's worth the effort. I'm also speaking about art and its inadequacy, but the necessity of trying to do—to express the inexpressible—drives me. I think of the little rowboat in *Elaboration of Absence* that crosses the divide between the positive and negative images of the whirlpool created by Rosa's drowning corpse. The rowboat *will* go down itself, but also may possibly effect some kind of a rescue. This is extremely important to me: the futility of art and the futility of many things that we do, but the sheer necessity of doing them anyway, and hoping that what we do will have some effect and do some good.

Before painting *Elaboration of Absence* I had started *Missing Persons* at my studio at Angel's Gate in San Pedro in 1990. When I started *Missing Persons,* I planned to place Rosa in the water. I put in some rowboats—one rowboat clearly and then a suggestion of another behind it. I worked with the image of Rosa in the water, using her profile. I can't remember all of it. I was thinking again of *But That Was in Another Country,* which I had just painted. I had done *The Canal,* the canal into which Rosa was thrown, and one called *Fore River,* that had two images of my mother on either side of this silver shaft, which was like Rosa's canal. So I'd been working with water, with Rosa's canal, which turned into my mother's *Fore River,* and then Rosa's body in the canal in *But That Was in Another Country.* In *Missing Persons* I again am unable to put Rosa into the water. Instead, I have the rowboats, and the water is a deep dark blue, with the rowboats shifting and shadowy and not totally visible. And at some point I go back and write in gold ink the words that I've often written in paintings. The upper part of the painting is turned golden in flowing movements that come down over the dark blue water, over the rowboats, and are reflected again in the water.

The next painting was *Sea of Words,* which was done in my Soho studio in New York. I had seen Joan Braderman's video based on a film her father had taken of his wife, Joan's mother, decades earlier. It showed Joan's mother rowing in a boat, which I thought was very beautiful. I asked if I could have stills from the video, so she gave me five or six different views of her mother in the same boat and in the same place. I made small studies of each of the views, one of which I gave to Joan, who gave it to her mother. The studies were mostly pale yellow and very delicate. I did the studies to get myself into what I wanted to do. I then laid a huge canvas on the floor, and I drew the woman in her rowboat in those different positions. I ended with an image of a large body of water crossed by small boats with women rowing. They don't meet or touch, but there is a feeling of community and continuity among them. Sometimes they almost touch.

At some point I decided to fill the large body of water with writing. In *Missing Persons* I had done the kind of writing that flowed and made movements that were continuous—like gusts of air moving in rhythm. In *Sea of Words,* I did broken sections. I would do a few words, then a few words under that, and a few words under that and then start again. *Sea of Words* is more choppy, and I used more colors in the writing—a copper color but also a lot of grays, browns, and whites, different tones to make these broken fragments of words. It ended up being a totally dense sea with different kinds of movements and choppy patches of words with little whitish boats and whitish figures, almost ghostly.

The figures are women, but they're not necessarily distinguishable as women. I took them from a woman, Joan's mother, and I didn't deceive, or in any way change that. But I realized that for me they were people in boats on a huge sea of words. The tradition is that if you want to represent human beings, you do it with a man. Human beings being represented always by the body of a man seems to me totally wrong, and so I represented human beings with the body of a woman—to make a point.

The words are from texts that are meaningful to me. They're not things I made up. I always read and remember texts that I care about, poems or the writings of people like Virginia Woolf or Julia Kristeva. Eventually, some of these words that mean a lot to me go into the paintings and doing them is a great joy to me. It's like chanting. It's like meditation. It's involving. The rhythm changes, the hand gets tired. Sometimes you can read the words, sometimes you can't.

The words are important when I'm writing them—in the making of the painting. What later becomes important is what's left, the trace. It's not important whether you can read it, or that you can agree or disagree with it. It becomes a texture, a breath, a movement.

I'd like to add here something about Rudolf's work, which I think is pertinent. After Steven died, Rudolf did some texts, in which he wrote horizontal lines of text on the surface of either a canvas or a piece of paper. These were one way that he dealt with his grief. He wrote from right to left, which is the way you write in Hebrew. He wrote Hebrew words, Yiddish words, and he wrote poems and songs in Lithuanian. He wrote all kinds of things that were memories of his and created a screen of these letters. Often the letters almost disintegrated into dots. He also made some rubbings which would end up looking the same way. He made a beautiful silk screen print, which consisted of words he had written in his very small, neat handwriting. He had these rows of tiny words—almost like sewn, thread-like things—printed in a lighter gray on a soft middle gray. Rudolf's words were straight and even, and my words are choppy and uneven and seem almost to create fingerprints as they swirl and bend.

The painting Women's History: Live Girls *(Plate 48) was shown in Stevens' solo exhibition* May Stevens: Sea of Words, *held at the UC Art Galleries of the University of Colorado at Boulder during January 1993. Moira Roth wrote the essay in the catalog brochure.*

WOMEN'S HISTORY: LIVE GIRLS

In *Women's History: Live Girls,* the figures are slightly under life size. Carol Jacobsen, an artist who does video, is very political, feminist, interested in class issues and in women who are imprisoned. For years she has interviewed them, made videotapes, and shown her videotapes in New York. She also works with the American Civil Liberties Union in trying to get rights for these women. I'd seen one of her videos and was very impressed with her work and dedication, so I asked her if I could have some stills from it. Eventually I asked her for a transcript of the interviews with the women, and I used these two elements, the stills and the text, to make this painting. I included a detail—the image of the circle of women from *Elaboration of Absence*—women prisoners in Germany at the time of the imprisonment of Rosa Luxemburg. In *Live Girls* the detail is small, without much color. It registers as a kind of memory, as a continuation of the situation of women—being held down, being in prison, being limited in the possibilities of what they can do with their lives.

Women's History: Live Girls shows three nearly nude figures, which are actually the same figure repeated three times. This is a very young girl, very small, she's in profile and almost in silhouette. She has very small breasts, a nice little rump, a skinny little waist, and a big head of hair. She's in profile and placed at intervals walking across this canvas. She walks at night, with neon lights on signs behind her. One says "Live Girls"; another says "Dancing." These various red and orange neon lights cast an eerie glow into the painting, which is largely dark blue with variations on blues. The girls themselves, the three girls who are actually one, are modeled with bluish tones, and some of the pink from the lights. They walk in front of a long car which is looking for them, or maybe they're looking for it. There's some iridescent silver paint on the car, and many words scattered in the background that are mostly illegible. The words come from the tapes of the girls being interviewed. So it's a night scene of very young girls walking, looking for johns in the cars. The neon sign "Live Girls" offended me deeply. It sounded to me like "live meat," or "live bait," those kinds of words applied to such girls. They're used in a way which is so ugly.

The tape that accompanies it comes from interviews that Carol Jacobsen did with these women in prison or those recently released. While people looked at the painting, I wanted to get that tape to play very low, like a continuous loop and to create images, ideas, and feelings that you could get by listening to the voice. Carrie Hamilton, one of Rudolf's art students from Pratt, read the words from several interviews. They are fragments of different stories of what these women experienced—about the entrapment by cops, or beatings by some

of the men that they sleep with, or about the daughters that they have to support. Some talk about how many years they've been doing this and how frequently they're caught because the cops have to fill a quota. They go to jail, spend the night there, pay a fine, and get out the next day. They then go back to what they have been doing. It's nothing but a revolving door.

✦ —— ✦

Tic-Tac-Toe

For a poster once, I quoted from one of the poems of Pablo Neruda, which I lettered in both Spanish and English: "The blood of the children in the streets is like the blood of the children in the streets." To me this speaks worlds, because it says that art has nowhere to go. There's no where you can take that phrase, "the blood of the children in the streets," and exaggerate it and make it worse, or make a metaphor or an artistic expression which will make it stronger or more meaningful. It's unspeakable.[23]

In *Tic-Tac-Toe* I try to speak to the horror of children being hurt, and I can't do it. But I try to do it.

✦ —— ✦

In the mid-1990s Rudolf and I shared a studio in Brooklyn in a section called DUMBO—Down Under the Manhattan Bridge Overpass. In 1996 I was in my studio there in Brooklyn working on the painting *Her Boats,* which is 12 feet long and 7 feet high, with large expanses of water and very small boats in it. It is covered with handwriting, which takes a lot of time to do.

I'm also following a newspaper story daily in the paper, which is the murder of Elisa Izquierdo. Elisa was about six years old, and she'd been killed by her mother. Her father was Cuban and her mother, Awilda, an American of Puerto Rican descent. The mother had been in a shelter, where the Cuban father worked. They met, and they conceived Elisa. Later on, Awilda left the Cuban father and took up with another man and had two more children. Elisa would go back and forth between her father and her mother. Her father wanted to keep her, but he wasn't allowed to. Children are usually forced to be with their mothers, unless something can be proven against the mother. Awilda was a coke addict, and in her relationship with her second partner it turned out that the two children of the new relationship were more important than Elisa. Elisa suffered a great deal from being abused and being considered less than the two children in the current relationship. She was burned with cigarettes, beaten, sexually abused, tied up, and made to sleep under the bed instead of on the bed.

I also read that the Cuban father may have been a practitioner of Santeria, which is a very common religion among Cubans. He might have had some Santeria ideas or practices, which he might have communicated to his little daughter. Everyone said he adored her and was very good to her. It's possible that she came home with some of these ideas, which drove the new partner of Awilda crazy, or maybe drove the whole family crazy. I read that her stepfather took her to the beach, perhaps Coney Island, and put her out in the water to get the evil washed out of her. Her Cuban father died, so there was no place else for her to go. Elisa suffered terribly and was eventually thrown by her mother against a cement wall and died.

There are beautiful pictures of her when she went to school. In the unfolding saga of Elisa that I was following in the newspapers every-day, it was reported that Prince Michael of Greece stopped in to visit the particular school where Elisa was a student. He was enchanted by Elisa, and he promised to pay for her education.[24]

I saw all these wonderful photographs of her. In one she is all dressed up for her first Communion. So while I was painting these big paintings with all the little boats on a huge sea of words, I was also reading newspapers every day about Elisa. I began to cut out the

images, and I bought the [New York] *Daily News* because they have bigger pictures, bigger headlines, and more details, and I put all of these things up on the wall opposite my painting. On one wall I have a beautiful painting of the boats on the sea of words, with golden writing, and on the other wall I've got all these heartbreaking pictures of Elisa.

I thought, I've got to do something about this. I started doing charcoal drawings, and it didn't work. There's no way that I could make it work for me—to do what I want to do in the drawing medium to express my feelings about this child's abuse. I thought a lot about the fact that it seems to be a very common thing, especially by addicts, to punish children by burning them with cigarettes.

Eventually I got some Gampi paper, which is an exquisite Japanese rice paper that is a little translucent and comes in either white or an ecru almost the color of human skin. I got the ecru and tore it into 6 x 8 inch pieces. I found images of children at play in different sources, Xeroxed them, cut them out, often isolating the child's body or changing the form of the original image into shapes that fit onto the 6 x 8 rectangle. I then pasted onto the delicate Gampi paper these images of children, which had been coarsely reproduced onto white paper, with the black Xerox ink beginning to fade and crack. I then burned the edges of the Xerox paper and through the imagery so that I would get a ring of brown around the hole, or simply speckles of dotted burns, because I'd touch it quickly. The pictures thus combined irregular-sized photocopying paper with burned edges and holes with this exquisite paper as background to represent the flesh of the children. One picture showed a black man in the backyard of a little house, maybe in Queens, tossing the ball to his little boy who is swinging a bat. I'd have the big man, the little boy, the bat being swung, and the ordinary little backyard—all a nice image—in contrast to what looks like a spray of bullet holes (burn marks) over the whole scene.

One of the images that was very difficult was three white children rushing toward the viewer, a boy and two girls. The boy is bigger and in the middle. They're heading right at you. I cut them out so that you had the children without any background except the Gampi paper. I was thinking a lot then about drive-by shootings, which everybody was talking about. Then I light a cigarette (a pack of which Rudolf had specially bought for me, since I don't smoke), suck on it to make it burn, and snuff that cigarette into the face of each of those three children. The Xerox paper catches fire a little bit and makes a golden ring, but goes out before I get the whole face out. I have to relight the cigarette and reinsert the cigarette tip into the face of each child.

It was terrible. You feel like a murderer. So I keep sticking the cigarette in again, to get the whole face out of each of the three children. So when I told a friend of mine about this process and how it made me feel, she said, "Why you're just like a murderer." She's accusing me of being a murderer for doing this. Then I say, "If I were writing a novel and there were a murderer as a character in my book, I would have to get into the mind of the murderer to make the book work." You cannot in any intelligent and profound way use a character whom you don't understand, whom you don't have a full feeling for, even if it's not a positive feeling. In Toni Morrison's novel *Beloved* a woman kills her child. This is a mother, and you have to understand what drove her to do that. Why did she do that? So I simply said to my friend, "If you're going to deal with a murderer in art, you have to understand, you have to be able to get into that head."

There were thirty-two in the original *Tic-Tac-Toe* series. I gave the series the name of a child's game. I wanted very much to keep the child flavor, and be aware that children play games, make up stories, and have wild imaginations. Some of the best images are more abstract than what I've been describing. I thought that if a child is abused in these ways and a child has a playful and wild imagination to begin with, who knows what kind of images they may have in their minds. For a child who has suffered sexual abuse, terrible pain, and betrayal, what would their playful imagination mixed with these extremes of abuse produce? So some of the images I have are simply tears and burns. In some cases I used real hair.

Figure 20. May and Rudolf
at Skowhegan, 1992.

I used hair also to suggest destruction, garbage, trash. Hair is very sexual, and intimate. There are many complicated things about hair. Hair grows in the most secret places in our body. So, I used some hair along with burn marks and tears, and I thought about trash, garbage. Kids are treated like garbage, and trash.

I also created a second series, which was called *Cross My Heart and Hope to Die,* which was similar.

Then I did a large collage called *All-y All-y In-free,* and it's in an exhibition which traveled for years, organized by the Bernice Steinbaum Gallery. *All-y All-y In-free* has many of the images from Elisa Izquierdo's story combined with all kinds of little pieces of trash, stubbed-out cigarettes, burnt matches, and also a tiny girl's purse. It looks like beige linen with a little zipper, and a little strap. It's about like two inches long and half an inch wide when you open up the zipper. I thought of that little purse as representing sexual abuse of a child. I bought several of those purses and have done a couple of images using them. I stubbed a cigarette into the purse of *All-y All-y In-free.* It hurts to look at it. I saw the Bernice Steinbaum Gallery traveling show in North Carolina, and *All-y, All-y In-Free* was there. I stood in front of the image and explained it to my audience. They gasped. Let them gasp.

At about this time Stevens had her own experience with an African American girl, whose spunk and inventiveness she admired.

Rudolf and I were in our Brooklyn studio, with two young men who had studied with Rudolf. Rudolf was very fond of both of them: Abdelali Dahrouch, Moroccan-born who grew up in France and studied in Paris, and Alex Villar, the young Brazilian artist who graduated from Hunter College. Both had become very helpful to Rudolf, and he, in turn, was very helpful to them. They were both working in our studio, helping to organize our paintings for better access. We left the studio that morning. They're talking, and I'd gone on ahead to the subway station, which is in an isolated location just over the bridge into Brooklyn. I went down the subway steps, and there's nobody around, there never is, and it's really kind of scary. But as I come onto the long main platform, I see a group of black kids ahead of me. Of course, I take note and think, "Who are they? Am I safe?" And as I get closer I see that they're just small kids. They're about ten years old, maybe under. As I walk up closer I see that the little girl in the middle of them has tiny braids all over her head with white beads on them. She looks so pretty, that I can't stop myself from saying, "I like your hair." The little boy standing next to her says, "I did it for her." She looks up when I say this and looks at me. I'm wearing high brown boots up to the knee, and I've been stomping down the subway steps and onto the platform trying to look very brave and threatening—hopefully to the world. And she says, "I like your sneakers," which is what she calls shoes, I guess. I laugh, and she laughs. I continue on past the group, and as I get past them, I turn back and see Rudolf and his two young, big friends. I'm sure the group of little black kids were as frightened of the three big white men coming toward them, as I was when I thought they were a bunch of boisterous teenagers. I see them looking at the three men coming slowly down the stairs. I turn back to the kids, and I shout at them, "They're with me." And then they knew that it was okay.

After spending several summers in the Santa Fe area, in late 1996 May and Rudolf made the move to New Mexico, and by January 1997, they had all of their furniture and art supplies moved into their home at 9 Torneo Road in the Eldorado section of Santa Fe. Old friends Lucy Lippard and Harmony Hammond lived in nearby Galisteo, as did Nancy Holt, with whom May developed a new friendship. Rudolf had not been in good health for some years, often tiring after short walks and experiencing chest pains, but never complaining. On March 6, 1998, his heart gave out as he was sitting in his favorite chair in his studio, while May was building a fire in the living room because Rudolf said he was cold. The finality came as a shock to her. Their friends, including two favorite students of Rudolf's, came to her support and organized a memorial service at the Santa Fe Museum of Art on Saturday, April 4. A second service was held at Exit Art Gallery in New York City on Sunday, May 17, 1998.

I had never been alone before Rudolf died. I lived for fifty years with him, and I realized that I now have to live alone, to become a new person, a person who's old enough and free enough to be adventurous, even shameless.

I've also taken to building new friendships. When I first came to New Mexico with Rudolf, I had three friends from New York: Nancy Holt, Lucy Lippard, and Harmony Hammond, and then later Sabra Moore—four friends from New York, all of them in the art world. I had Rudolf, and I had my art. I thought that's all I need. I came to New Mexico to live a quieter life, to paint all the time, to be with Rudolf and take care of him, because he was ill with his heart condition.

But my four friends have their lives: Lucy has a lover, Harmony has a lover, Nancy has Buddhism, and Sabra has a husband. They're very busy with their lives. They all travel. We all travel. I realized that I really have to sink roots into New Mexico and make new friends here and to feel connected to New Mexico. So I have done that. I now know Lee Myers, a political activist who defends battered women. Linda Rice is my gardener, who was an art student at Kenyon College. My old friend, Francesca Estevez, a lawyer who works in the district attorney's office in Silver City, New Mexico, comes often to visit me with her family. She prosecutes domestic abuse cases.

But I also travel frequently to New York to see exhibitions, including an exhibition of Rudolf's work at the Jersey City Museum in the summer of 2003, and to Boston, where I had my large solo show at the Museum of Fine Arts in the summer of 1999 and where I often spend Christmas or Thanksgiving with friends in Cambridge. But I need to work in Santa Fe. I'm planning a new series based on my own body.

Living in New Mexico after Baranik died, Stevens became interested in Buddhism. She admires its teachings, although she realizes that many aspects of it contradict her understanding of her self.

I'm alone a lot. I now have to deal with a lot more time and space and emptiness, and somehow Buddhism fits that perfectly.

All kinds of spiritual things are very strong in Santa Fe, most of which I avoid and have great suspicion of. Nancy Holt lives near me, and I've become quite close to her. She is a member of the board of a Buddhist sangha, which is close by. On Tuesday nights I have been going to the sits, and trying to meditate and discuss with Nancy problems that I have with Buddhism. She is mentoring me. She herself seems to be very happy, healthy, and successfully managing her life and her loss.[25] Having suffered losses myself, I'm interested in seeing how she does that. She also goes on retreats. One of the things that sharpened my interest was the time Nancy came back from being away for three weeks and was looking particularly glowing and serene. She'd been on a retreat where you do not speak with others. All silently meditate and silently eat together, and walk in the woods, each in his or her own little path. So I thought, my God, to be alone in the woods and not speak for three weeks must be a tremendous experience.

I thought I wanted to try it. Nancy gave me information, and I have been going for about a year to the various events including several retreats but not very long ones. I think one was perhaps a week long. You don't speak, you don't even make eye contact. What's interesting is to think about what you find inside yourself and how you will handle that, and what kind of terrors you may have to face, facing yourself alone.

The other challenging aspect about Buddhism is the basic idea that change is the law of life. Change is inevitable. It happens, and you have to face it, deal with it, and maybe even welcome it. It's an exercise of learning who you are when you face great major changes, and to use them as steppingstones for a new way of being or living.

The quality of my life always changes my art. I actually feel happier now than at any other time in my life. I think I am more forgiving of myself and of other people, and that might well have to do with Buddhism. I have tended throughout my life to be quite self-critical, trying to hold myself to very high standards of behavior and also being critical of other people, even judgmental. Buddhism taught me that to love someone they don't have to be perfect. I needed to know that, instead of being critical all the time and looking for the perfect person to love.

I'm not entirely successful with Buddhist meditation. You're supposed to meditate every day. I've tried, and it doesn't work. I get just totally distracted. It seems like too much of an effort, and I fail all the time. They tell me that you should just keep doing it, and eventually something will happen. Sometimes I am successful, but only occasionally. So, I am actually not a good meditator, although I keep trying. I can meditate better when I'm with the group than when I'm by myself.

Often there are dharma talks after meditation sits. You often stay seated still in the place where you were meditating, and the leader or teacher will give a lesson from the teachings of Buddha. A discussion can follow his or her teaching. There was one teacher, at one retreat I was on, who at the end of the meditation said we should all close our eyes and get into our meditation posture and send loving, good thoughts, and good wishes to the people of Afghanistan. I thought, they need food and need to have the American soldiers out, and it made me feel helpless.

Another thing that happened in meditation is that at some point we were asked to send good wishes or love to some of the people in the world whom we admired, and people called out names. The names were people like the Dalai Lama. I called out Nelson Mandela. There was a hush in the room. There's nobody whom I admire more than Nelson Mandela. But I saw I was on the wrong wavelength. I asked someone about my response, and this person said, "Well, all the people they were talking about were people on the spiritual path." And I said, "Nelson Mandela was twenty-seven years in prison, he made friends out of his jailors, and then he got out of jail, and instead of revenge he did truth and reconciliation. What do you mean spiritual path?" So I'm torn. But I find much of value in Buddhism.

I thought, maybe one of the reasons why everything I say at meditation classes rings wrong is because I come from a tradition of the Left. Also, I was in therapy. Those are different ways of thinking, and that's why I never hit the right note in my Buddhist sessions.

I was in therapy before Steven died, because he was so ill and disturbed. I was seeking help in therapy when he died. Therapy was tremendously helpful to me, and has been. Because of therapy, I'm very involved in my story. I have made my paintings out of my story. My mother, her life, my father, and what I felt about his life, his thinking, and his way of being. So, story to me is terribly important. But I now realize how much of my story I make up. My therapist told me about a woman who came and told him the story of her childhood. Then one day she found a diary she had written when she was that child. She brings it, and they read it together. It's totally different from what she had said in the sessions. So, your story is flexible, maybe invented.

Now the Buddhists say we need to set our stories aside. Their point is that when you believe your story, you are less free to behave and act in new ways, because you think you know who you are, how you should act, and what your personality is. And so you always do this, and you always do that. That's who you are. But if you can leave your story aside, then you could look at this new situation without the

baggage. You could say, "Oh look at this situation! Why don't I do this?" You could do something totally different, because you're not burdened with the story of how you always behave.

They want you to live in the moment. You are here, and you are free. It's about liberation, they say. You're free from your past, your customs, your prejudices, and your usual behavior. And you look at the situation with a free clear mind and you think, "Oh, it would be good to try this," because you've become free from habit and custom and free from the bondage of the personality you've constructed.

I've lived my story. Now I think it would be very nice to change. The Buddhists say, "Change is the law of life." I don't have to be the same person I was. But, I'm not going to get rid of who I was. It's impossible. There's too much there. It has constructed me. But the more I could leave part of it or invent new ways of behaving, probably the better, or the more fun.

And I've done it. I pierced my ears. I just saw a pair of earrings and thought, I would love to wear those. I went and got my ears pierced. I now walk naked around the house, which I never did before. I have a boyfriend, which I've never had before, since I was married. I feel freer perhaps. I'm not living with anybody, and I don't have to please anyone. I can please myself. Some of these thoughts that I'm telling you now are new ways for me. I also have to deal with aging and with frailties we get as we age—arthritis in my case. So Buddhism helps.

→ —— ←

Go Gentle, *1983, was acquired by the Museum of Fine Arts, Boston, as a gift from Carl Andre, and it was frequently exhibited. When Stevens was honored by the Alumni Association of the Massachusetts College of Art in 1997,* **Go Gentle** *was installed on the first floor of the MFA near the entrance. The popularity of the painting with the public and MFA staff alike led to the MFA's decision to present a large exhibition of Stevens' late work at the Museum in 1999, curated by Barbara Stern Shapiro.*

For the catalog that accompanied the exhibition, Shapiro conducted an interview with Stevens and observed that "the concept of 'series' seems to be your life's production."[26] *Stevens responded as follows:*

THE MUSEUM OF FINE ARTS EXHIBITION, 1999

I start with an idea and I always find there's more to say about it, more ways to look at it. I have this thought or this theme and I work on it. And then when I finish I think, oh, but look, you can see it from this side. You can see it from another angle. Let's try it this way. It's like massaging something, like continuing to see it, and look at it, and think about it, and go all around it, and discover more. I like that. I like it because I've always hated what I conceive of as kind of dilettantism where you do a little bit of this and a little bit of that, you know. I want to really plumb the depths. I want to get to know my subject, make people, invite people, even force people to get involved. Someone said that I don't talk down to my audience, that I expect them to work at it. I expect them to get involved, to participate, and to put it together themselves. I love that. Often, I think of my work as cinematic. There's a narrative which goes on and changes and you discover more and more the more you spend time with it.[27]

To another question posed by Shapiro, "As viewers what can we bring to a work of art?" Stevens answered:

Looking. Really looking. You have to be ready to get into it. You have to be available. But also the art has to invite you, even hook you. And hook you, and hook you! So that you want to spend some time with it. I want my paintings to haunt you so that you carry them away with you. They raise questions you want to think about, to ponder.

The exhibition received favorable reviews. Christine Temin, writing for the **Boston Globe,** *praised the exhibition. Her review touched on those qualities that viewers often take away from a Stevens exhibition: the dark brooding quality of many of the paintings, the importance of words, and the beauty of paint and execution. Excerpts from Temin's review are as follows:*

> *It's black, the color of death, that dominates the Rosa Luxemburg works. Here Stevens extends the tradition of Goya, Manet and Daumier, in dark, politicized paintings, hers distinct from theirs because the protagonist is a woman. . . .*
>
> *Language is important to Stevens, herself an essayist, critic, and poet, and it plays a key part in a more recent series, "Women, Words, and Water," in which women occupy tiny boats bobbing on seas of indecipherable texts, some by Virginia Woolf and feminist Julia Kristeva. At a distance, though, you don't even recognize the minute, obsessive, hand-cramping calligraphy for what it is. It becomes just a texture.*
>
> *A beautiful texture. Unlike some theory-driven artists, Stevens revels in loveliness. Her paint handling is gorgeous and her color sense exquisite, becoming ever more refined in the 1990s, especially in nearly monochromatic pictures like the luminous "Pearl."[28]*

Ken Shulman, writing in **The New York Times,** *commented on Stevens' ability to take a highly personal image, the image of her mother, which she "transforms into an archetype." "The final image [in* Go Gentle*] shows Alice seated on her stool, mute and frightened. She raises her hands in an attempt to articulate words before her eyes. It is the most powerful work in the show, one that has caused more than one visitor to pause and weep."[29]*

<p style="text-align:center">✦ —— ✦</p>

PAINTINGS— HOMAGE TO RUDOLF

I began scattering Rudolf's ashes in bodies of water. My new paintings tell the story of Rudolf, our life, and our love together. It's not a visible story but one transformed into a scene of water with light on it. What I'm doing with the paintings has become a little more abstract, a little more universalized, less specific. I love the transparency and the different spatial things that happen. There's the sense of the surface of the water, and then the ground below, and the sand and rocks in between. The light reflecting on the surface of the water is giving you something of what is above and beyond the scene, and then you also see through the surface of the water down to what's happening below. There could be different depths, temperatures, and densities at different levels. The river bottom and its sand, stones, plants or coral, or whatever else grows there have a presence. There is a sense of them. Everything in the water seems to be alive, moving, and has its own character. All of this I like to suggest when painting water.

Sometimes I include writing in the paintings of rivers and other bodies of water, but they are words you can't read. I mentioned before that Rudolf began to do words as part of his working out his grief over the death of Steven. So in these paintings of rivers that are my homage to Rudolf, I write the words "Gracias a la vida, que me ha dado tanto," which was the song that Rudolf asked to have sung after his death. So at his memorial in Santa Fe, and again in New York City, I played a recording by Violeta Parra, a Chilean folk singer, who wrote the song. She wrote: "Gracias a la vida," thanks to life, and "que me ha dado tanto," which has given me so much. Those words are on my paintings since Rudolf died, as part of my grieving for Rudolf. I no longer use the little boats of women, which I used

often in prints as well as large paintings. Now I am doing paintings of the rivers and bodies of water where I have distributed, with friends of his and mine, the ashes of Rudolf.

The first one was done in Santa Fe, where I distributed ashes in the Santa Fe River with Joyce Fuller, an old friend who'd come to be with me. The second painting was of Galisteo Creek with Lucy Lippard and Harmony Hammond. When I was in Cambridge, you, your son Andy Whitfield, and I distributed the ashes in the Charles River in Cambridge. I went to Martha's Vineyard and again scattered ashes with Joyce Fuller. In Maine, in a rowboat with Lucy, I scattered ashes into the Atlantic. In all these places we took the ashes out of a little bag, moved our hands over the water, and watched the ashes go down. In Ireland Alanna O'Kelly, her husband Brian Kennedy, and their three children went with me to the shore of the Atlantic near Connemara, above Galway. Alanna said, " Let's pick wildflowers first." We did, and we threw those into the water. Then I poured ashes into the hands of the children, and Unamaya, who's only three years old, said, "This isn't ashes, this is sand." And I said, "It looks like sand, but it's ashes." And the kids put the ashes in, and we photographed that. I think all of these paintings have "Gracias a la vida, que me ha dado tanto."

When Max Kozloff saw *Galisteo* in my exhibition at the Mary Ryan Gallery he called it "a great painting." Andy Whitfield, who is a musician, a tenor, saw *Galisteo,* and sent me a letter that included an audiotape. He said that that painting moved him a great deal and made him think of a particular piece of music from Benjamin Britten's opera, *Peter Grimes.* The music has a seaside section to it, with four different parts. He taped the *Moonlight* segment, which is fantastic, so beautiful, and, I think, exactly like my painting. It's dark and rich, but has some brighter passages that make me think of the band of paint that goes through the deep blue. The band turns whitish and then it turns turquoise at some points. It comes and goes a little bit through the dark ground. The music is so much like it, with the high notes of a flute going through it.

The music is an incredibly beautiful piece, and I took the tape with me to Headlands Center for the Arts, in Sausalito, when I painted for five weeks in the summer of 2001 as an Andy Warhol Foundation grant recipient. I played the tape while I painted, and for some of the friends I made there. It kept me going. It was really a wonderful gift.

In Headlands I started three more large paintings. One was of the Napa River, where I had been teaching at the Oxbow School before coming to Sausalito. And then I did a painting of the lagoon in Headlands using snapshots I made. In that painting I stressed the fact that the Headlands Center for the Arts occupies the barracks of a military installation no longer in use. The old gun emplacements are there, which were aimed at Japan during World War II. They were there to stop the Japanese from invading America.

The third painting that I started in Headlands is called *Confluence of Two Rivers,* which leads to the river of Rudolf's childhood in Lithuania. I asked Sandra Skurvida, who was the curator for Rudolf's 1996 retrospective in Vilnius, Lithuania, and now studies with Donald Kuspit at Stony Brook, to take some of Rudolf's ashes back to Lithuania. So she carried Rudolf's ashes back to Lithuania and scattered them in the two rivers that flow into the Nemunas River and took photographs for me. I did a large painting with snow-covered banks and a very turbulent and dark stream. Rudolf loved snow, because he grew up with snow very much part of the landscape. There are some broken pieces of snow and ice floating in the river. That will perhaps be the final painting of this series.

Rivers and Other Bodies of Water

The show at the Mary Ryan gallery in spring 2002 was called *Rivers and Other Bodies of Water.* In the large paintings *Galisteo, Connemara,* and *Atlantic,* Rudolf's ashes were a central image, although this was not obvious. There were two smaller paintings that were about 5 x 3 feet, which had been started as one, but I ripped them apart and made them into two. I thought of them as being presented as a pair, side by side, but the gallery decided to split them up and place them on different walls. They ended up being dark blue, and called *Hudson I* and *Hudson II,* referring to the Hudson River, where my son went to end his life. He used to play and run along the banks when he was a teenager. We saw the Hudson River from our Riverside Drive apartment.

Steven had taken a snapshot of his dog in the water swimming back with a little stick in his mouth, and a fragment of the bridge was visible in the top of the snapshot. I used that snapshot for *Hudson I,* which depicts an expanse of waves with different tones of dark blue and a dog swimming in the lower left. You can just barely make her out, because the color and value are so close to the tones of the water. In the upper right corner and at the top of the painting is a shadowy bridge.

The second painting, *Hudson II,* uses the same motif and the same place. Again, there is an expanse of water, with waves and activity, but in the place where the dog had been there is an eddy of swirling water with reddish and purplish tones. I used that motif when I did *Elaboration of Absence*—to show where Rosa's body had disappeared. So here in *Hudson II,* the dog has disappeared, and there are only the circles of water where the body has gone. It is subtle. It speaks of loss, and it is near the place where Steven died. But it also comes from when he played there.

I'm always aware of death. When Steven died, I remember at first I thought I couldn't bear to walk up the street where we lived knowing that this was the path that he took as he went to his death. Later on I thought about all the people who had walked on that street and have since died. People have died who lived in this house. People have died who swam in that water.

I scattered Steven's ashes in the Hudson. When my mother died we brought her ashes and scattered her ashes in the same place in the Hudson. When I was at the Bunting Institute in Cambridge, I walked by the Charles River. So when Rudolf died, I decided to put his ashes in these rivers and others where we had walked.

It all ties in. It begins with the canal. Rosa was thrown into a canal, so I begin working with the canal. I have my mother in one painting sitting on two sides of a canal which started out as Rosa's canal, but then I named it *Fore River,* which is my river where I swam as a child. So I do all these canal paintings, and eventually Steven dies close to the water. They all connect. It's all one body of water that connects my childhood, my love of water, my swimming . . . and then it goes into Rosa, her being thrown into the water, the canal, her death, and then it goes into the Hudson River, yes. So there's this kind of circularity, continuity, and it's the way I feel about life and death, about circularity, continuity. There's nothing strange or weird about it. It's extremely natural. So *Galisteo, Connemara,* and *Atlantic,* which refer to the scattering of Rudolf's ashes, are part of that continuity.

Other Questions, Other Thoughts, Other Artists

I questioned Stevens as to what painting processes she considers important when working on her water paintings. What is she thinking about and trying to achieve through the language of painting? She answered that the topics which she considers relevant are size, the surface of the painting, control vs. accident, and iridescence.

Size: I don't want it to be a picture, something you put a frame on and hang in your living room. I want it to feel like a place—that you are there, in it. By making it very large and hanging it low people go up to it and are surrounded by it. I'm looking for maximum effect and involvement to the person who is looking at it.

Surface: The painting is quite thin in most places usually, and this is because I want it to act like water. When I put paint on it flows, it goes down, it makes vertical drips, and it gives the painting a structure. The drips create a grid, which I control of course. The drips also serve the function of giving a spontaneity, so that it's not preplanned in any serious way. Because I am open to accident.

Control and Accident: I feel I can control anything I want on the canvas. I can invent different surfaces, different textures, different colors, and I'm not worried about any kind of accident that happens. The only thing I have to do about an accident is evaluate. I love the freedom of it and the spontaneity of it, but if it doesn't work for the whole, then it has to be altered or taken away, which I can very easily do.

I remember a writer who came into my studio at Headlands in the summer of 1999, who asked: "Can you get rid of the drips?" And I said, "Maybe, if I want to. They suggest the freedom I want."

Iridescence: I started to use iridescent paint when I was doing the *Ordinary/Extraordinary* series. I used a pewter that was a warm gray and had a shine to it. Since I was using old photographs of Alice and Rosa, I wanted to suggest the passage of time. This changing gray, mottled because of the light change, would suggest the past much better than a flat black.

I had never liked shiny things, anything that gives a false sense of glamour. But I realized that shine is all over nature. It's in water. Water catches the sunlight, the moonlight, and dances with it in movement. I would see the sidewalks of New York with the little flecks of mica glittering at night like diamonds. Shine in nature is fantastically beautiful. It's not about wearing sequins or shiny lipstick.

Rudolf used to look at some of my paintings and ask, "Why don't you paint the color that exists from the spot you like best?" He would be referring to a shiny area which changes color as you move. But the reason I don't do that is because I want the paintings to reach out to the viewer, attract the viewer, and pull the viewer in. The shine of iridescent paint looks one way, then it changes. The shine changes to another color, another degree of light and dark when you move. It gives the quality of life and vitality to a surface. Maybe you like one view rather than another, and that's good. You can move back and forth.

I also inquired why she continues to use words in her paintings.

Words are everywhere. Everything we know has names, adjectives, verbs, adverbs and so forth that go with that thing that they are about. Things are covered with words and stories, so much so that it's hard to see anything freshly. When I use words in my paintings, they describe some of the ideas and emotions that go to make that painting. But just as the words become illegible, the specific impulses that generate the painting dissolve into the whole, give up their identity to become a thread, a tone, a sound, a passage that is a vital element in the configuration, but not necessarily one that is individually distinguishable.

In October 2004 I asked Stevens which were the artists she admired in the past and which artists she most admires today. She spoke at length, but then followed up the conversation by sending me her notes for the conversation. Her written words appear on the following page.

✦ — ✦

The artists I have loved and learned from: Goya, Picasso, Ingres, Delacroix—above all, the drawings of Rodin and Daumier, the paintings of Velasquez, and closest to my heart, Vermeer and Rembrandt. Some Courbets, many Gauguins and Van Goghs, Bonnard for his color, Matisse for his sensuousness, Medardo Rosso for his little golden wax figures melting into each other, Artemisia Gentileschi for her *Judith Slaying Holofernes,* with help from her fully participating maidservant, and De La Tour for the nearly transparent fingers of a young woman shielding a candle in a darkened room and the wit of gypsies and pickpockets filching the gold from some country bumpkins.

Among my contemporaries I admire Louise Bourgeois and Kiki Smith for the depth and wit and passion that feeds their work. In each the voice is truly her own: Dreams, fears, memories, hauntings, longings, surface in totally original, no-holds-barred manifestations. Each is in full control of a vast arena of impulses and an equally vast expanse of roadways and alpine trackings leading to a kind of primal knowledge.

Bourgeois' *Spider,* a huge metal creature you can walk into, among the many rough semi-rusted legs that are crude, unexpected and easy to bump into making them clang fiercely, bringing museum guards on the run. Bourgeois says it's her mother, that spiders are good mothers. She has made many wonderful drawings of the spider as mother, with and without her young. Sometimes it makes me think of Muriel Rukeyser's poem on cockroaches in which she says: I do not know the songs you sing your children.

And Kiki Smith's two figures cast in wax, a man and a woman a few feet off the floor as if suspended from the ceiling. They move you by their simplicity, their ordinariness. They are not beautiful. They are not *not* beautiful. Their proportions are normal, nothing to make them special, exceptional, except their downcast eyes, suggesting an inner life and the pale splashes of white, splashed around her nipples and on his thighs next to his penis. Kiki says the work is about wasted gifts.

Recently ten artists of established reputations made a print for ACT, a political organization active in opposing the war in Iraq. Of the ten only one, Richard Serra, created an image that spoke strongly to the subject. His black hooded figure evoked Goya's fierce depictions of savagery during the wars of his lifetime. The other artists mostly created their signature image which was for sale as a benefit for the cause. How wonderful it is when the effort is two-pronged, one for the money, two for the message, the reminder, the emphatic protest of an unforgettable powerful pointed pictorial statement that uses art's immense array of visual weapons to sting the mind, to add an emotional wallop to the interaction between viewer and artwork. Why not use art's power to help stop a war?

The following is from an earlier conversation, but she would voice it today.

For me art has always been extremely sensual, and I've always related sensuality to sex, sexuality, and emotionality. Because of their emotional quality, sometimes my paintings have affected people very deeply, which pleases me. For me they are that way, they are emotional, because they grow out of events in my life and people in my life.

There is something about just making the painting itself that seems to me to involve a kind of sensitivity, attention, and a feeling of fullness that is similar to a sexual experience. Picasso is supposed to have said, and probably lots of other male artists have said it also, that the brush is a penis, and that their art is the expression of their sexuality. They say that they can't paint a woman model unless they sleep with her. I'm not trying to build a female case for a similar situation. But I do feel that there's a lot of sensuality in my art and in my approach to my art.

Even when I did *Big Daddy,* who was supposed to be gross, fat, self-satisfied, impervious to human situations, and totally self-involved, drawing those curves of his body was sensuous. I do feel that a fat body with curves can be absolutely, sumptuously beautiful. And I realized that as I was making the curves of Big Daddy, painting him pink and putting him against a cobalt blue background, that there was something absolutely gorgeous about that. It's okay, you can find beauty in all kinds of things—curves and curves overlapping one another—luscious!

When Peter Schjeldahl wrote on Richter's series of paintings of the Baader-Meinhof group, he brought up Edgar Allen Poe's remark that the most poetic of all subjects is a young woman dying.[30] Because it's erotic. Schjeldahl remarked that the erotic is aesthetic. When Rosa dies, that's not erotic. Part of that eroticism they talk about, you notice, is about when a young woman dies. A middle-aged woman—that's not erotic anymore. When it's a young woman it's erotic, because it's about someone who is passive. An older woman would be less passive, more active. When some people think that the most erotic thing is very young girl, a child, it's passivity that they're talking about. Virginity means someone you can use, someone who's not an active person, someone empty of experience. It's like Pygmalion making Galatea into something. This is about women as children, that you can have and make and be paternal with and also be

sexual with. I can understand that eroticism, but it's against women as people. It takes all the power away from women. A dead young woman as erotic? It's a perverse notion! But it's very traditional. It's in our culture, the culture of the past.

At this point in my life I'm also interested in aging and in death and the circular relationship of life and death. I've always been interested in life and death and in the way in which those things flow together and give meaning to each other. But I would like to see them in a different way. I would like to see death as not a final thing and not necessarily a fearsome thing, but something which permeates life. Life, I feel in some sense, permeates death. Cecilia Vicuña, my Chilean friend, artist and poet, made a remark in an interesting way. She said, "Life just goes on. Life is eternal. Death is only a moment." I suppose she means that death is a transition, death is a door, a swinging door, both ways. The challenge is to make these things meaningful in a specific way.

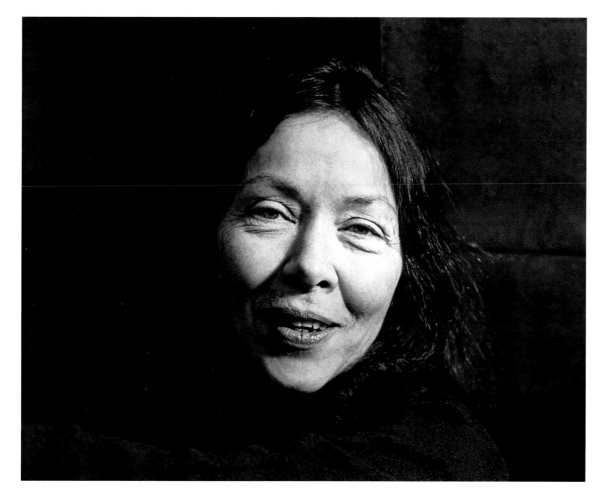

Figure 21. May Stevens, 1976.
Photograph © Mary Beth Edelson.

MAY STEVENS:
THE DIALECTICS OF REPRESENTATION,
THE PRAXIS OF PAINTING

*M*ay Stevens has been engaged with issues of visual representation for forty years or more. Her paintings have moved through various phases: from the *Freedom Riders* pictures of the early 1960s to the *Big Daddy* series of the late 1960s and early 1970s, from the history paintings of the late 1970s to the *Ordinary/Extraordinary* series of the 1980s, from *Women, Words and Water* of the 1990s to the present elegiac river paintings that pay homage to the memory of her late husband, Rudolf Baranik. In between were the collages and photomontages: small works done as part of the *Ordinary/Extraordinary* series, *Tic-Tac-Toe, Burning Horses,* and *Kill Books,* as well as recent collages submitted to theme exhibitions. In each of the phases she has sought to "re-present"—to present again to her viewers—images in her mind constructed from a combination of sources and ideas. She draws from her concrete surroundings and her changing lived experiences, from the poetry and literature that has moved her; and from her ever deepening capacity to draw on her memories to imagine and to empathize with those who have been oppressed, refused opportunities, and denied a full life.[1]

As is evident, from reading her words in "May Stevens: In Conversation" and viewing her paintings, representation to Stevens is not a simple sign-to-signified relationship. In her art representation becomes a complex dialectic that displays contradictions and suggests resolutions through intertwining history with the present, the extraordinary with the ordinary, timelessness with the provisional. Moreover, the paintings embody the process—the performative act of making the picture—within the finished material work. Above all, there is the contradiction of communicating a deeply complex moral content through the (basically amoral) sensuous surface beauty of color and paint handling. As she has lately written:

Figure 22. *Freedom Riders,* 1963. Gouache on paper, 48 x 60 in. Private collection.

> I like to think I can make a painting that represents forces and situations, pressure and relief, confusion and resolution, synthesis and interference, a drama which reenacts the way things are. . . . I think I can do that through color and movement, through the struggle that goes into finding the solution to the particular problem I'm dealing with on canvas. I stop when the painting reaches a place where it tells me something has happened which I could not have planned for. For which I have no name, which exists nowhere else.[2]

Not only color and movement make Stevens' representations effective, but the whole range of painterly techniques: size, surface, paint touch, the matte versus the iridescent qualities of pigment, montage effects, trompe l'oeil effects, layering, repetition and spacing of motifs, scripted words, and drip marks.

In her "Conversation," Stevens makes clear that she consciously draws on her experiences to shape the ways she has handled the contradictions in her life and brought those contradictions into her painting. Her awareness

of the bigotry of her father and his co-workers shaped her deep commitment to fighting racism. Her experiences as a working-class girl gave her insight into the latent injuries of class to her mother's generation; her mother, Alice, had neither the education nor the medical care to regain her wholeness after her son, Stacey, died. The time Stevens spent attending women's "consciousness-raising" sessions during the early 1970s deepened her awareness of sexism and of her own possibilities to grow and to change the world. Developing within the women's movement, these sessions helped women artists articulate in words and their respective artistic mediums—to bring to consciousness—their experiences, memories and feelings about gender and power relations. And Stevens' encounters with loss—of her mother, her son, and her husband—became touchstones for many of her paintings.

Poetry and literature have also shaped Stevens and have suggested solutions to painting problems. Imaginatively rephrasing the lines of other poets, she has created maxims to impress on us what she knows to be true, such as "the blood of the children in the streets is like the blood of the children in the streets," drawn from Pablo Neruda, that reminds us of the inadequacy of metaphor.[3] Or, she rhetorically asks, "If the book we are reading does not take a pickax to the seas of pity that lie frozen within us, then why are we reading it?"—a question, combining words from W. H. Auden and Franz Kafka, that urges us to respond to the power of art.[4] The stories she loves to read are often about neglected people who manage to overcome their circumstances and rise to a level of self-sustaining imagination, such as Félicité in Flaubert's "A Simple Heart." Or, the hunger artist in Kafka's tale who admits at the end of his life that it was his inability to find any food to his liking, not his will, that brought him to the point of death.

She also writes her own poems as meditations, often during moments when she longs for an absent loved one, such as the poems written on the train after visits to her mother in the Framingham nursing home. Or, when she desires to capture a sensation too elusive for pictorial representation, as in her unpublished poem, "Standing in a River," in which she describes herself standing in water with minnows nibbling at menstrual blood escaping from her body.[5]

The words she includes in her paintings come from many genres of literature and writing: studies of Chinese women by Julia Kristeva, an essay, "A Room of Her Own," by Virginia Woolf, an epigraph introducing a poem by T. S. Eliot, a study by Carlo Ginzburg probing medieval European documents that reveal the experiences of people accused of witchcraft, or the informal jottings of World War II soldiers barracked in the Sausalito headlands to defend California from Japanese invasion. Sometimes the title makes the reference to literature, such as "Go Gentle," which reverses Dylan Thomas' famous admonition to his father to fight death.

At times she rails against her inability to create representations adequate to her imagination and her ideas. But she stays the course, even setting aside a canvas for a year or two, until she sees a resolution to the struggle to represent the "unrepresentable." As she wrote to me recently, upon reading my words printed in an earlier draft of this essay: "To find the image that works for me involves discarding easy solutions and

carefully watching what happens on the canvas, seizing on accidents, random events, letting the painting 'boil and bubble' until it (finally) speaks to me in a voice that matches the timbre of my attention."[6] Her ongoing experimentation with "finding the image" has been a constant of her life's art.

Nevertheless, over the decades her techniques have evolved, in concert with the different kinds of images and different contents—saturated color and flat painting for the didactic and satiric Big Daddy paintings; modulated hues with indecipherable calligraphy for the women and boats paintings; and liquid translucency for the river paintings that pay homage to her husband, Rudolf Baranik. Periodically she leaves the medium of painting when the message of her art becomes intensely particular and pressing. She turns then to montage—the juxtaposition of cutout or torn photographic images, lettering, script, and even other scraps from life—a method historically employed for polemical visual statements.

The material sources for her paintings' imagery have varied and include newspaper and television images, old family photographs, scenes of feminist activists and performance artists, and snapshots of rivers and landscapes. Subjects from her own life have made the themes concrete: her mother, Alice; her father, Ralph; her husband, Rudolf Baranik; her son, Steven Baranik; her sisters in the feminist movement; and her chosen role model, Rosa Luxemburg. And the content has been complex: the civil rights movement confronting racism; feminism questioning patriarchal authority; celebration of the camaraderie of political activists; sorrow and loss; abuse of innocence; elegiac tributes to loved ones; and awareness of the mutual permeability of life and death.

In the process of making her art, she probes her own responses to racism, injustices, prejudices. She reflects on past emotional feelings, on words spoken or read, and on sensuous bodily experiences, such as swimming through water or watching flowers grow in her garden. She interprets these recollections of experiences as not particularly unique to herself, but characteristic of others of her gender, of her class origins, or of the place where she lives. When pressed, she becomes more inclusive. The figures in the four boats in *Sea of Words* represent all humankind; they appear to be women because Stevens, contradicting traditional practice, prefers to have woman represent humanity. The past blends with the present as Stevens translates remembrances into paradigms that both seek to maintain the specificity of person, place and event as well as to enlarge, if not transcend, that discourse. She has said, "Alice represents all women." Indeed, her images achieve their power through their resonance with experiences we also share or can empathetically imagine.

In her paintings the single image strives to convey complex content. With their suggestion of resolute militarism (bullet-shaped head, helmet, and flag bunting) and duplicitous patriarchy (twinkling eyes and smirking grin), the individual Big Daddy pictures both repel and attract us. When brought together in an exhibition, the sheer number of variations of Big Daddy reinforce their impact on the viewer. The series strategy also gives a heightened effectiveness to the *Ordinary/Extraordinary* paintings, and especially to the five paintings hung canvas to canvas in the *Alice in the Garden* series. Also for the collages, she means them to be seen in sets of at least two, as with the double-page spread for the first issue of *Heresies* in 1977. The later *Tic-Tac-Toe* collages of 1996 could not be sold, except in sets of three.[7]

But as she moves from one series to the next, often a motif or a figure lingers on, one that she includes in one or two paintings of the next series. She does not abandon the thoughts that

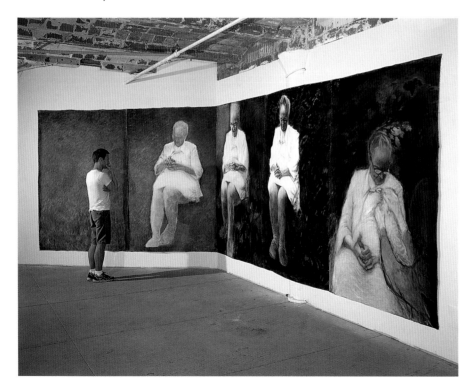

Figure 23. Installation view of *Alice in the Garden,* 1988–1989, in Stevens' Brooklyn studio.

go into a series; rather the thoughts are redirected toward new images that supersede the earlier set of images in a dialectical process of forming, refining, abandoning, and then reforming the representation.

Her style also invariably carries over. Stevens' series also link together internally through a dynamic process that unites the exploration of an idea or a theme with the style—the actual layering of the material basis of the work, whether it be a painted or collaged surface. This interaction of the materiality of the art object and the ideas brought to it in turn suggests more ideas, themes, and the necessity for style change that further generates more paintings and collages. Stevens explains:

> I start with an idea and I always find there's more to say about it, more ways to look at it. I have this thought or this theme and I work on it. And then when I finish I think, oh, but look, you can see it from this side. You can see it from another angle. . . . I want to really plumb the depths. I want to get to know my subject, make people, invite people, even force people to get involved. Someone said that I don't talk down to my audience, that I expect them to work at it. I expect them to get involved, to participate, and to put it together themselves. I love that. Often, I think of my work as cinematic. There's a narrative which goes on and changes and you discover more and more the more you spend time with it. . . . I want my paintings to haunt you so that you carry them away with you. They raise questions you want to think about, to ponder.[8]

She would agree with art historian David Summers, who has argued: "actual representation . . . is primarily *communication,* not the *expression* of private images or meanings . . . but rather that which is effected *through the common.*"[9] It is telling that Stevens called a painting that featured her *Heresies* co-editors *The Dream of a Common Language*.[10]

Trying to communicate to us what joy, quietude, sorrow, horror, and moral urgency might mean encourages her to suggest parallel thoughts through words outside the canvas—by giving lectures on her work, by writing extended captions for many of the large paintings, and by telling her story here in this book. The phrase from Antonio Gramsci "pessimism of the intellect" has taught her that she cannot represent the unrepresentable, not even with words; but it is "the optimism of the will" (the second part of Gramsci's phrase) that urges her to attempt at least an equivalence that will have an emotional impact.[11] She feels responsible to represent the moral issues of her social and political era, and she trusts her audience to engage with her in completing the representation.[12] Her paintings, therefore, have a cultural mission—to demand the attention of the viewer and to insist on an empathetic, even cathartic, response to fundamental issues. She wants you, the viewer, to feel as strongly as she does. This is what I call the "praxis" of painting.

✧ — ✦

In 1963, when water hoses were turned on African American children when they marched in protest in Birmingham, when Martin Luther King Jr. made his "I have a dream" speech on the Washington, DC, mall, when four children were killed in a Birmingham church bombing, Stevens made her debut at the Roko Gallery with the show *Freedom Riders* (See Figures 22 and 24 and Plate 1). She had not gone to the South. She was living in the suburbs raising a son and teaching in the New York City public schools far from the violence experienced by the Freedom Riders. But she read about them in the newspapers, accompanied them in spirit as they rode the buses south, imagined their solidarity as they linked arms, and felt outrage over the relentless racism they were experiencing. In one of these works, words were necessary. She scrawled the block letters "White Only," in reverse, on the painting with the same title, which announce to the black man that he cannot enter into the space inhabited by the artist and by us, the viewers. Stevens knew that the social and political powers of the southern states

Figure 24. *White Only,* 1963. Gouache on paper, 48¹/₂ x 18¹/₈ in. Private collection.

depended upon such words to control and discipline the explosive resistance of African Americans rising up against centuries of slavery and Jim Crow laws.

Four years later, in January, 1967, Stevens contributed to the *Collage of Indignation* exhibition held at the Loeb Student Center of New York University. Like all the other contributors to the exhibition, she was provided with a 2 x 2 foot Masonite panel on which to make her art. She chose to use a square of black cloth instead, and she simply wrote "Morrison Shall Never Die" (Figure 26). The words are an epitaph memorializing Norman Morrison, a Quaker who had immolated himself in Hanoi to protest against the United States involvement in the Vietnamese civil war. An image of Morrison in the act of death would be too horrible, too "unrepresentable." She preferred the words of a song sung by the Vietnamese, "Morrison Shall Never Die."[13] Besides, the more enduring image would be the epitaph for the memory of his death and a call to arms that his death was not in vain.

The Vietnam War in the late 1960s and early 1970s brought about a polarized political situation in the country, with "hawks" against "doves"—supporters of the war opposed to those in the peace movement. For Stevens, the alienation of each side from the other recalled the alienation that she felt separated her mother from her father, and that separated herself from them both. After painting *The Family* (Plate 2) and *The Living Room* (Plate 3) in 1967, she realized the symbolic potential of the image of her father, a decent man but whose racist mind-set was all too familiar to his daughter. Building on that image, Stevens created *Big Daddy* (Plate 4) and then *Big Daddy in Vietnam* (Plate 5) during the winter of 1967–1968.

As her father's image gradually lost its individuality, Big Daddy emerged as a unique iconographical image, embodying a broader psychological and political reality. The meaning was complex to the artist, who remarked to the art writer Cindy Nemser:

> Although I have stylized my Big Daddy figures, I have always been aware of the complexity of the situation of being a racist, sexist middle American human being. I come from Middle America and I think I understand it. It is not a simple matter of hating those who don't understand and are backward in their concepts and damaging to people.[14]

By saying "my Big Daddy," she recognized the puffed-up monster as her own creation that she had universalized into a bland authoritarian patriarchy. For viewers the tensions between our polarized response, our anxiety of recognition and denial on the one hand and our wry amusement toward a cartoonish buffoon on the other hand, force us to think about the realities of the current antiwar movement. Even the ironic title, "Big Daddy," prompting recollections of childhood security and the admiration of a daughter for a father, further intensifies our reaction, pushing us to revisit and to merge psychological and political concerns.

Stevens' Big Daddy became a unique icon of the political art scene of the late 1960s and early 1970s. She exerted power over the image through irony and humor, calling him "Big Daddy Paper Doll" in one image. In another image, she put paper doll tabs on the clothes he was meant to wear: military man, policeman, butcher, hangman. Integral to the series was the ridiculously squat, wrinkled, tongue-wagging bulldog, which sat on Big Daddy's lap. At first the Big Daddy images were flat, with a limited range of colors—red, blue, and white—dominating her palette. By the early 1970s, with the *Big Daddy Draped* series, the paint handling had become more lush;

the compositions, more Baroque. The face and body disappear behind the twisted and puckered folds of the American flag in the paintings *Top Man* (Plate 13) and *Striped Man* (Plate 14), both done in 1976. In 1976, the Bicentennial Year, Stevens made a double portrait of herself and Benny Andrews, another activist artist and an African American (Plate 16). The two of them challenge the racist Big Daddy by invading his space. Big Daddy, no longer menacing, had already become the butt of a joke in *Metamorphosis,* 1973, in which the patriarch is transformed into his dog while, simultaneously, the dog is transformed into a small frog-like creature with a human face.

A parallel metamorphosis was also taking place in her own consciousness as she moved away from the imagery of Big Daddy. The women's movement encouraged a new kind of thinking, the realization that women could change the world and would make history in that process, just as men had been doing. Wanting to celebrate and preserve a moment of exciting historical change, she enlisted her close friends and painted *The Artist's Studio (After Courbet)* (Plate 21) in 1974. She seated herself on a chair in front of *Metamorphosis* and introduced eight friends: artists Arnold Belkin, Felicity Rainnie, and Sylvia Sleigh on the left, and behind Stevens on the right, her husband, Rudolf Baranik, the translator and critic Joachim Neugroschel, and artist Nancy Spero. Spero's artist husband, Leon Golub, and critic Lawrence Alloway are seated. She explained her choice of sitters to art writer Cindy Nemser shortly after *Artist's Studio* was finished:

> These are the people with whom I feel quite close. We have a great deal in common in terms of our interests in the art world. While the styles and viewpoints of the artists and critics may differ, all these people are interested in the political aspects of art as well as being very deeply concerned with painting. Remember Courbet was a very active political person and was a socialist and a real fighter and I would conceive of all these people as fighters, too.[15]

Stevens enthusiastically embraced Courbet as a guide to a new kind of history painting that treats ordinary people and contemporary events as having historical import, such as his *Burial at Ornans.* Like Courbet, with *The Painter's Studio: A Real Allegory Summing Up Seven Years of My Artistic Life,* 1855, she was celebrating her friends and declaring her transformation into a painter/activist immersed in her own historic time.

In the mid-1970s with a committed group of women artists, critics, and art historians, Stevens organized the first issue of *Heresies.* Friends, meanwhile, introduced to her the writings of Rosa Luxemburg, the Polish-German communist revolutionary, who became a model for Stevens in the struggle against male dominated power relations.

Stevens crafted her early representations of Luxemburg—montages that included layering both the personal and the political words of Luxemburg over Xerographed images from books. Stevens sympathized with the woman who both wrote personal letters to her lover and who, as a radical political activist, wrote *The Accumulation of Capital.* Stevens also wanted to contrast the intellectual Luxemburg with her own comforting mother, Alice, and to represent the two women as not polar opposites but as sharing many commonalities. In the dialectical process of moving from one to another and then looping back to repeat an analysis from a different perspective, she hoped to represent the contrast and overlap between the personal life and the life committed to political radicalism.

At that time she was reading Adrienne Rich's *Of Woman Born,* an influential collections of essays published in 1976. Rich had written, in her essay "Motherhood and Daughterhood":

Figure 25. *Malcolm X,* 1965. Ink on parchment, 20 x 17 in. Courtesy Mary Ryan Gallery, New York.

Figure 26. *Morrison Shall Never Die,* 1967. Courtesy Mary Ryan Gallery, New York.

Many women have been caught—have split themselves—between two mothers: one, usually the biological one, who represents the culture of domesticity, of male-centeredness, of conventional expectations, and another, perhaps a woman artist or teacher, who becomes the countervailing figure. Often this 'counter-mother' is an athletics teacher who exemplifies strength and pride in her body, a freer way of being in the world; or an unmarried woman professor, alive with ideas, who represents the choice of a vigorous life. . . . This splitting may allow the young woman to fantasize alternatively living as one or the other 'mother,' to test out two different identifications. But it can also lead to a life in which she never consciously resolves the choices . . .[16]

Indeed, throughout the series of paintings on Luxemburg and her mother, Stevens plays with and extends the complementarity of the two figures without ever resolving or definitively choosing one over the other.

As she developed her imagery, Stevens looked to sources for information on Luxemburg and acquired a growing library of biographies and writings by Luxemburg. For her own mother, she pushed back into her memories and family histories to recall what her mother's life must have been like. In talks and on panel discussions, she described her own mother:

My mother had to leave grade school because her father died and her labor and pitiful salary were needed at home. She went to work for the rich people on the hill as a mother's helper. My mother was a very good student in elementary school, loved reading and mathematics, but she never got another chance to learn.[17]

Such memories renewed her sympathy for her mother, who came to represent all women robbed of an education because of poverty, gender discrimination and class attitudes. To heighten those contradictions and to relate the relevance of both Alice and Luxemburg to contemporary women became Stevens' goal.

Stevens thus embarked on the series, eventually called *Ordinary/Extraordinary,* that would take her to the early 1990s. The first manifestation was the two-page spread she did for *Heresies,* begun in 1976 and published in the first issue of January 1977 (Figure 17). The left side of the page, titled *Tribute to Rosa Luxemburg,* contains three images. The top portion consists of two pages reproduced from the biography by Paul Frolich: on the right an oval photograph of the young Luxemburg faces on the left a reproduction of a typescript page of French poetry. Over this page Luxemburg had written in her own script, using her own urine, a secret message to Fanny Jezierska smuggled out of prison in the book. The middle image is a photograph of Luxemburg's cell at Wronke prison. The bottom image shows the Freikorps soldiers celebrating at the Eden Hotel where they were quartered, following their murders of Luxemburg and Karl Liebknecht in January 1919.

Written at an angle over the entire montage is Stevens' handwriting of an excerpt from an English translation of one of Luxemburg's letters. The lower half of Stevens' excerpt reads:

To be human is the main thing, and that means to be strong and clear and of good cheer in spite and because of everything, for tears are the preoccupation of weakness. To be human means throwing one's life 'on the scales of destiny,' if need be, to be joyful for every fine day and every beautiful cloud—oh, I can't write you any recipes how to be human, I only know how to be human and you too used to know it

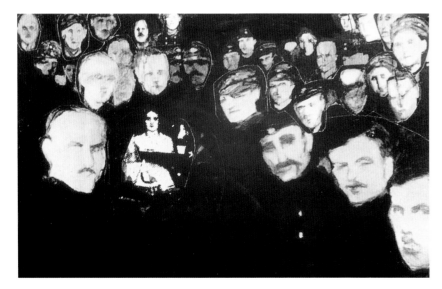

Figure 27. *Eden Hotel,* 1988. Photomural, 132 x 204 in. Exhibited at the New Museum of Contemporary Art, New York. No longer extant.

when we walked for a few hours in the fields outside Berlin and watched the red sunset over the corn. The world is so beautiful in spite of all the misery and would be even more beautiful if there were no half wits and cowards in it. Come, you get a kiss after all, because you are basically a good soul. Happy New Year![18]

The montage aesthetic—words and photographic images from different contexts and historical moments layered and juxtaposed—suggests complex and open-ended meanings. It is characteristic of Stevens to choose a passage from the political letters of Rosa Luxemburg that touches on the poetics of a cornfield outside Berlin at sunset. Not only does Luxemburg contrast with Stevens' mother, Alice, but the two sides of Luxemburg—the political and the personal—differ in compelling ways.

The montage on the right of the two-page spread, *Two Women,* consists of a top band of images of Rosa Luxemburg—as a child of twelve, as a young woman of forty, and as the bloated corpse that floated to the surface of the Landwehr Canal in March 1919—and a bottom band of snapshots of Alice Stevens—as a child with her two siblings, as a young matron holding her first born, and as an elderly nursing home inmate. The vertical pairing expresses the differences: whereas Luxemburg is shown alone, Alice is surrounded by family and home. Captions also tell of differences: whereas typewritten texts for Luxemburg suggest authorities publicly substantiating the identifications, Stevens' own scripted text for her mother indicates the private nature of her own memories.

In 1976, while working with the *Heresies* collective, she was also involved in other projects, such as the "Sister Chapel," originally conceived by Elise Greenstein as an ambitious project that would eventually include a hall of fame, a museum, a library, and an archive. What was realized was an installation that consisted of a circle of twelve over-life-sized portraits on canvas of historically important women and archetypes done by Stevens and other East Coast artists.[19] Stevens selected the Renaissance painter Artemesia Gentilischi, whom she painted as a tall, statuesque woman holding a paintbrush and standing in front of a panel of letters culled from a biography (Plate 17). Writing in 1976 and making reference to Mary Daly's *Beyond God the Father,* a popular book in some feminist circles, art historian Gloria Orenstein described the spirit that characterized the Sister Chapel:

> According to [Daly's] redefinition of sacred activity, it would seem that the vocation of inspiring women to participate in the creation of their own history is a sacred vocation. The images of women both real and archetypal which will be displayed in the Sister Chapel reflect the two poles of Mary Daly's definition—that of the participation in Being and that of the participation in History.[20]

Not all feminists would have fully agreed with the particular dualism that Orenstein describes, but all who participated in the Sister Chapel project concurred it was time to celebrate women and to bring them into the history books.

Rather than pursue subjects from past art history, Stevens began to situate within contemporary history women committed to family and community, as well as to art and social change. Stevens sought to explore in each of her women friends the two mothers Rich had spoken about. Like *The Artist's Studio,* she used photographs to place her friends in two

Figure 28. May Stevens standing in front of a portion of her painting *Soho Women Artists,* 1978. Photograph © Maren and Reed Erskine.

compositions: *Soho Women Artists,* 1977–1978 (Plate 22), and *Mysteries and Politics,* 1978 (Plate 23). Stevens later described her goal as visualizing "women conducting our lives through our own efforts, arguing out problems and discussing solutions; an intellectual ferment, a moving into areas scarcely *thought* before."[21] Her aim was to highlight feminists working independently but in concert.

In *Soho Women Artists* Stevens removed herself from stage center and placed herself modestly at the rear left. To her right are four members of the *Heresies* collective: lesbian artist and writer Harmony Hammond, performance artist Marty Pottenger, influential teacher and pattern artist Miriam Schapiro, and feminist critic Lucy Lippard. Seated on the floor are Joyce Kozloff, another *Heresies* artist, with her son, Nikolas. Conceptual artist Sarah Charlesworth enters at the right on her bicycle. Louise Bourgeois, encased in her soft sculpture of breast forms, anchors the center of the painting. Stevens turns to the left to face her community neighbors: Signora D'Apolito, from a neighborhood bakery, and two elderly Italian American men she frequently saw on the street. Behind the scene of women gathering for conversation are fragments of three of Stevens' paintings: *Benny Andrews and Big Daddy, Artemisia Gentileschi,* and *Big Daddy Draped.*

Over the winter of 1977–1978 Stevens painted *Mysteries and Politics,* which brought together eight artists, two art historians, one anthropologist, and three babies, along with images of her mother, Alice, and Rosa Luxemburg. Two years later, at a panel discussion held at the AIR Gallery, Stevens began by stating that she saw "theory—and life—embedded in the painting." She then described the genesis of the painting:

> The development of my thinking was crystallized by 3 factors that I am conscious of: one was the reading of Adrienne Rich's *Of Woman Born;* another was the desire to reproduce consciousness as we experience it, on many levels; and, last, the ways that working with other women on *Heresies* had become an important part of my life.[22]

Stevens then explained two concepts from Rich's book that were helping her to formulate the direction of her art. Quoting Rich, she continued:

> The rejection of dualism, of the positive-negative polarities between which most of our intellectual training has taken place, has been an undercurrent of feminist thought. And rejecting them, we reaffirm the existence of all those who have through the centuries been negatively defined: not only women, but the "untouchable," the "unmanly," the "nonwhite," the "illiterate": the "invisible." Which forces us to confront the problem of the essential dichotomy: power/powerlessness.[23]

This encouraged Stevens to try in the future "to let into my art less definable aspects of experience" after the previous eight years of making art "that had to do with attacking authoritarian political and social structures and the social horrors that result from them."[24]

Stevens included three women on the left side of the painting: Betsy Damon, in the act of performing the "Seven Thousand Year Old Woman"; above her, Pat Steir, who represented to Stevens the poetic mysteries of magic; and at the top a postcard fragment of the performance artist Mary Beth Edelson. To Stevens these three represent female sexuality and offer "a complementarity" to the other political women.

Toward the middle sits antiwar activist artist Poppy Johnson, who dangles her twins, a girl and a boy, on her knees. Next come the two Marxist art historians; Carol Duncan stands behind and to the left of myself. Stevens saw me as representing the dualism united as one: "the activist woman becoming pregnant." To the right of Stevens, whose face is again obscured, are sculptor Suzanne Harris and painter Joan Snyder, seated on a folding chair and also pregnant. Snyder's farm in Pennsylvania sometimes served as a retreat for the *Heresies* group (Figure 13, page 36). Behind Snyder and next to the image of Rosa stands Amy Sillman, an art student at the School of Visual Arts. At the far right is feminist anthropologist Elizabeth Weatherford.[25]

Virginia Woolf inspired Stevens to include Alice, cradling the infant May, and Luxemburg. As Stevens explained in her previously mentioned 1980 panel talk, "Virginia Woolf's writings on the simultaneity of consciousness—with past and future leaking into the present in flashes from our earlier lives, from our dreams and from our desires made me want to include the two white figures which represent images from other times, other places—a different level of reality."[26] Alice and Luxemburg underscore what Stevens then saw as the theme of dualism in the painting—the desire for a family life in uneasy alliance with the pull of intellectual life and the need for political activism. Later, in 1994 Stevens characterized the role of these godmothers in *Mysteries and Politics:*

> It is about mind-body division. Alice is mother and not intellectually or politically active, but devoted to family and children. And Rosa represents the intellectual life. She affects the world on the public scale in a powerful way. Both of these realms are valuable. It is possible to bring them together, but also problematical.[27]

"Dualism" to Stevens was but another word for "contradiction." In her 1980 talk she recognized the multiple contradictions in the painting beyond the expressed content:

> The painting has many other contradictions: it is too big for easy transportation or selling; it is traditional in that it uses painted representations of figures; it is formal in its concern with the relationship of forms, colors, patterns, negatives and positives that jump, jar or lie quiet or nearly disappear into each other. It is utopian in depicting a community of women, each in her individualist nature attempting to have meaning in juxtaposition with others. It is awkward in its explorations of these difficult relations, still not proven in reality. It is literary, historical, narrative, full of content and allusion, burdened with feminist principles, political and art historical references and formal questions.

Stevens concluded: "Like many women it attempts to do too much, and it wants to leave nothing that is valuable out. It speaks in the vernacular because it would like to be understood."[28] The painting was her most ambitious painting to date and pointed her toward a more sustained focus on the politics of class as well as gender.

Following the three contemporary history paintings, Stevens continued to construct collages of Luxemburg and her mother and to embark on the large paintings for her *Ordinary/Extraordinary* series.[29] The contrast and commonalities between the two women allowed Stevens to analyze and to uncover her own beginnings—on the one hand, as a dutiful daughter and then a mother; on the other, as an artist and political activist. She sought to inquire how such figures as political radicals and working-class women come to a consciousness of themselves, how they find a voice, how they are silenced, and how they silence themselves. And further, she sought through her work to rescue her mother from the sad and oppressed life she had.

Her first large painting was of her mother—*Everybody Knows Me* (Plate 33), a title which came from the last words of a long narrative she wrote describing her mother in her artist's book of 1980. The painting consists of the three images of Alice Stevens included in *Two Women*—as a child, young matron, and older woman, which she had used before in her collages. However, in this first large painting she used metallic pewter paint in order to give the sense of dematerialization (in memory and material substance) that old images from photographs exhibit. She also adopted the aesthetic of the reductive, corrupted, Xeroxed photocopy—the aesthetic of imagery that has undergone repeated recopying and has subsequently lost its halftones. This technique mimics the effects of time that erase the details of pictorial memory, thereby preserving the

reductive essence of an image. Without depth or nuance the resulting silver and grey images communicate mere fragments of former lives and past feelings. But Stevens pushes the dialectic; she turns the image into its opposite. She desires that the past come as alive as the present, and thus uses iridescent pewter and silver paints, which change their reflective qualities as the viewer moves from one side to another when viewing the painting. The effect replicates a series of mirrors reflecting the viewer.

In 1981 Stevens began another painting of her mother (that was eventually to become *Go Gentle*), but set it aside to work on several smaller works based on contemporary photographs of Luxemburg and her political friends, such as *Dreams and Theories I, Dreams and Theories II, Rosa and Leo* (Plate 28) and *Rosa and Louise Kautsky* (Plate 29).

As we know from her "Conversation," the return to Luxemburg was not arbitrary and relates to the suicide of her son, Steven. In her large paintings she took as her subject the funeral of Luxemburg and demonstrations commemorating the event: *Demonstration*, 1982 (Plate 30), *Voices*, 1983 (Plate 31), and *Procession*, 1983 (Plate 32). Courbet's *Burial at Ornans* would also become personally relevant.

Demonstration depicts an annual event held in both East and West Berlin in the post-War period that commemorated the anniversary of the deaths of Luxemburg and Karl Liebknecht.[30] In West Germany the postwar radical Left still revered both Luxemburg and Liebknecht as socialists and as advocates for peace. In 1984 Stevens described the way she fused form and content through her use of a dry technique: "The painful dryness in this painting, that persists in spite of the loosening of the handling, has to do with a great feeling of impoverishment, loss, the taking away, absence."[31] While her private emotions over the loss of Steven fueled the energy to paint the series, she never faltered from her goal to tell the story of Luxemburg specifically and all political movements generally that women and men desiring social change and social justice have generated.

The second painting of the trilogy, *Voices*, 1983, represents the actual funeral march for Luxemburg and Liebknecht held in early 1919. Stevens here focuses on the two coffins, above which are scrawled the words of Rosa Luxemburg, written five days before her death. Stevens explained:

> Overhead [are] Rosa's last words from *Die Rote Fahne,* where she wrote: "The revolution has been crushed, but it will rise again. And it will say with trumpets blazing, 'I was. I am. I will be.'" *Ich war. Ich bin. Ich werde sein.* Over Rosa and Karl's coffins, over and over again these words pile up, turn and fall and rise. They are like sounds. They make a vaulted space or a series of vaultings for the sound to resonate in, connoting and denoting. The signifier becomes the signified. In these three paintings Rosa has gotten smaller and finally disappeared. Her meaning has become absorbed into the painting, into the context and the resonance of her life. She is her afterimage.[32]

Here again form is fused with content; Stevens thickly applies a creamy paint and fills it with touches of color. The words "Ich bin, ich war, ich werde sein" are not the graphic words of a placard carried by a crowd, but the words of memory, of voice, and above all of revolution. They rise and fall, push forward and back, and drift across the space.

With *Procession* Stevens goes back further in time to the demonstrations that occurred immediately after the deaths of Liebknecht and Luxemburg. Again, Stevens sees the form and the content working in harmony: "…the stark contrasts: browns, granular, ground in, but quite flowing through—breaking down barriers connecting one form to another—almost like strokes of a strobe light, frozen figures, almost shadows burnt into the earth by an atomic blast." The painting represents "All the peace marches and demonstrations I ever went to are in these crowds. Above the heads, their heads in pinks and purples, handwriting, words, Rosa's words . . . all but gone."[33]

In this group of three paintings, each painting develops from and supersedes the stylistic solutions of the previous one, even though the consecutive images go further back into time—from current demonstrations, to the funeral, to the first spontaneous demonstration. *Demonstration,*

based on a photographic source, has a flat surface with silver and pewter colors. The strokes are painterly, if dry, and words enter the picture as signage on political placards. *Voices* eliminates the pictures of Luxemburg and Liebknecht, becomes even more painterly, and adds touches of color. The slogans on the placards disappear, but words insinuate themselves as emissaries of Luxemburg's thoughts. With *Procession* the crowd has returned with greater corporeality, incited into action by the sheer numbers of their own gathering. To Stevens this supersession of one idea over another—replacement without destruction—was a principle of her dialectical outlook on life, her politics, and the way she understood both history and the workings of consciousness. In her representations she constantly adds new ideas and insights to her paintings without rejecting out of hand the older ideas. She does not think in terms of a clash of opposites as in some classical definitions of dialectics, but, instead, lets the old ideas absorb the new and the new supersede the old until she arrives at a fresh synthesis.

After completing the three paintings Stevens returned to *Go Gentle* (Plate 34). The partially completed painting already included a vignette of the heads of Alice and her two siblings, repeated flatly in two colors from the photograph in *Two Women*. At the left margin stands Alice, in a blousy dress and a large hat. The original photographic image had already begun to be three-dimensional in 1980, when she painted the small canvas, *Alice in Summer*. Alice stands enveloped in a garden surrounded by white, pinkish, and copper-colored flowers among green leaves. In *Go Gentle* the dominating image is the doubled image of her mother, painted with a full chiaroscuro modeling and deep colors. To the right is a shadowy echo of that doubled image. Stevens' memory, coaxed by photographic snapshots, of her mother at the Framingham nursing home, inspired the pose. She had playfully thrown dandelions that her mother attempted to catch, but to viewers the hand gestures connote the struggle to engage with life and the eventual failure of that engagement. But Stevens has made her peace with that. Reversing Dylan Thomas's admonition to his own father to rage against death, it is all right for Alice to "go gentle" into that dark night.

After *Go Gentle* Stevens made three other large paintings where she doubles or triples the image of her mother: *Fore River,* 1983 (Plate 35), *A Life,* 1984 (Plate 36), and *Signs,* 1985. But in 1985—the year her mother died—she painted *Forming the Fifth International* (Plate 37) in which the doubling is with Luxemburg. The source of the image was a photograph of Luxemburg seated on a park bench with a friend, an image that Stevens had previously painted in the monochromatic 1981 painting *Dreams and Theories.* At the right side of the painting Stevens placed Alice in her full fleshy corporeality, who animatedly pats her leg and looks across at the pensive Luxemburg, a graphic figure painted in black and white.

After these Alice pictures, Stevens returned to Luxemburg for her 1988 exhibition *One Plus or Minus One* at the New Museum of Contemporary Art (Figure 18). Only two works were in that show—the large (11 x 18 feet) photomurals based on *The Murderers of Rosa Luxemburg,* 1986 (Figure 30), and *Rosa Luxemburg Attends the Second International,* 1987 (Plate 39), both of which drew their imagery from group photographs. The first resonated with Stevens' then current concern about death squads in Latin America throughout the 1980s; the second probed the issue of women as participants of political movements dominated by men. Hence, the concerns of the present suggested the choice of past moments of history.

Stevens returned once again to Alice during 1988–1989 when she was a Fellow at the Bunting Institute of Radcliffe College. From the gritty streets of Soho artists' lofts, small manufacturing buildings, restaurants, and high-end shops, Cambridge seemed almost pastoral. The four clapboard buildings that housed the Bunting Institute administration and Fellows were clustered around a quadrangle of grass on a tree-lined street with low buildings. The Radcliffe and Harvard campuses with their Colonial brick buildings and ample quadrangles of grass and

Figure 29. *Alice in Summer,* 1980. Acrylic on canvas, 36 x 24 in. Courtesy Mary Ryan Gallery, New York.

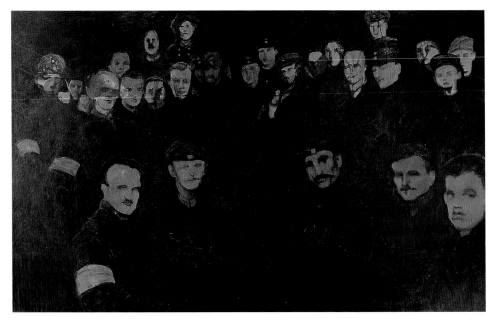

Figure 30. *The Murderers of Rosa Luxemburg,* 1986. Acrylic on canvas, 78 x 126 in. Courtesy Mary Ryan Gallery, New York.

trees, as well as the Cambridge Common, were a few blocks away. The Charles River wound its way through Cambridge and Boston, as it emptied into Boston Harbor; from the footpaths on the Cambridge side of the river a stroller could take in the vistas of university buildings and scullers testing their skills on the calm waters. The less hectic pace at the Institute and encouragement from the staff provided both a nurturing and intellectually stimulating culture for all of the Fellows. Stevens' choice to do the *Alice in the Garden* series in the large studio the Institute provided seemed appropriate to the ambiance of her new environment.

In this series of five paintings, often installed as one long painting, Alice appears five times. In four of the panels she sits (but without a visible chair) in a field of lively green strokes as she studies and twists her hands. Stevens spoke with Barbara Stern Shapiro about the meaning of Alice's hand gestures: "Those hands articulate the painting and they become like writing. Her gestures are like brushstrokes or like handwriting because they are small movements of the same kind of forms which are communicating to those who are watching them, whether it tells them specific words or specific ideas or just some sort of movement which gives a sense of the desire to be understood."[34] In the far right panel, Stevens includes her own arm reaching into the painting to insert a dandelion into the fabric weave of Alice's dress. The inclusion of the artist is a Brechtian jolt that reminds the viewer that this Alice is Stevens' creation, and that we, the viewers, are looking at canvas and paint. The middle panel, given the separate title *Green Field,* is a long horizontal field of agitated green strokes in which is placed a small, silhouetted figure with a hat and cane, who may or may not be Alice. Actually, Stevens says, "Alice is taking her leave."[35] The setting suggests the fields Stevens' memory recalled in her "Conversation"—the green fields toward which she swam in her Quincy salt water inlet as a child, only to discover that the blades of grass were sharp as knives.

During the 1990s, beginning with *Missing Persons,* 1990–1993 (Plate 59), and *Sea of Words,* 1990–1991 (Plate 60), Stevens focused more intensely on the subject of boats in water, sometimes empty and sometimes filled with women. It may have been her sojourn in Long Beach, where she was Visiting Artist during the spring 1990 semester at California State University and where she had a studio in San Pedro at Angel's Gate, a former army post overlooking the ocean, that influenced her to shift from paintings of the garden and canal to the sea.

With the new series, *Women, Words and Water,* Stevens leaves history behind and turns toward a sociology of women. But her work continues to be informed by her own experiences as a feminist. She has not rejected her mother or Luxemburg as sources of inspiration and solace, but they are now distanced and stilled.

Stevens began to explore other ideas of ways to represent women and their lives symbolically.[36] She saw a video by Joan Braderman that included an old 8-mm film clip that Braderman's father had taken of his wife rowing a boat. From Braderman Stevens borrowed five stills from the video, which inspired her to paint five variations in watercolor of a single woman rowing a boat (Plate 58). About this new direction, she explained to Moira Roth, "After having drowned Rosa [in the image *But That Was in Another Country*], I wanted to do a woman on top of the water, so I started sketching rowers."[37]

For *Sea of Words,* 1990–1991, she incorporated the four rowers in their boats as distant forms on a shifting sea of water. The figures, themselves, are not necessarily four different figures, but could easily be just one figure in different motions. Stevens layers in waves over

the surface transcriptions of texts in a small handwritten script of ocher, black, gray, and white paint. She recalled to Roth the voices of the text:

> The voices in the *Sea of Words* are the voices of our feminist mothers. I started by choosing lines from Virginia Woolf's "A Room of One's Own," those that specifically pointed to the discrimination and oppression of women. Next I went to Julia Kristeva's "About Chinese Women," and I copied out sentences that elaborated on an ancient Chinese sex manual that advises both the man and woman to concentrate on the woman's sexual pleasure in order for the greatest good to be achieved for both. Finally, I went back to Woolf, this time to "A Writer's Diary," sections that seemed so close to my own experience of an artist's way of being and working. After I had written, layering and overlapping, these words, I thought about the sequence of the three choices I had made, and what it meant. First, the oppression of women. Second, women's sexual pleasure. And third, the joy of work. I thought how this layering accurately marks what matters to me in that order of deepening importance.[38]

Over ten years later, in the interviews done for this book, she told me that the words were important as manifestations of her thinking at that time. She felt a joy when inscribing them into the painting, because the content and import of the words paralleled her own thoughts. Facing the contradiction between painting as performative process and as finished exhibition-worthy product, Stevens selects the process, thereby resolving the Yeatsian choice between "perfection of the life, or of the work."[39] Perfecting the process whereby she can live her life in the act of painting is the equivalent, to Stevens at that moment, to the perfection of the work. At those moments when the painting becomes alive and vital to her—the two perfections merge. Thus, Stevens' large canvases—at times filling her field of vision, embracing her with its sensuousness and its color, echoing in her ears the words of her mothers—became intense relationships that suspend time while maintaining duration, like an endless loop.

During 1990 Stevens returned to work on an earlier painting of Luxemburg disappearing into the water, a painting that would eventually be called *But That Was in Another Country* (Plate 47). In the early stages of the painting, which I saw on the wall of her studio at the Bunting Institute in 1989, Luxemburg's feet and skirt, as her body sinks into the canal, were not mere suggestions but specifically articulated. Stevens set the unnamed painting aside, as she so often does when a solution does not seem right, to work on new paintings. But she remained preoccupied with the problem of representing Luxemburg physically gone but alive in the world of ideas and political influence. After reworking the final version titled *But that Was in Another Country,* only the whirlpool of dark water remains to suggest the brief turbulence created by "the purple blossom of her skirt billowing in the water."[40] To this she added words in block letters—from an epigraph introducing T. S. Eliot's poem "Portrait of a Lady"—to a trompe l'oeil strip of paper and Scotch tape. If one could peel off the illusionist quotation, the swirling water would completely hide the secret of its contents.

Stevens added the title because she "wanted its message to be clear . . . realizing how difficult it is to make this idea and this image clear to people who live in another country and in another time."[41] However, Stevens knows the full quotation from the Eliot poem and is fond of quoting it: "Thou has committed—/Fornication: but that was in another country,/ And besides, the wench is dead." The original source is Christopher Marlow's play, *The Jew of Malta,* at a point when Friar Bernadine queries the main character, Barabas, about his past. The Frair begins, "Thou has committed—." Barabas completes the thought and adds the dismissive remark.[42] To men of affairs past sexual dalliances (or even sexual aggressions—Marlowe does not make clear what had happened) have little significance, especially ones that took place in a foreign country with a woman of no station and, who, because dead, cannot bring suit or make trouble.

Stevens finished the four panels of *Elaboration of Absence* in 1991 (Figure 31), the last major work to refer specifically to the life of Rosa Luxemburg. The top panel represents a circle of women prisoners taking their exercise in the prison courtyard, as Luxemburg may have done while in prison during World War I. The silvery whirlpools of water in the second panel suggest the ripples in the water when Luxemburg's body was thrown into the Landwehr Canal; the large blurred glowing forms in the fourth panel resting on the floor suggest the bridge lights directed into foggy vapors.

The third panel consists of a long text, fragments culled and paraphrased from Carlo Ginzburg's *Ecstasies: Deciphering the Witches' Sabbath* (1991). The text reads:

> TO NARRATE MEANS TO SPEAK HERE AND NOW WITH AN AUTHORITY THAT DERIVES FROM HAVING BEEN (LITERALLY OR METAPHORICALLY) THERE AND THEN . . NOT ONE NARRATIVE AMONG MANY, BUT THE MATRIX OF ALL POSSIBLE NARRATIVE . . ELSEWHERE . . THE ELABORATION OF ABSENCE . .

Ginzburg is not a feminist, but he opened up the distant past for Stevens and suggested the possibilities for women's wisdom in those earlier times. It is imperative, to Stevens, to narrate the truth to those who have not been able to see or permitted to know. She admired Ginzburg because he told the stories of medieval European women from their point of view:

> He possesses an amazing ability to sense what happened when the witches crossed over to the other side through drugs, dreams or incantations. The whole point of his book is to understand what they did and what they really knew. I felt I was enlarging my context by reading this. I wasn't just staying with my own time and reading feminist theory but instead was reaching back into a distant past, contacting other kinds of beings.[43]

The words she marshaled from Ginzburg become incantations augmenting a complex representation that crosses positive and negative, space and time (there and then/here and now), like the small rowboat that moves its way from the right side through the middle to the left. The rowboat's destiny is ambiguous—perhaps it will rescue or perhaps it will be destroyed.

Stevens began *Missing Persons,* with the thought of representing Luxemburg disappearing into the water, but abandoned the idea. Instead two empty boats are moored together in a vaporous atmosphere that obscures their full substantiality. Into the water that laps at their bows Stevens has written words in barely decipherable handwriting. She no longer recalls where the words originally came from—perhaps Woolf, or perhaps Kristeva.[44]

From the mid- to late 1990s, Stevens continued exploring images of women in boats and gliding through water, producing a series of lithographs and mixed-media works, such as *River Run,* 1994 (Plate 61), *Indigo,* 1999 (Plate 67), *Pearl,* 1999 (Plate 68), and the large paintings, *Her Boats,* 1996 (Plate 62), and *Fear and Desire,* 1996–1997 (Plate 63). Her *Tic-Tac-Toe* collages (Plates 53 to 55) interrupted that pastoral.

In 1996 she was jolted by a news story about the murder of Elisa Izquierdo, a child abused by her mother and her mother's boyfriend. Stevens, isolated in her Brooklyn studio and in the process of painting *Her Boats,* became focused on the history of the Elisa's abuse, of her circumstances, and of the promise she had shown to her teachers. The lurid events detailed by the daily papers contrasted with the family snapshots of Elisa dressed in first communion clothes. How to represent the unrepresentable? To seek an answer to that question when thinking about atrocities done to innocent children, she turned to Pablo Neruda and his poem "Explico Algunas Cosas" ("I Explain a Few Things"). He, too,

had brooded on this and concluded that metaphors cannot meet the task of representing the unrepresentable: "y por las calles la sangre de los ninos/ corria simplemente, como sangre de ninos" ("and through the streets the blood of the children/ ran simply, like blood of children."[45]

Stevens then turned again to the technique of collage, using actual newspaper clippings or degraded photocopies of them, because she wanted the works to look like fragments of real life. For the *Tic-Tac-Toe* series Stevens chose to engage in a contradictory act: to create an imagery of Elisa and other children from the newspaper photographs, and then methodically to destroy those images, by tearing at them and pressing burning cigarettes into their images. Through the process of mimicking the original creation of a child by a man and a woman and then the destruction of that child through physical and psychological abuse, Stevens hoped to get closer to the horror of the original acts of abuse. Although a full emotional grasp of such acts was not possible, at least her audience might experience the "pickax" of a cathartic release.

At the turn of the twenty-first century, Stevens was at work on another series of paintings memorializing the death of her husband, Rudolf Baranik. Stevens gathered various groups of friends and, together with them, scattered the ashes in various rivers that the artists had known and visited. It was a ritual that had been repeated before when Stevens and Baranik had scattered the ashes of her mother, Alice, and their son, Steven, in the Hudson River. Thus, Rudolf, like Alice, Steven, and Luxemburg over eighty years ago, returns to many rivers and bodies of water—sites that he and Stevens had frequented during the fifty years they had been together.

Stevens recorded on camera her friends scattering the ashes into rivers and other bodies of waters, and she used the photographs to paint a series of pictures of those rivers and waters. This time her concern was to make the works beautiful and lyrical, with combinations of translucency, opaqueness, and the inclusion of delicately written script, as she has done for *Connemara (Rock Pool, Ireland)*, 1999–2001 (Plate 73). With *Galisteo (Creek, New Mexico)*, 2000 (Plate 74), a thin shaft of blue-white, like a moonbeam reflection, slices through the painting. With *Water's Edge II, Charles River, Cambridge*, 2002–2003 (Plate 80), the translucent yellows and tans are contradicted by the ashes on the surface. These large riverscapes have no horizon line and no sense of a stable vantage point; instead, the viewer feels their power to bathe and cleanse the tensions of everyday life. Gone are the earlier contradictions. The paintings have become places to meditate upon the present moment—which encompasses both life and death—and a vibrant stillness.

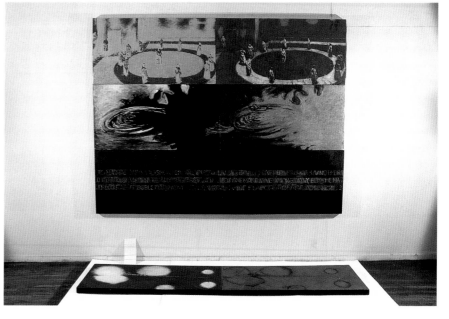

Figure 31. *Elaboration of Absence*, 1991. Acrylic on canvas, four panels, each 26 x 104 in. Courtesy Mary Ryan Gallery, New York.

✢ —— ✢

Stevens' story does not end here on the whispered elegiac note that her recent paintings evoke. True, the lyricism of her late paintings is informed by her living in the New Mexico landscape—a vast, uninterrupted circular vista that wraps around her house in the desert—and by the quiet moments of meditation in her garden that induce in her a sense of peace. But Stevens remains fiercely committed to justice and to political change, and her collages keep that faith, such as the *Kill Books* collages (Plate 87) and other political collages submitted to the frequent political art shows mounted in the Santa Fe area. Ultimately, the dialectics of representation that have powered her art throughout her career bring us to the realization that contradictions are necessary. Contradictions give motion and energy to both life and art, and through the struggle to bring about a resolution, we can hope to come to new truths.

1. "May Stevens: In Conversation" has been pieced together from audiotapes of conversations with the author, primarily from August 2002, when we first made plans to collaborate on this book, but also from September 2003 and October 2004. For her conversation about her early years and the Paris sojourn, I have also drawn on audiotapes of March 1987, July 1987, and August 1990.

2. From a taped interview of August 2002, when Stevens was seventy-eight.

3. William Earnest Henley (1849–1903), an English poet, wrote "Invictus," a poem Stevens greatly admired in her youth. He also wrote criticism, edited journals, and collaborated with Robert Louis Stevenson on four plays.

4. Gerard Manley Hopkins (1845–1889) was an English poet, whose poems were first published posthumously in 1918 by his friends.

5. Rudolf Baranik, "Biographical Notes," in Jonathan Green, curator, *Rudolf Baranik Elegies: Sleep—Napalm—Night Sky,* exhibition catalog (Columbus: University of Fine Art, The Ohio State University, 1987), pp. 65–85. See also David Craven, *Poetics and Politics in the Art of Rudolf Baranik* (Atlantic Highlands, NJ: Humanities Press International, Inc., 1997).

6. See *Selections from the Prison Notebooks of Antonio Gramsci,* ed. and translated by Quintin Hoare and Geoffrey Nowell Smith (New York: International Publishers, 1971), p. 175, note 75.

7. Rudolf Baranik, "Autobiographical Notes," offset notebook, privately printed, nd, pp. 9–10. Photocopies of the reviews of these shows are included on pp. 10ff.

8. Baranik, "Autobiographical Notes," p. 8. Also quoted in Craven, *Poetics and Politics in the Art of Rudolf Baranik,* p. 54.

9. This is a conflation by Stevens of two quotations: Franz Kafka, "Writing is the axe that breaks the frozen sea within us," (see Franz Kafka letter to Oskar Pollak, January 27, 1904, in *Letters to Friends, Family, and Editors,* trans. Richard and Clara Winston [New York: Schocken Books, 1977], p. 16) and W. H. Auden, "Intellectual disgrace/Stares from every human face,/And the seas of pity lie/Locked and frozen in each eye," from "In Memory of W. B. Yeats," *Another Time* (New York: Random House,

1940). I want to thank Leslie Epstein for steering me to the right authors.

10. I have been unable to locate this idea in the Adrienne Rich literature I have examined.

11. This painting will be reproduced by the United States Post Office in a group of ten commemorative stamps titled "To Form a More Perfect Union" in 2005. Other artists whose work will be used include Jacob Lawrence, Romare Bearden, and Alma Thomas.

12. See Francis Frascina, *Art, Politics and Dissent: Aspects of the Art Left in Sixties America* (Manchester and New York: Manchester University Press, 1999), pp. 113–130.

13. See Lucy R. Lippard, "Dreams, Demands, and Desires: The Black, Antiwar, and Women's Movements," in Mary Schmidt Campbell, *Tradition and Conflict: Images of a Turbulent Decade, 1963–1973,* exhibition catalog (New York: The Studio Museum in Harlem, 1985), and Francis Frascina, *Art, Politics and Dissent.*

14. See Mary D. Garrard, "Feminist Politics: Networks and Organizations," in Norma Broude and Mary D. Garrard, eds., *The Power of Feminist Art: The American Movement of the 1970s, History and Impact* (New York: Harry N. Abrams, 1994), pp. 88–103.

15. See Judith K. Brodsky, "Exhibitions, Galleries, and Alternative Spaces," in Broude and Garrard, eds., *The Power of Feminist Art,* pp. 104–119.

16. See Carrie Rickey, "Writing (and Righting) Wrongs: Feminist Art Publications," in Broude and Garrard, eds., *The Power of Feminist Art,* pp. 120–129. The other publications discussed by Rickey that sprang up at this time were *The Feminist Art Journal, Women Artists Newsletter/Women Artists News, Womanart, Chrysalis,* and *Woman's Art Journal,* the last of which is still being published.

17. *Racism Is the Issue* was *Heresies* no. 15. A taped conversation, dated October 21, 1982, included the editorial collective responsible for the issue: Vivian E. Browne, Cynthia Carr, Michele Godwin, Hattie Gossett, Carole Gregory, Sue Heinemann, Lucy R. Lippard, May Stevens, Cecilia Vicuña, and Sylvia Witts Vitale.

18. May Stevens' letter to author, November 29, 1993. Quoted in Patricia Hills, "May Stevens: Painting History as Lived Feminist Experience," in Patricia M. Burnham and Lucretia

Hoover Giese, eds., *Redefining American History Painting* (New York: Cambridge University Press, 1995), p. 310.

19. Laura Mulvey's "Visual Pleasure and Narrative Cinema," *Screen* 16 (Autumn 1975), pp. 6–18, has been frequently anthologized.

20. See http://www.kirjasto.sci.fi/luxembur.htm for a short biography about Rosa Luxemburg.

21. Quoted in Judith Pierce Rosenberg, "Art and Motherhood: A Profile of Painter May Stevens," *Sojourner: The Women's Forum* (May 1993), p. 19. The essay was written on the occasion of the exhibition of *Go Gentle* at the Museum of Fine Arts, during the summer of 1993.

22. Lucy R. Lippard, "Masses and Meetings," in *May Stevens: Ordinary/Extraordinary, A Summation, 1977–1984* (Boston: Boston University Art Gallery, 1984), unpaged.

23. The phrase is from Neruda's "Explico Algunas Cosas" ("I Explain a Few Things"): "y por las calles la sangre de los ninos/corria simplamente, como sangre de ninos" (and through the streets the blood of the cildren/ran simply, like children's blood") from Pablu Neruda; see a variant translation in Neruda, *Residence on Earth,* Donald D. Walsh, trans. (New York: New Directions, 1941).

24. For a summary of Elisa's life and death, see Sharon E. Epperson and Elaine Rivera, "Abandoned to Her Fate," *Time* 146 (December 11, 1995), pp. 32–36.

25. Nancy Holt's husband, Robert Smithson, died in a plane crash in 1973.

26. "A Conversation with May Stevens and Barbara Stern Shapiro," in *May Stevens: Images of Women Near and Far, 1983–1997* (New York: Mary Ryan Gallery, 1999), p. 13.

27. Ibid.

28. Christine Temin, "Personal and Political, Stevens' Work Gives Presence to Women," *The Boston Sunday Globe,* June 20, 1999.

29. Ken Shulman, "A Crusader Who Lets Her Heroes Be Human," *The New York Times,* Sunday, June 27, 1999, p. AR32.

30. Peter Schjeloahl, "Death and the Painter," *Art in America* 78 (April 1990), pp. 248–257.

1. On the theoretical concept of "Representation," see David Summers, "Representation" in Robert S. Nelson and Richard Shiff, eds. *Critical Terms for Art History* (Chicago: University of Chicago Press, 1996), 3–16; W. J. T. Mitchell, "Representation," in Frank Lentricchia and Thomas McLaughlin, eds. *Critical Terms for Literary Study* (Chicago: University of Chicago Press, 1990) and W. J. T. Mitchell, *Picture Theory* (Chicago: University of Chicago Press, 1994), especially his last chapter, "Some Pictures of Representation."

2. Letter dated September 3, 2004, to the author.

3. "May Stevens: In Conversation," note 23.

4. "May Stevens: In Conversation," note 9.

5. Unpublished poem, "Standing in a River," sent to the author on September 23, 1991.

6. May Stevens, written on the margins of the October 12, 2004 draft of this essay.

7. Although we call many of the groups "series," there is no seriality; hence, they function more like clusters, like constellations that revolve around a set of ideas.

8. Quoted in "A Conversation with May Stevens and Barbara Stern Shapiro," in *May Stevens: Images of Women Near and Far*, exhibition catalog published for the Museum of Fine Arts, Boston (New York: Mary Ryan Gallery, 1999), 13.

9. Summers, "Representation," p. 15.

10. The painting was based on a photograph taken at AIR Gallery, on the occasion of an open discussion of the *Heresies* issue on Race, just published. Stevens borrowed the title from a poem by Adrienne Rich.

11. "May Stevens: In Conversation," note 6.

12. Donald Kuspit has written about Stevens and the "art of conscience"; see his essay "Art of Conscience: The Last Decade," in *Art of Conscience: The Last Decade,* exhibition catalog (Dayton, OH: Wright State University), 1981.

13. "May Stevens: In Conversation," p. 32.

14. Quoted in Cindy Nemser, "Conversations with May Stevens," *The Feminist Art Journal* 3 (winter 1974–1975), p. 6.

15. Quoted in Nemser, "Conversations with May Stevens," p. 6.

16. Adrienne Rich, *Of Woman Born: Motherhood as Experience and Institution* (New York: W. W. Norton, 1986), pp. 247–248. First published in 1976.

17. From a text for a panel discussion, "Art and Class," held at Artists Space, April 9, 1976. I moderated that panel discussion, which also included Carl Andre, Rudolf Baranik, Kevin Whitfield, Lucy Lippard, and Imiri Baraka. For the current quotation, she has substituted "rich people" for "mill owners."

18. Excerpt from a letter written to her friend Mathilde Wurm, December 28, 1916, quoted in J. P. Nettl, *Rosa Luxemburg* (London: Oxford University Press, 1966), p. 662.

19. The other artists were June Blum, Ronni Bogaev, Martha Edelheit, Elsa Goldsmith, Shirley Gorelick, Betty Holliday, Alice Neel, Cynthia Mailman, Sylvia Sleigh, and Sharon Wybrants. See Gloria Feman Orenstein, "The Sister Chapel—A Traveling Homage to Heroines," in *Womanart* (Winter/Spring 1977), pp. 12–21.

20. Orenstein, "The Sister Chapel," p. 13.

21. Letter dated November 29, 1993, to the author, titled "Some Notes on History Painting."

22. The panel discussion focused on "Theoretical Concepts of Feminist Art," held at the AIR Gallery, March 24, 1980; the artist provided the author with her three-page unpublished text.

23. Ibid.

24. Ibid.

25. For an extended discussion of *Mysteries and Politics,* see Patricia Hills, "May Stevens: Painting History as Lived Feminist Experience," in *Redefining American History Painting,* eds. Patricia M. Burnham and Lucretia Giese (New York: Cambridge University Press, 1995), pp. 321–22. My discussion of Stevens' *Ordinary/Extraordinary* series is a much revised and reduced version of that essay.

26. Stevens, "Theoretical Concepts of Feminist Art."

27. February 6, 1994, conversation with the artist.

28. Stevens, "Theoretical Concepts of Feminist Art."

29. Stevens knew she was moving into a new phase of the women artists' movement—the "second wave"—the period when women artists sought not just to celebrate women who had achieved a measure of self-esteem and recognition, but to critique the conditions, the ideologies, and the images that perpetuated sexism, racism, and class differences; letter from Stevens to author, dated November 29, 1993. See Gouma-Peterson, Thalia and Patricia Matthews, "The Feminist Critique of Art History," *Art Bulletin* 49 (September 1987), pp. 326–357.

30. Commemorative marches were held in both East and West Berlin; in East Berlin the marches were official, in West Berlin they were not.

31. Stevens, Transcript of Dialogue with Donald Kuspit, held at the Boston University Art Gallery, March 1984, p. 2.

32. Ibid.

33. Ibid.

34. Quoted in "A Conversation with May Stevens and Barbara Stern Shapiro," in *May Stevens: Images of Women Near and Far* (New York: Mary Ryan Gallery published on the occasion of the Museum of Fine Arts, Boston, exhibition, 1999), p. 12.

35. Conversation with the artist, February 11, 2005.

36. Joan Braderman, video still from *No More Nice Girls,* 1989. 44-min. video.

37. Moira Roth, "Stevens: Women, Words and Water," in *May Stevens: Sea of Words,* exhibition catalog. (Boulder: CU Art Galleries, 1993), np.

38. Roth, "May Stevens: Women, Words and Water," np.

39. See "May Stevens: In Conversation," p. 11.

40. Telephone conversation with the artist, September 21, 2004.

41. Ibid.

42. Quoted from www2.prestel.co.uk/rey/jew.htm

43. Quoted in Roth, "May Stevens: Women, Words and Water," np.

44. I want to correct my essay, "May Stevens: Painting History as Lived Feminist Experience," p. 330, in which I stated that the words came from Angela Carter's *The Sadeian Woman,* a feminist analysis of the Marquis de Sade's pornographic novels. That is not correct. Stevens denies that Carter was a source or had any influence on her.

45. See note 3.

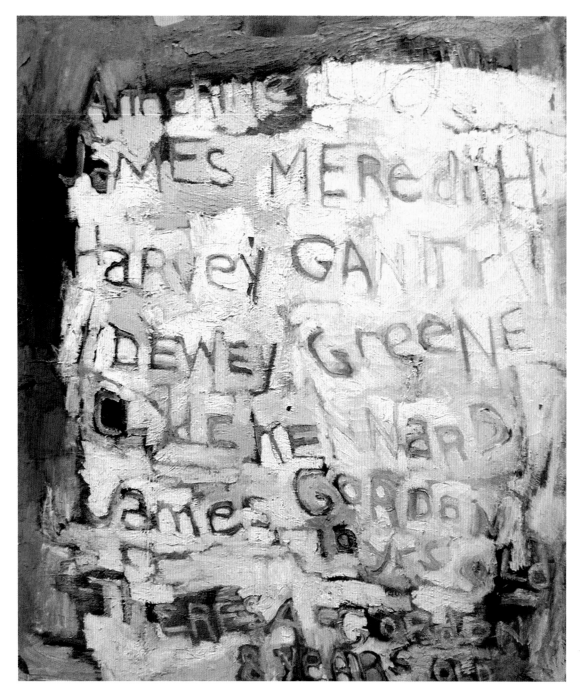

Plate 1. *Honor Roll*, 1963.
Oil on canvas, 42 1/2 x 36 in.
Courtesy Mary Ryan Gallery, New York.

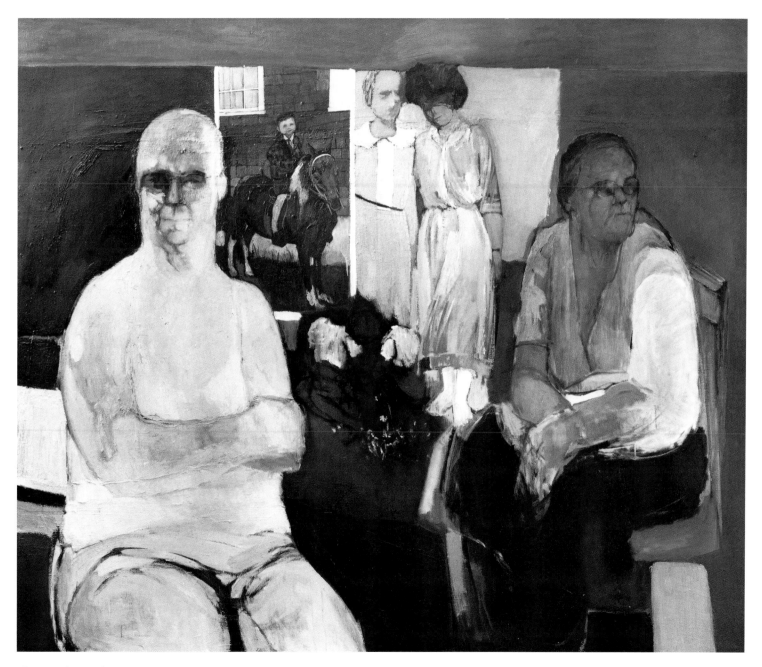

Plate 2. *The Family,* 1967.
Oil on canvas, 62 x 75 in.
Collection of Schenectady Museum, Schenectady, NY.

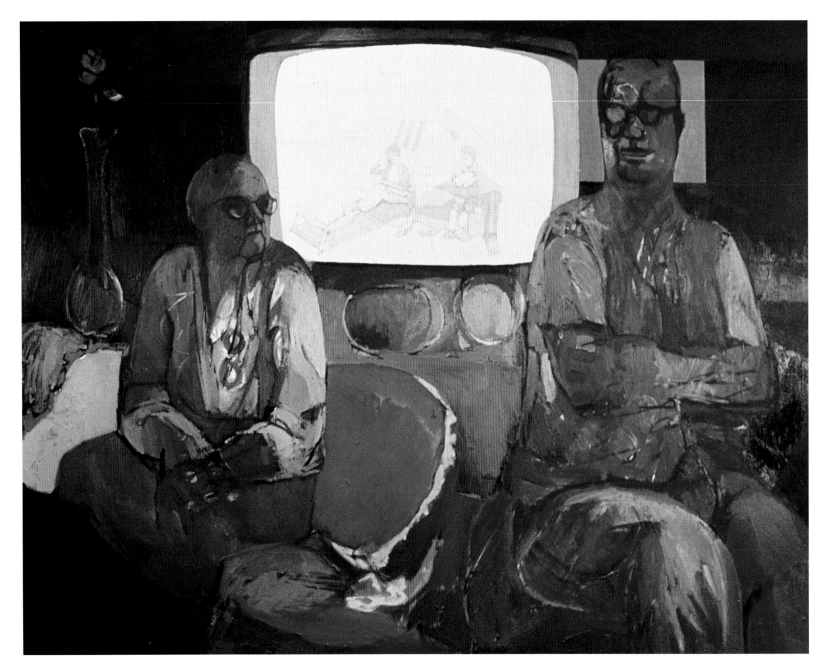

Plate 3. *The Living Room,* 1967.
Oil on canvas, 64 x 81 in.
Binghamton University Art Museum.

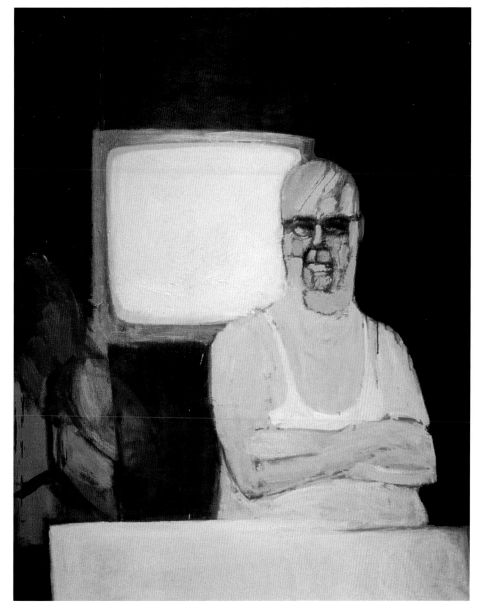

Plate 4. *Big Daddy,* 1967–1968.
Oil on canvas, 60 x 40 in.
Photograph courtesy Mary Ryan Gallery, New, York.

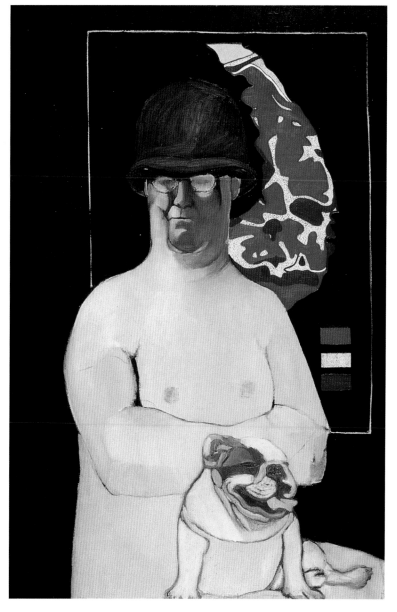

Plate 5. *Big Daddy in Vietnam,* 1968.
Oil on canvas, 60 x 40 in.
Courtesy Mary Ryan Gallery, New York.

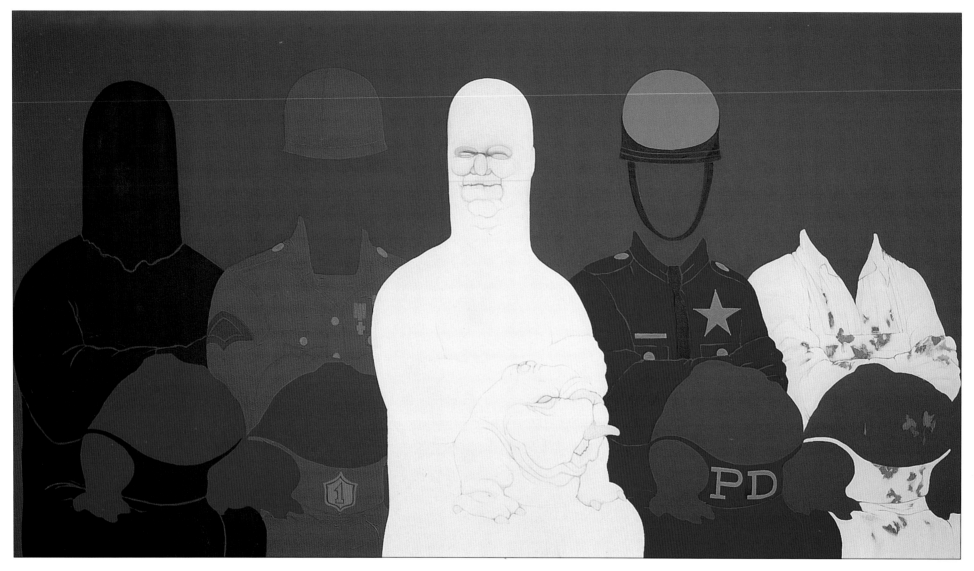

Plate 6. *Big Daddy Paper Doll*, 1970.
Acrylic on canvas, 78 x 168 in.
Brooklyn Museum, National Endowment for the Arts, and Bristol-Myers Fund, 72.122.

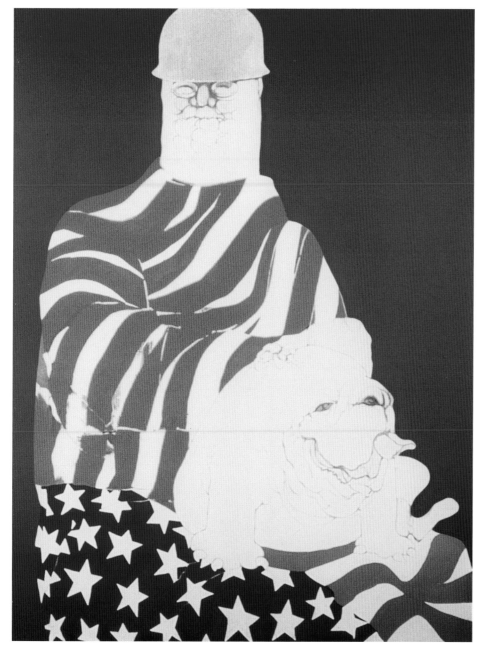

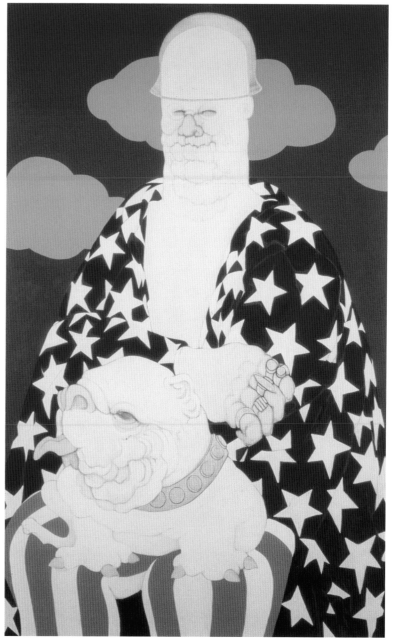

Plate 7. *Big Daddy Draped,* 1971.
Acrylic on canvas, 77 x 61³/₄ in.
Jersey City Museum, gift of the artist, 2001.

Plate 8. *Pax Americana,* 1973. Acrylic on canvas, 60 x 40 in.
Gift of the Charles Z. Offin Art Foundation, Inc.
Courtesy of the Herbert F. Johnson Museum, Cornell University,
Ithaca, New York.

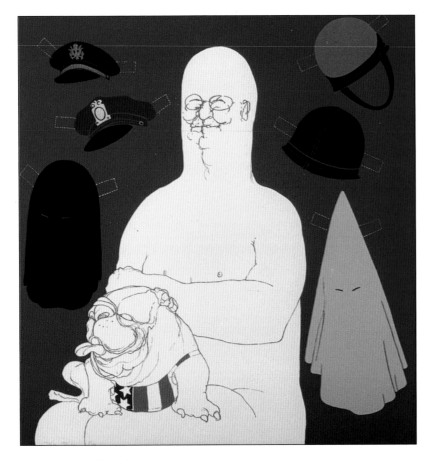

Plate 9. *Big Daddy with Hats,* 1971.
Color silkscreen, 23 x 24¹/₂ in., edition of 75.
Collection of Andrew Whitfield.

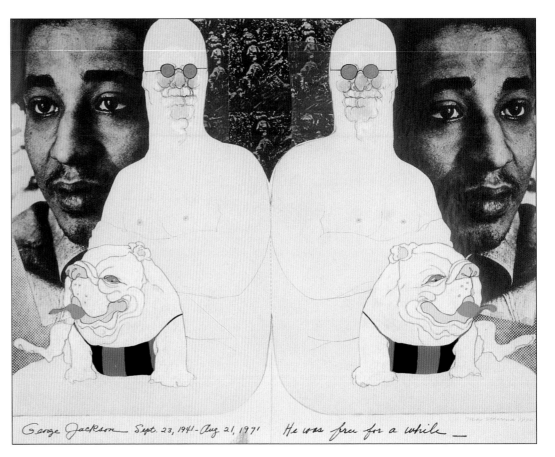

Plate 10. *Big Daddy and George Jackson,* 1972.
Collage on paper, 22 x 27³/₈ in.
Courtesy Mary Ryan Gallery, New York.

Plate 11. *There's Nobody Like Me,* 1972.
Ink and gouache on paper, 11 x 15 in.
Courtesy Mary Ryan Gallery, New York.

Plate 12. *Two Studies for "Bliss",* c. 1973.
Ink and gouache on paper, 8 x 9 3/4 in.
Courtesy of Mary Ryan Gallery, New York.

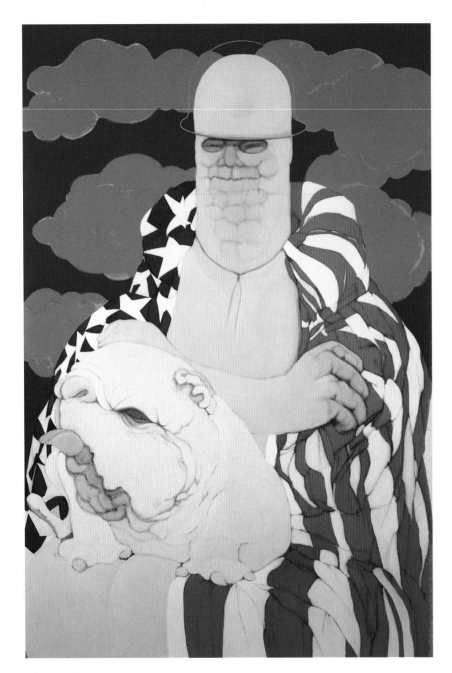

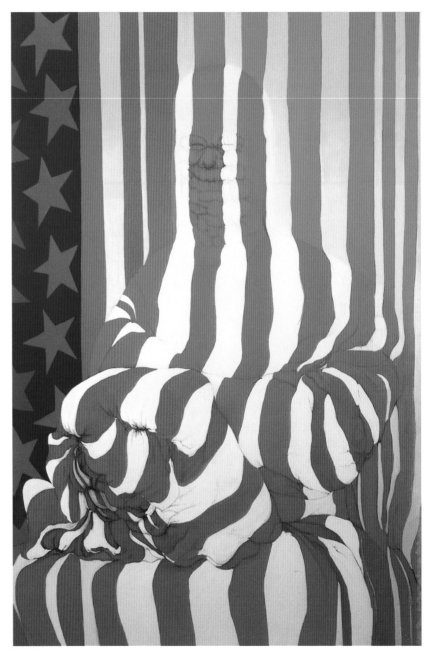

Plate 13. *Top Man,* 1975.
Acrylic on canvas, 60 x 40 in.
Courtesy Mary Ryan Gallery, New York.

Plate 14. *Striped Man,* 1976.
Acrylic on canvas, 60 x 40 in.
Courtesy Mary Ryan Gallery, New York.

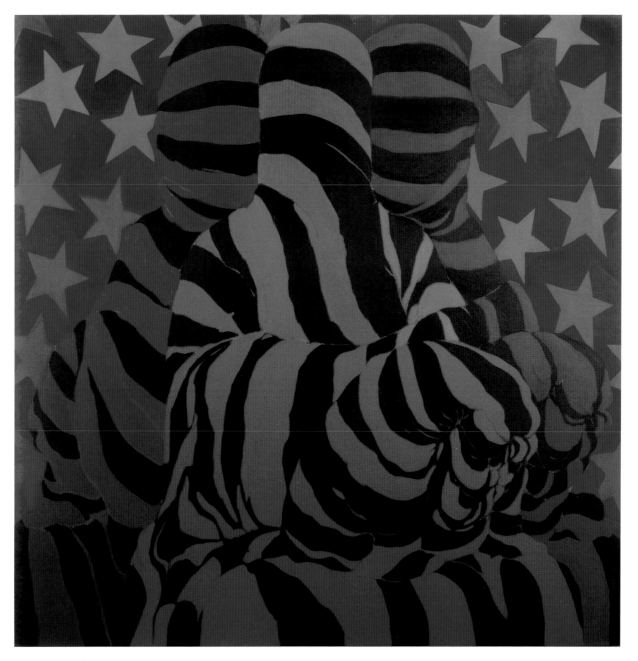

Plate 15. *Dark Flag,* 1976.
Acrylic on canvas, 60 x 60 in.
Whitney Museum of American Art, New York

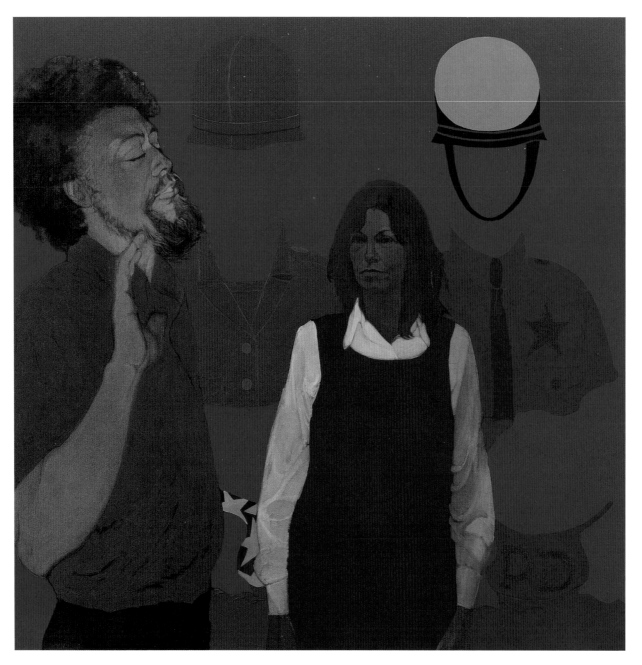

Plate 16. *Benny Andrews and May Stevens in Front of Big Daddy Paper Doll,* 1967.
Acrylic on canvas, 60 x 60 in.
National Academy Museum, New York; gift of the artist.

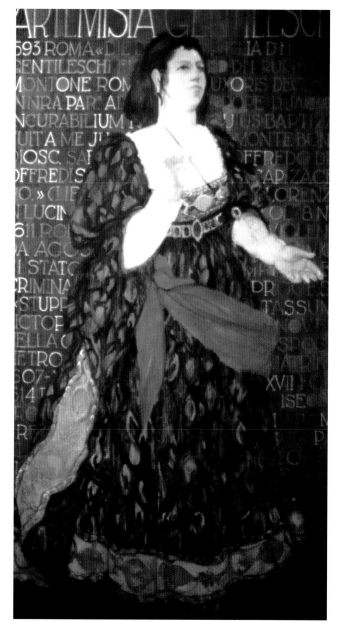

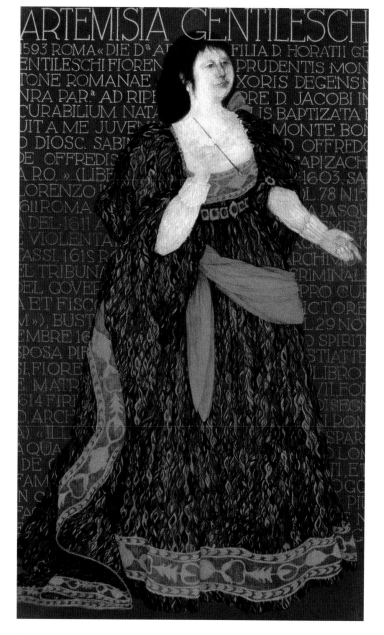

Plate 17. *Artemisia Gentileschi,* 1974.
Acrylic on canvas, 72 x 38 in.
On loan to National Museum of Women in the Arts, courtesy
Mary Ryan Gallery, New York.

Plate 18. *Artemisia,* 1979.
Lithograph, 39 x 23 in., edition of 50.
Private collection.

Plate 19. *Lawrence Alloway as Baudelaire,* 1974.
Pencil on paper, 10³/₄ x 14 in.
Courtesy Mary Ryan Gallery, New York.

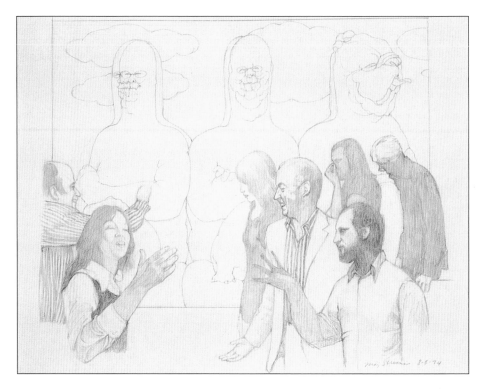

Plate 20. *Study for Artist's Studio,* 1974.
Graphite on paper, 10³/₄ x 14 in.
Courtesy Mary Ryan Gallery, New York.

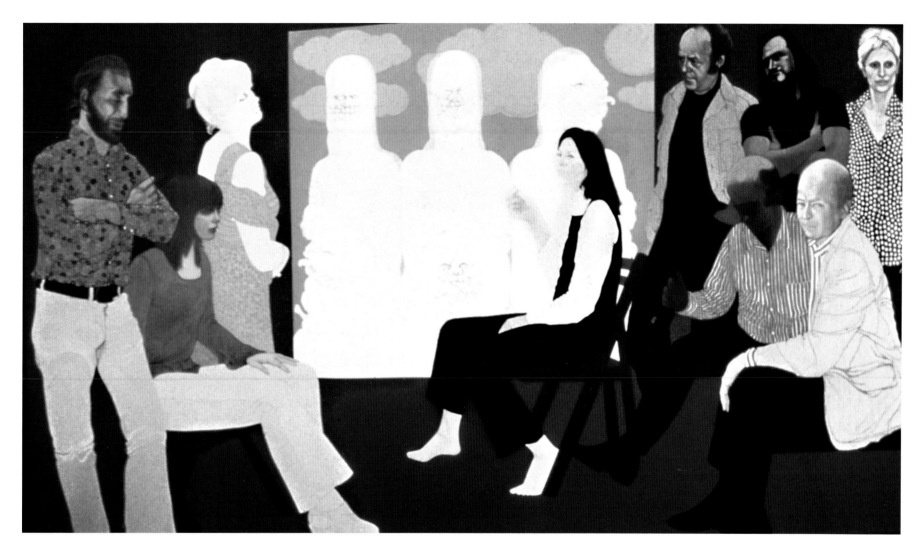

Plate 21. *The Artist's Studio (After Courbet)*, 1974.
Acrylic on canvas, 78 x 144 in.
University of Missouri/St. Louis; gift of Lois and Robert Orchard.

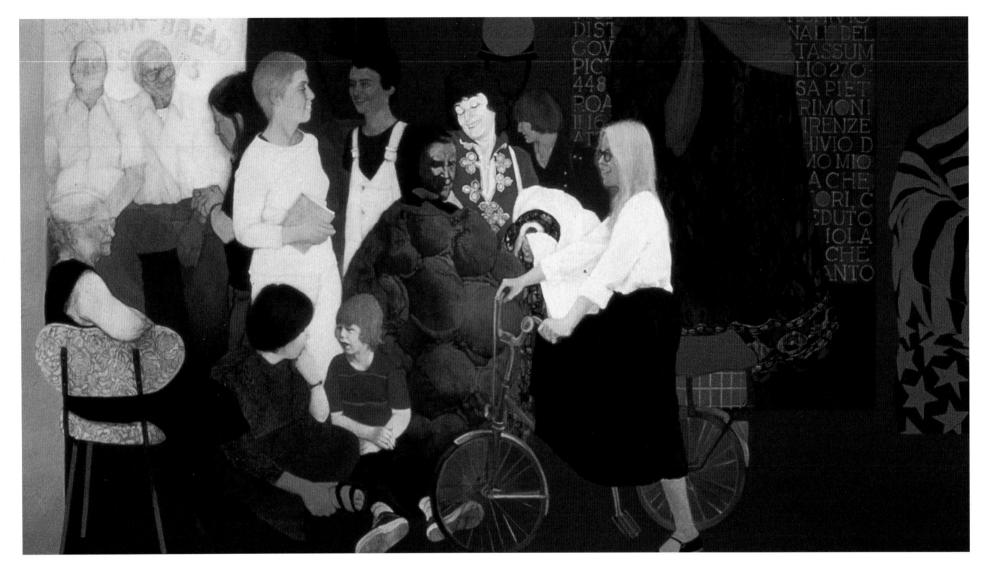

Plate 22. *Soho Women Artists,* 1977–1978.
Acrylic on canvas, 78 x 144 in.
National Museum of Women in the Arts, Washington, DC.

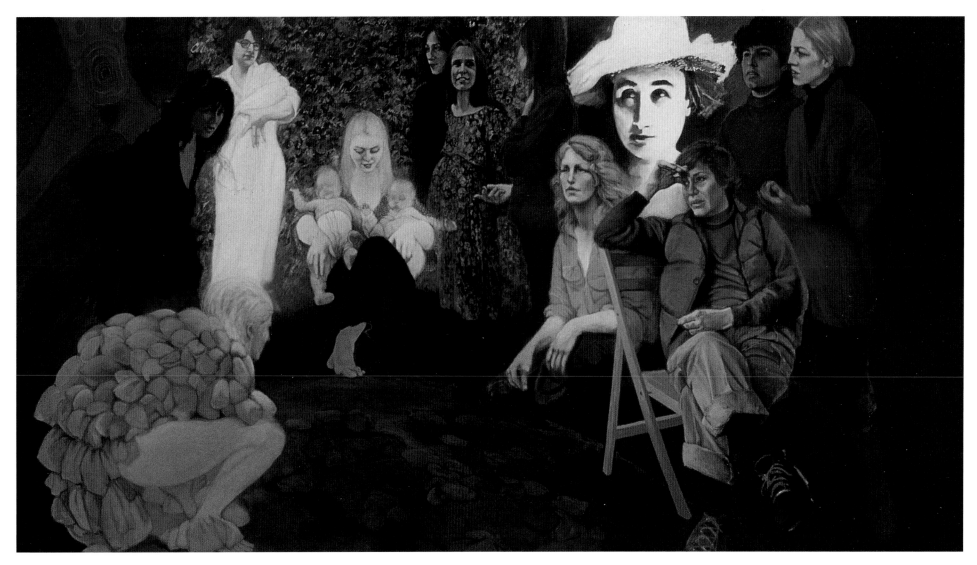

Plate 23. *Mysteries and Politics,* 1978.
Acrylic on canvas, 78 x 144 in.
San Francisco Museum of Modern Art, gift of Mr. and Mrs. Anthony Grippa.

Plate 24. *The Dream of a Common Language,* 1981.
Acrylic on canvas, 22 x 28 in.
Courtesy Mary Ryan Gallery, New York.

Plate 25. *Solidarity,* 1981.
Acrylic and collage on paper, 17$^{1}/_{2}$ x 22$^{1}/_{4}$.
Courtesy Mary Ryan Gallery, New York.

Plate 26. *Cortage, Berlin, January 1919*, 1982/2001.
Iridescent acrylic on paper, 22 x 30 in.
Courtesy Mary Ryan Gallery, New York.

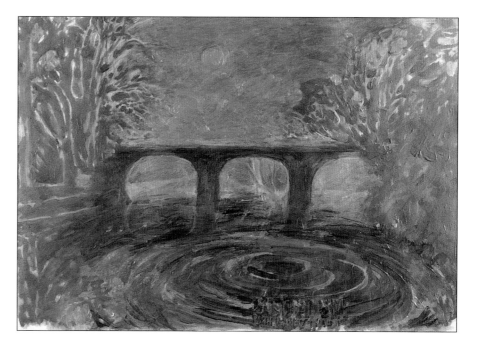

Plate 27. *The Canal*, 1982/2001.
Iridescent acrylic on paper, 22 x 30 in.
Courtesy Mary Ryan Gallery, New York.

Plate 28. *Rosa and Leo,* 1982/2001.
Iridescent acrylic on paper, 22 x 30 in.
Courtesy Mary Ryan Gallery, New York.

Plate 29. *Rosa and Louise Kautsky,* 1982/2001.
Iridescent acrylic on paper, 30^{7}/$_{8}$ x 22^{1}/$_{2}$ in.
Courtesy Mary Ryan Gallery, New York.

Plate 30. *Demonstration,* 1982.
Acrylic on canvas, 78 x 120 in.
Collection of Donald Kuspit.

Plate 31. *Voices,* 1983.
Acrylic on canvas, 72 x 120 in.
Courtesy Mary Ryan Gallery, New York.

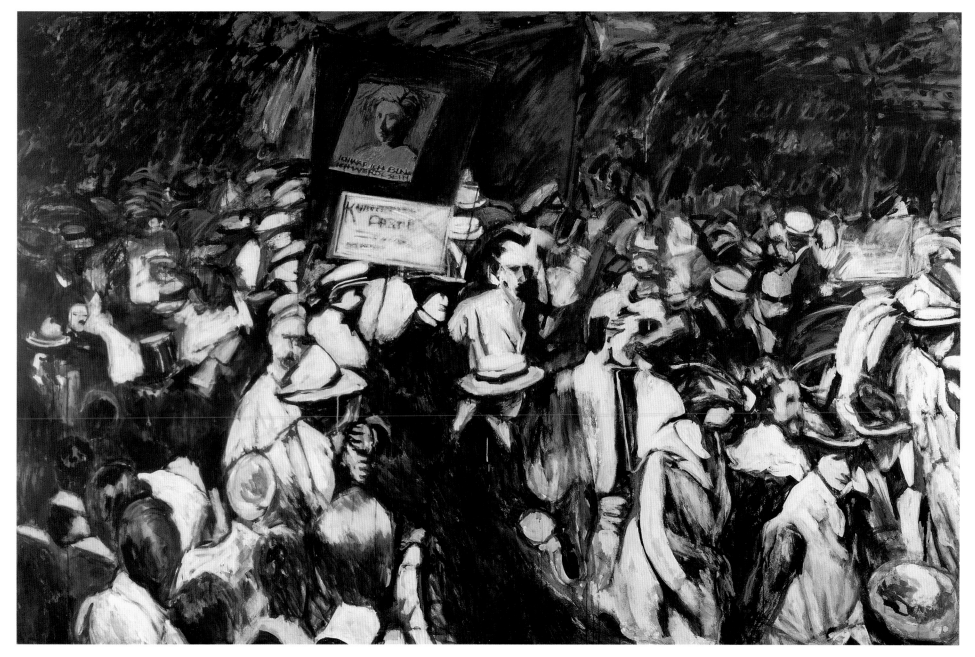

Plate 32. *Procession,* 1983.
Acrylic on canvas, 78 x 120 in.
The Metropolitan Museum of Art, New York; gift of May Stevens and Patricia Hills.

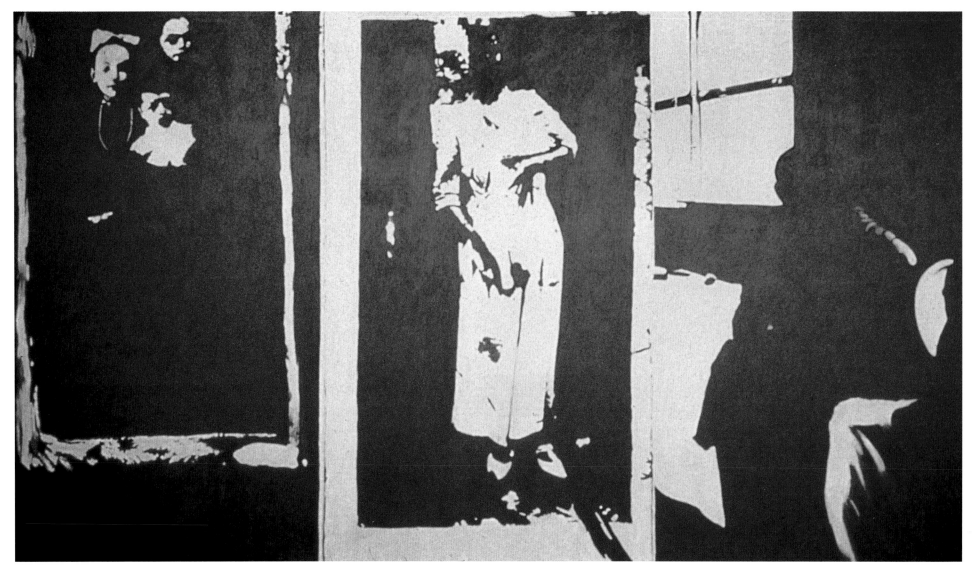

Plate 33. *Everybody Knows Me,* 1981.
Acrylic on canvas, 78 x 142 in.
Private collection.

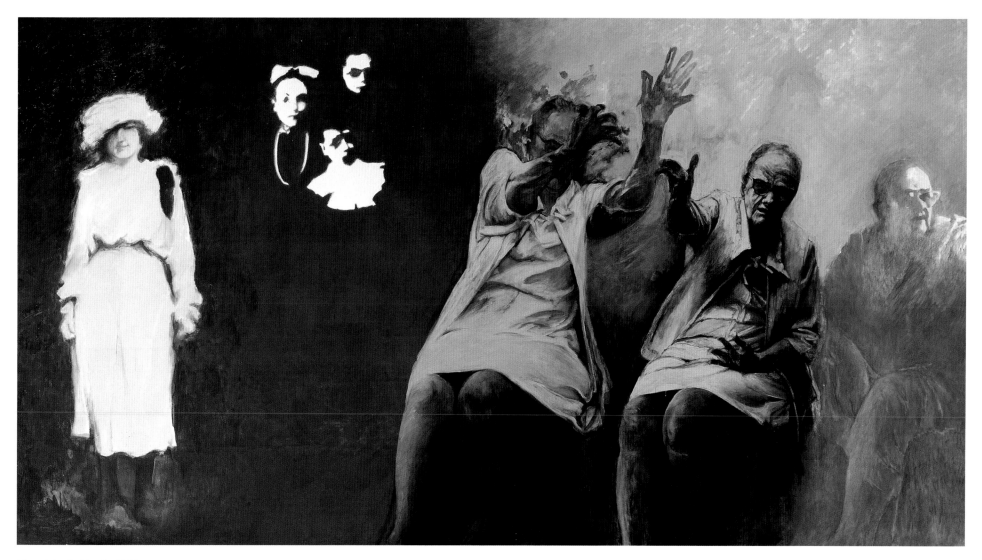

Plate 34. *Go Gentle,* 1983.
Acrylic on canvas, 78 x 142 in.
Museum of Fine Arts, Boston; gift of Carl Andre, 1991.580.
Photograph © 2005 Museum of Fine Arts, Boston.

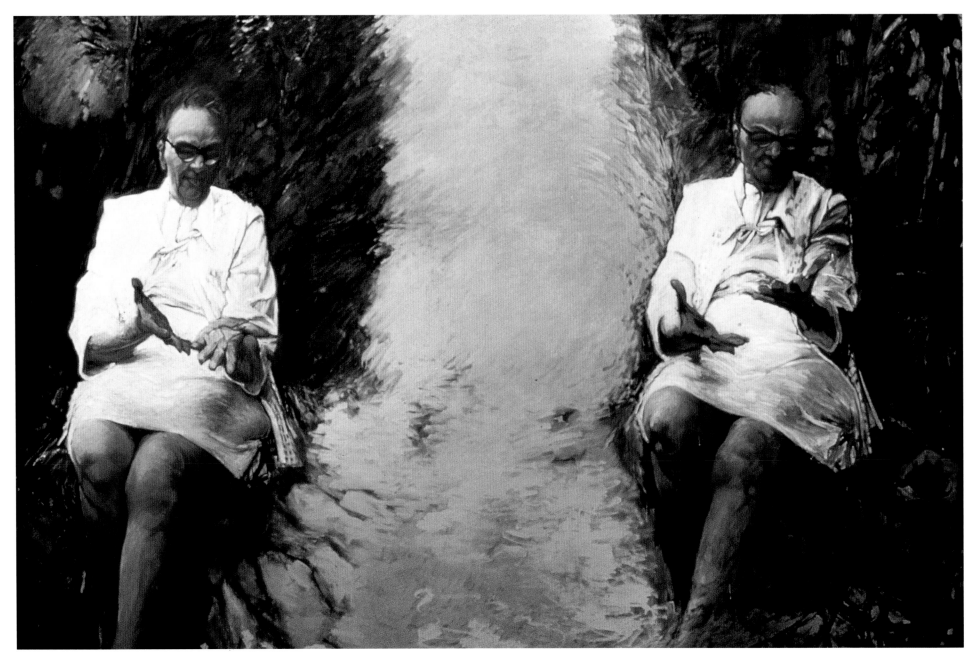

Plate 35. *Fore River,* 1983.
Acrylic on canvas, 78 x 120 in.
Courtesy Mary Ryan Gallery, New York.

Plate 36. *A Life,* 1984.
Acrylic on canvas, 78 x 120 in.
Courtesy Mary Ryan Gallery, New York.

Plate 37. *Forming the Fifth International,* 1985.
Acrylic on canvas, 78 x 120 in.
Collection of the artist.

Plate 38. *Death Squad,* 1986.
Acrylic on canvas, 55 x 80 in.
Courtesy Mary Ryan Gallery, New York.

Plate 39. *Rosa Luxemburg Attends the Second International*, 1987.
Acrylic on canvas, 78 x 120 in.
Courtesy Mary Ryan Gallery, New York.

Plate 40. *The Canal,* 1988.
Acrylic on canvas, 78 x 119 in.
Courtesy Mary Ryan Gallery, New York.

Plate 41. *Green Field,* 1988–1990.
Acrylic on unstretched canvas, 84 x 144 in.
Courtesy Mary Ryan Gallery, New York.

Plate 42. *Alice in the Garden,* 1988–1989.
Acrylic on unstretched canvas, 84 x 290 in overall. Panel B.
Courtesy Mary Ryan Gallery, New York.

Plate 43. *Alice in the Garden,* 1988–1989.
Acrylic on unstretched canvas, 84 x 290 in overall. Panel C.
Courtesy Mary Ryan Gallery, New York.

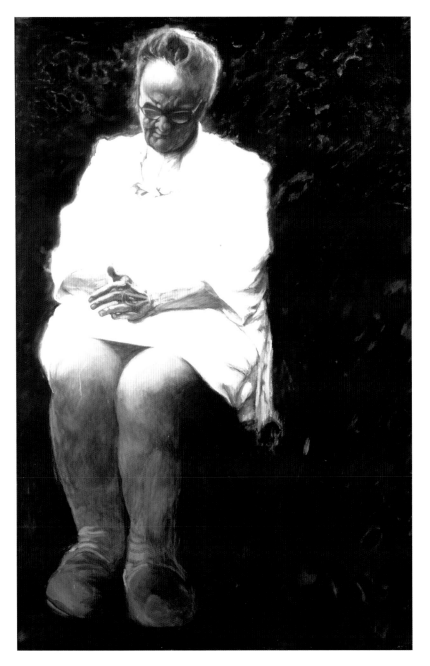

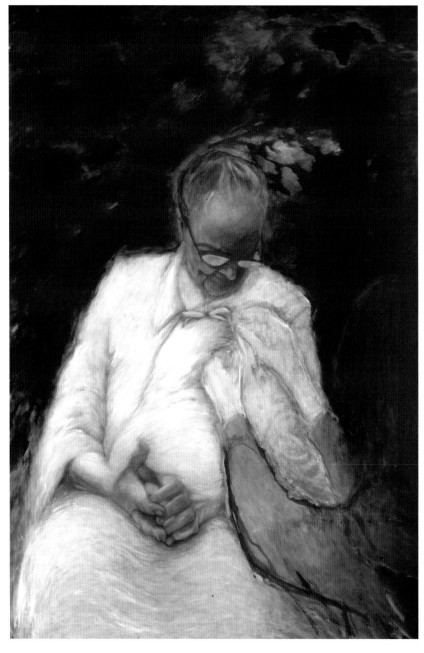

Plate 44. *Alice in the Garden,* 1988–1989.
Acrylic on unstretched canvas, 84 x 290 in overall. Panel D.
Courtesy Mary Ryan Gallery, New York.

Plate 45. *Alice in the Garden,* 1988–1989.
Acrylic on unstretched canvas, 84 x 290 in overall. Panel E.
Courtesy Mary Ryan Gallery, New York.

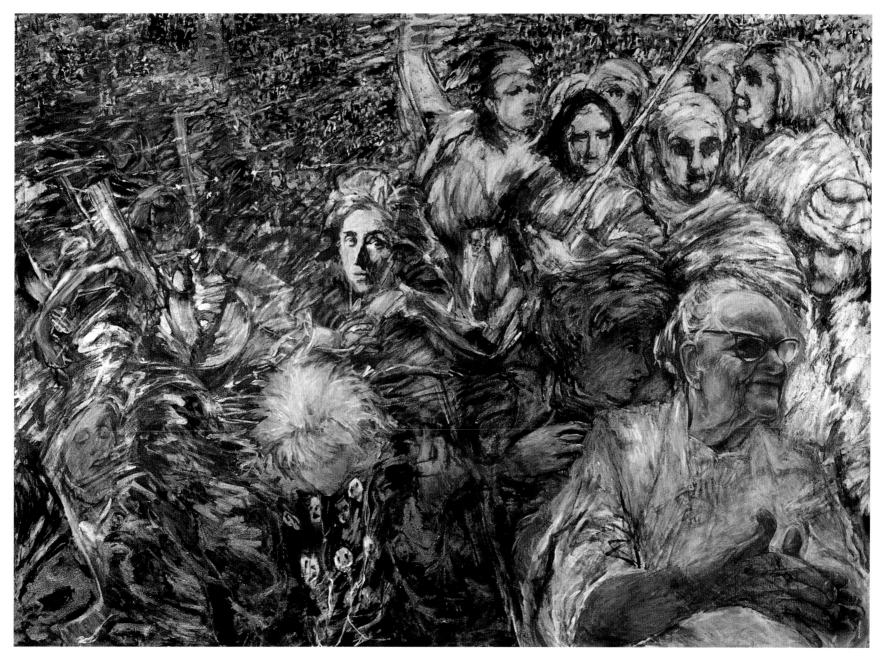

Plate 46. *Alice Goes to the Movies,* 1990.
Acrylic on unstretched canvas, 84 x 120 in.
Courtesy Mary Ryan Gallery, New York.

Plate 47. *But That Was in Another Country,* 1990.
Acrylic on unstretched canvas, 84 x 135 in.
Courtesy Mary Ryan Gallery, New York.

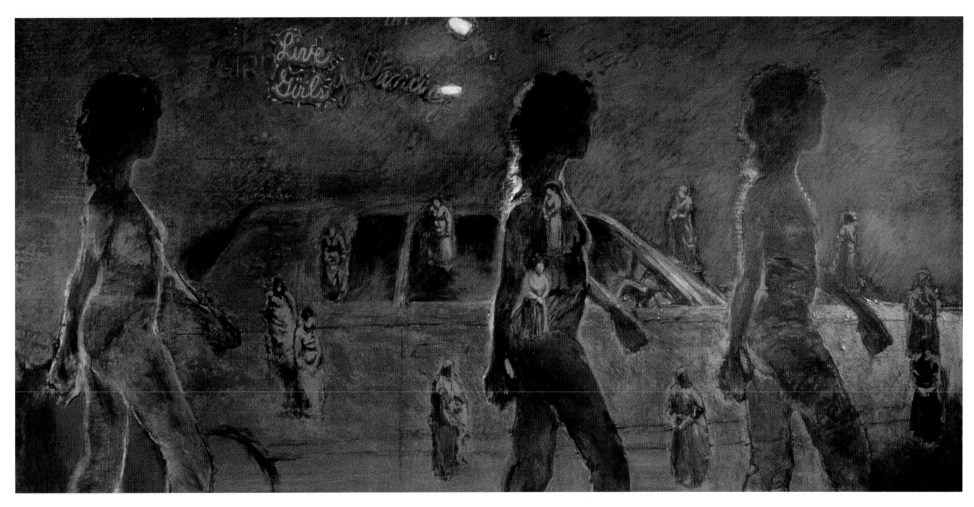

Plate 48. *Women's History: Live Girls,* 1992.
Acrylic on canvas, 72 x 134 in, with audio component.
Courtesy Mary Ryan Gallery, New York.

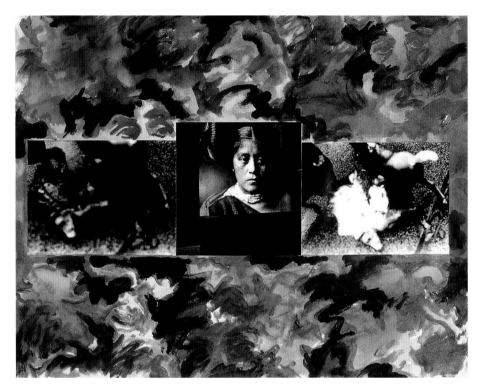

Plate 49. *Crossing Series: The Hopi Woman with Fallen Horses,* 1990.
Acrylic and collage, 19 ³/₄ x 25 ³/₄ in.
Courtesy Mary Ryan Gallery, New York.

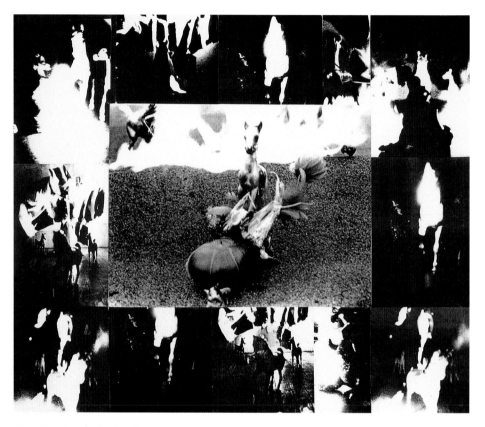

Plate 50. *Crossing Series: Ceremony,* 1990.
Acrylic and collage on paper, 19 x 23 in.
Courtesy Mary Ryan Gallery, New York.

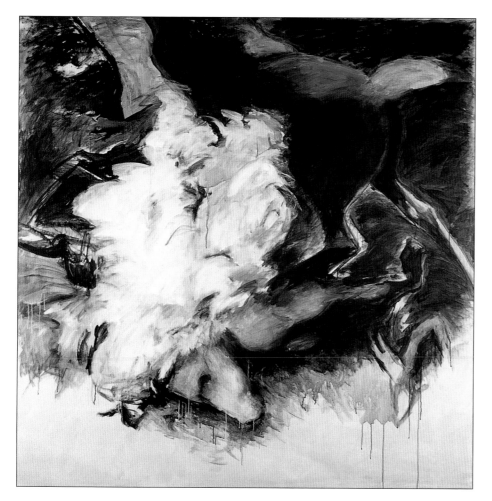

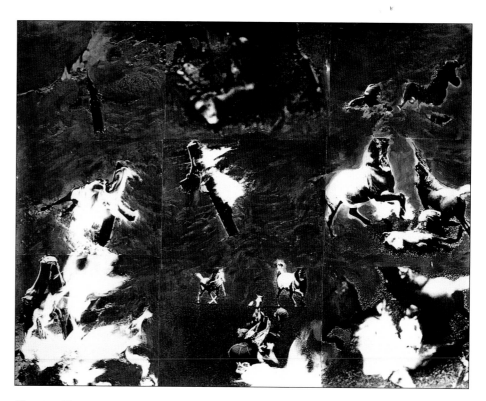

Plate 52. *Horses on Fire,* 1990.
Acrylic and collage, 21³/₄ x 27 ¹/₄ in.
Collection of Civia Rosenberg.

Plate 51. *Quemada II,* 1991.
Acrylic on canvas, 72 x 72 in.
DeCordova Museum and Sculpture Park, Lincoln, Massachusetts.

Plate 53. Untitled from *Tic-Tac-Toe* series, 1996.
Mixed media, 8 x 5 in.
Courtesy Mary Ryan Gallery, New York.

Plate 54. Untitled from *Tic-Tac-Toe* series, 1996.
Mixed media, 8 x 5 in.
Courtesy Mary Ryan Gallery, New York.

Plate 55. Untitled from *Tic-Tac-Toe* series, 1996.
Mixed media, 8 x 5 in.
Courtesy Mary Ryan Gallery, New York.

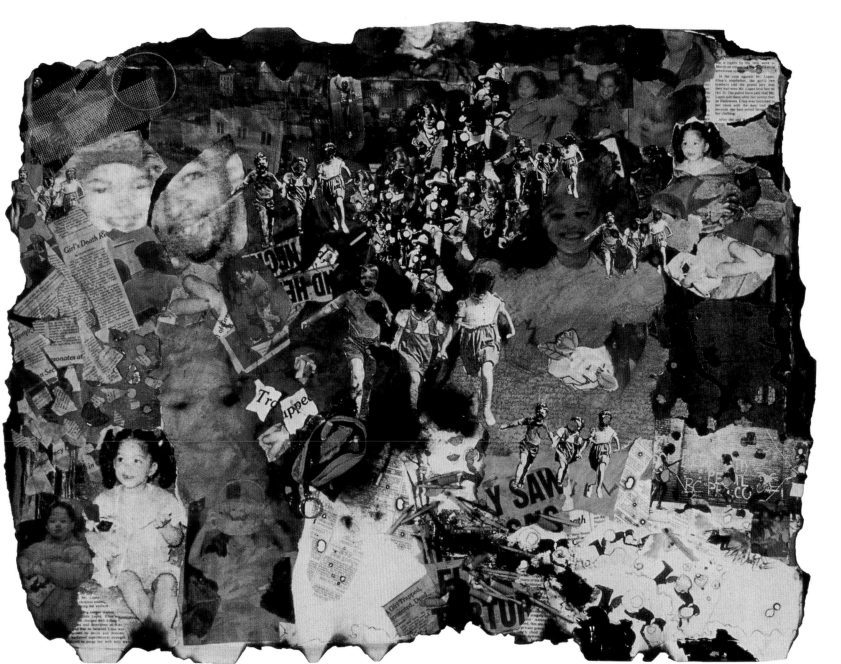

Plate 56. *All-y All-y in Free,* 1996.
Mixed media with hair and tobacco, 30 x 40 in.
Courtesy Mary Ryan Gallery, New York.

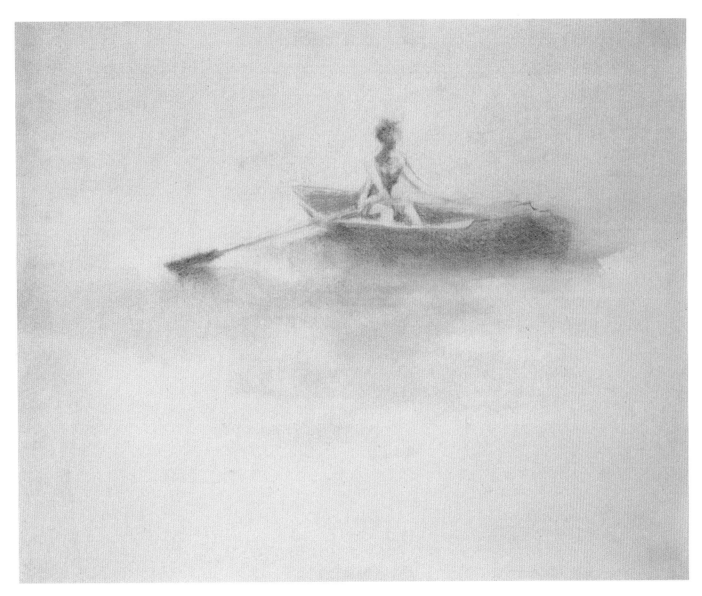

Plate 57. *Woman in a Rowboat, No. 4*, 1989.
Acrylic on paper, 14 x 17 in.
Collection of Jane Cooper.

Plate 58. Still image from the video *No More Nice Girls*, 1989, 44 min., by Joan Braderman.

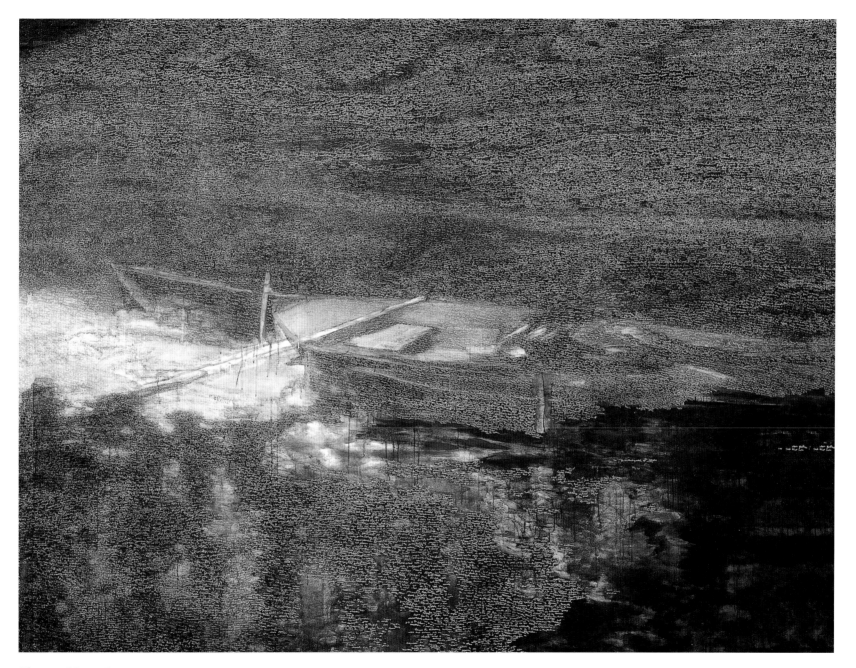

Plate 59. *Missing Persons,* 1990–1993.
Acrylic on unstretched canvas, 80 x 104 in.
Collection of Gwenda Joy Joyce.

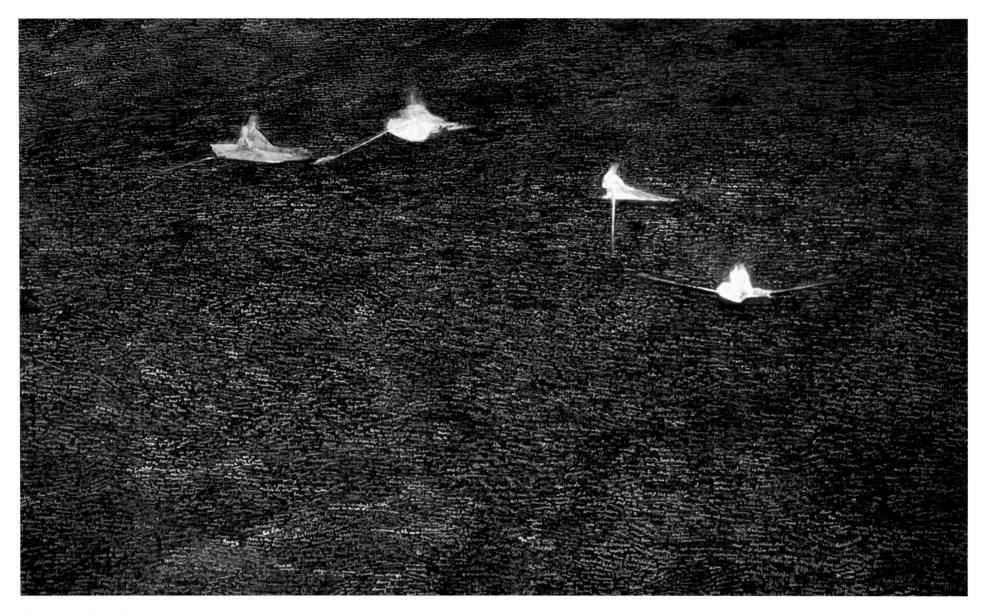

Plate 60. *Sea of Words,* 1990–1991.
Acrylic on unstretched canvas, 84 x 132 in, with audio component.
Collection of McCormick Place Convention Center Art Collection, Chicago.

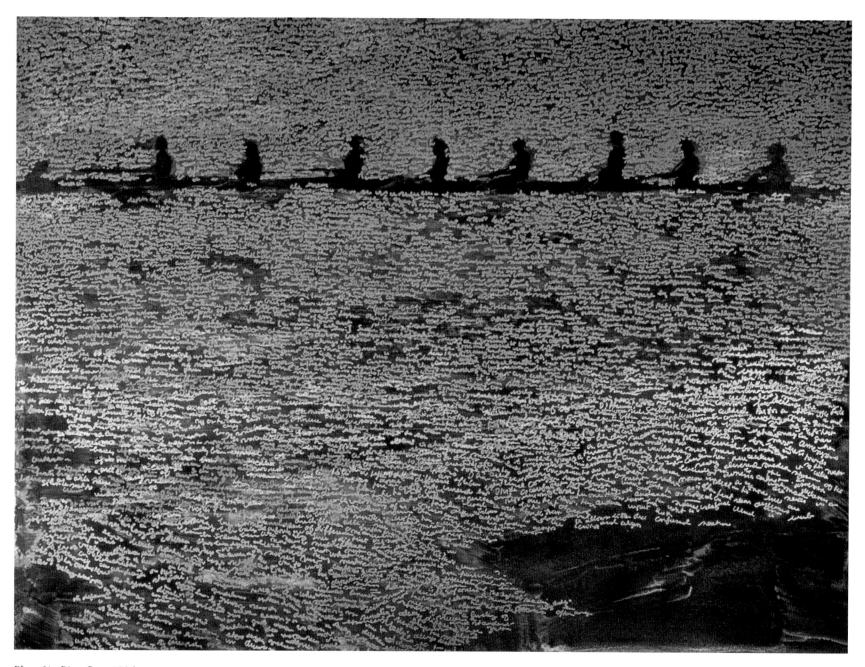

Plate 61. *River Run,* 1994.
Color lithograph, 22 x 30 in., edition of 20.
Collection Library of Congress.

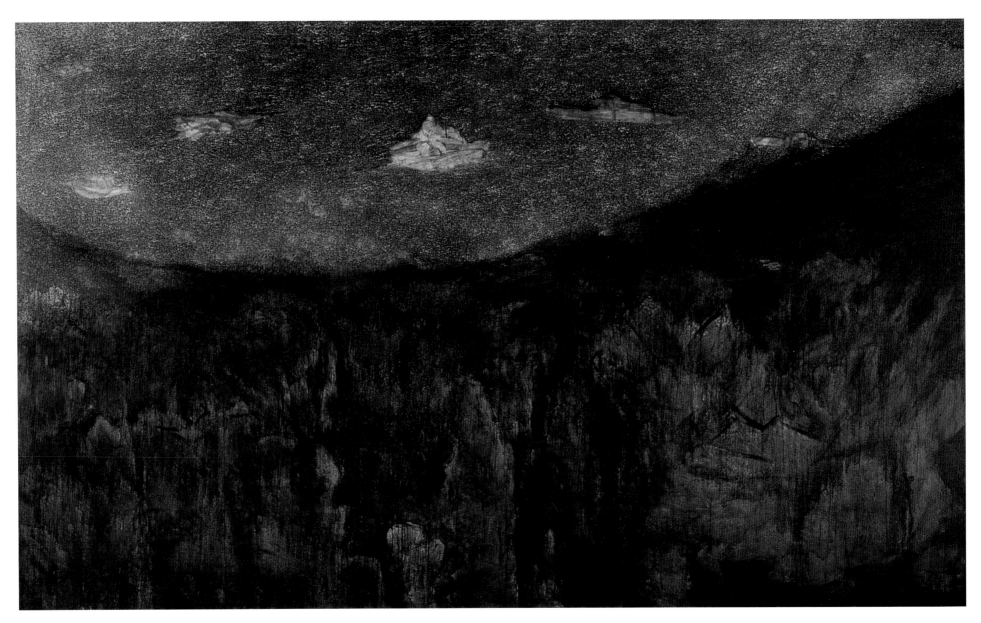

Plate 62. *Her Boats,* 1996–1997.
Acrylic and gold ink on unstretched canvas, 84 x 142 in.
Courtesy Mary Ryan Gallery, New York.

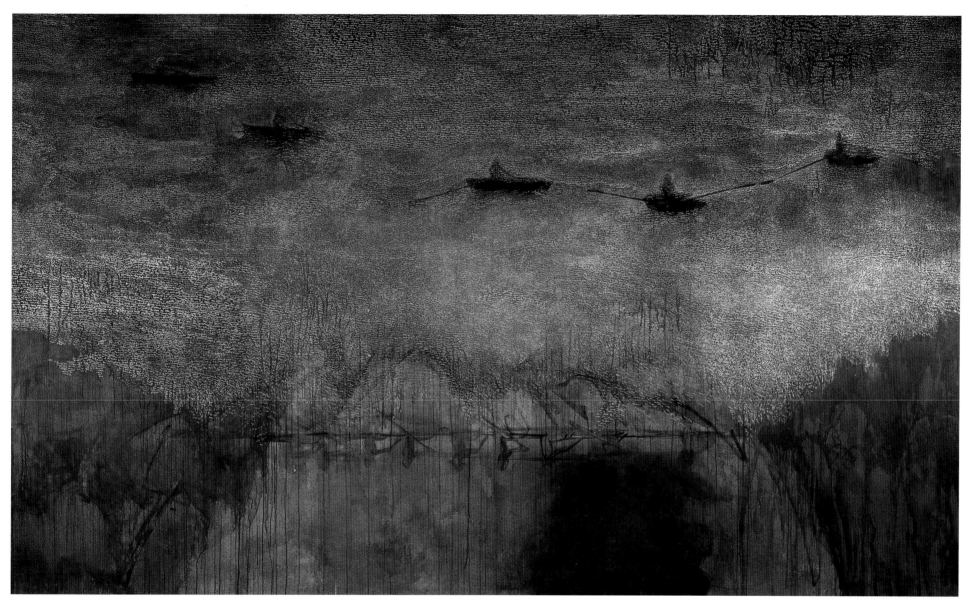

Plate 63. *Fear and Desire,* 1996–1997.
Acrylic and gold ink on unstretched canvas, 84 x 142 in.
Private collection, promised to the Museum of Fine Arts, Boston, in honor of Barbara Stern Shapiro.

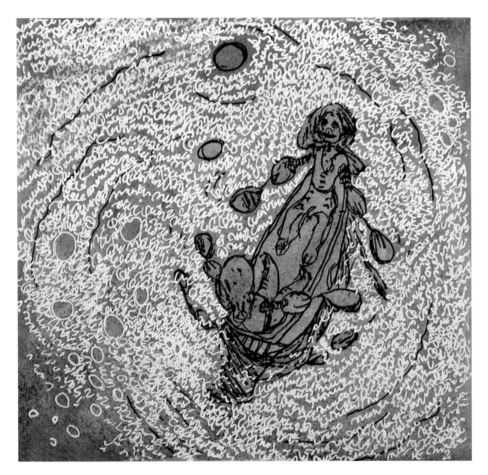

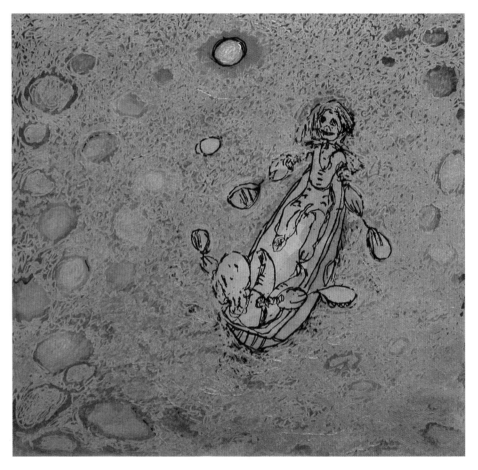

Plate 64. *By the Light of the Silvery Moon,* 1997.
Etching with hand coloring, 22 1/2 x 15 in.
The Metropolitan Museum of Art, New York, Stewart S. MacDermott Fund, 2000.

Plate 65. *By the Light of the Silvery Moon,* 1997.
Etching with hand coloring, 22 1/2 x 15 in.
Private collection.

Plate 66. *Waiting III,* 1998.
Mixed media over lithograph, 17 x 22 in.
Courtesy Mary Ryan Gallery, New York.

Plate 67. *Indigo,* 1999.
Lithograph, 20 x 30 in., edition of 18.
Courtesy Mary Ryan Gallery, New York.

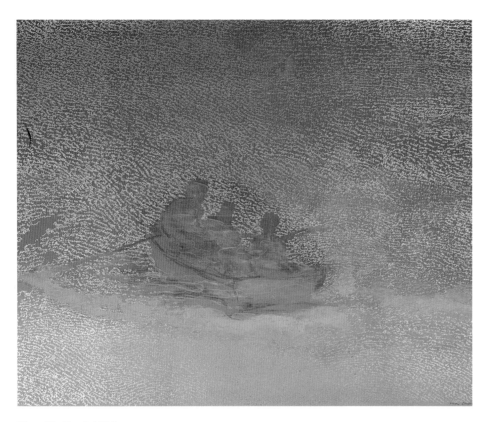

Plate 68. *Pearl,* 1999.
Mixed media, 22 x 30 in.
Private collection.

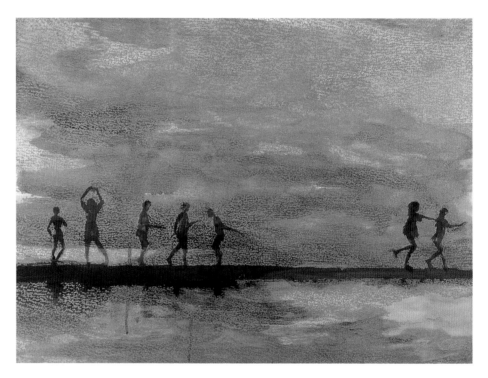

Plate 69. *Untitled (Grey and Gold),* 1999.
Mixed media, 22 x 30 in.
Private collection.

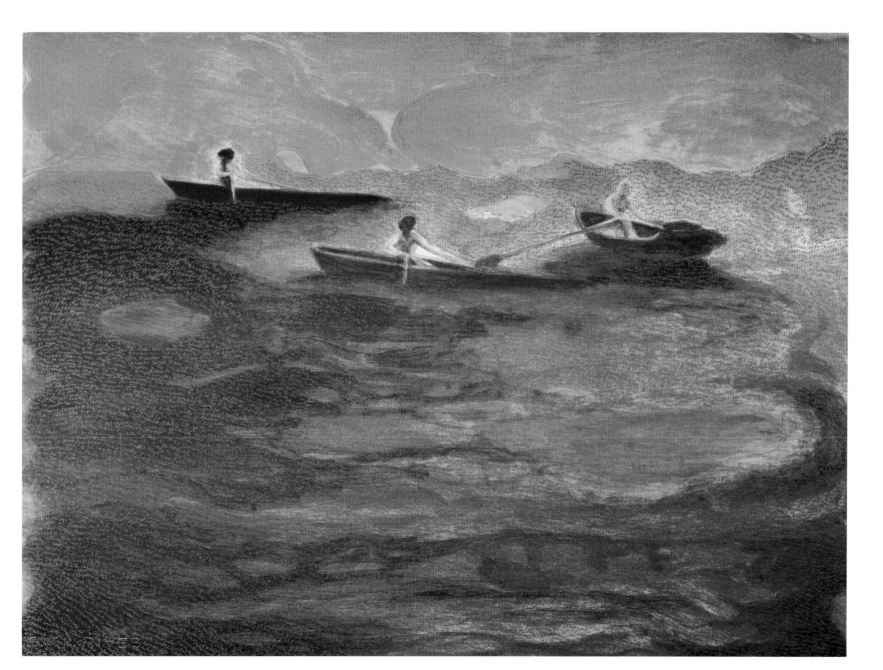

Plate 70. *Three Boats on a Green, Green Sea,* 1999.
Lithograph, 22 x 30 in., edition of 26.
Courtesy Mary Ryan Gallery, New York.

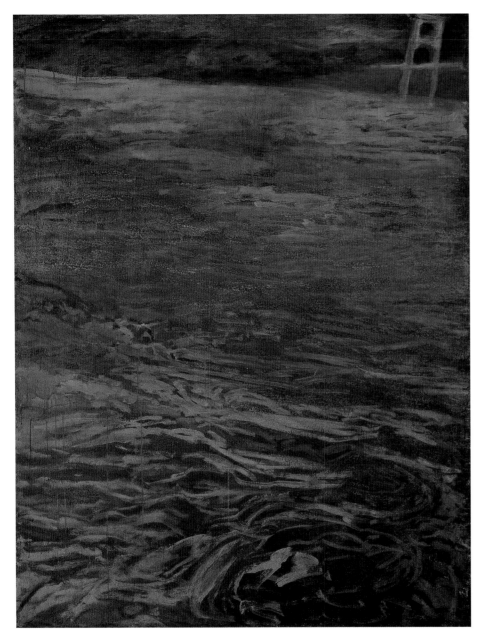

Plate 71. *Hudson I (Night Swim),* 2000.
Acrylic on unstretched canvas, 76 x 58 in.
Courtesy Mary Ryan Gallery, New York.

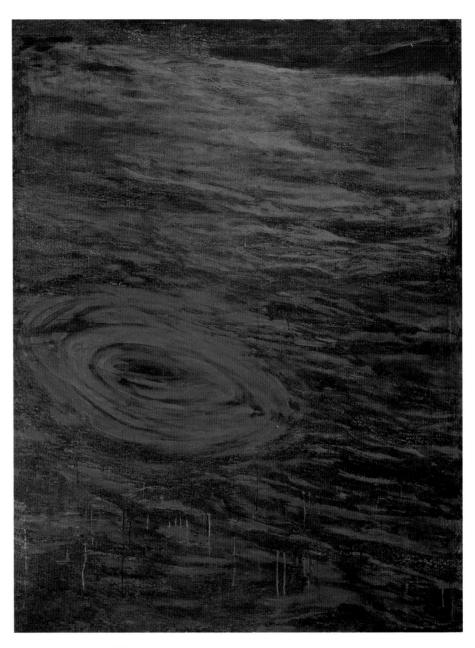

Plate 72. *Hudson II (Eddy),* 1998–2000.
Acrylic on unstretched canvas, 76 x 58 in.
Courtesy Mary Ryan Gallery, New York.

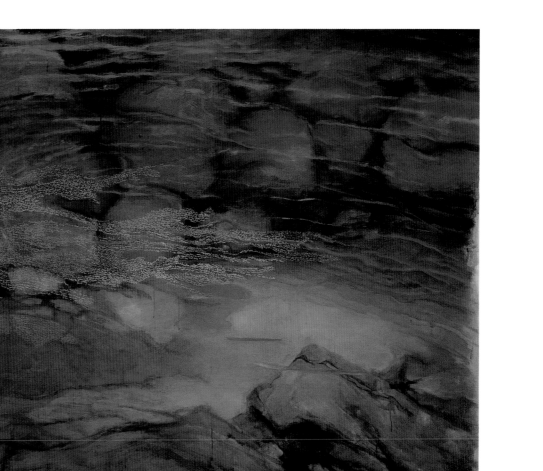

Plate 73. *Connemara (Rock Pool, Ireland),* 1999–2001.
Acrylic on unstretched canvas, 82 x 90 in.
Joslyn Art Museum, Omaha, purchased with funds given in memory
of Linda Albin by her husband, Art, her children, and her friends.

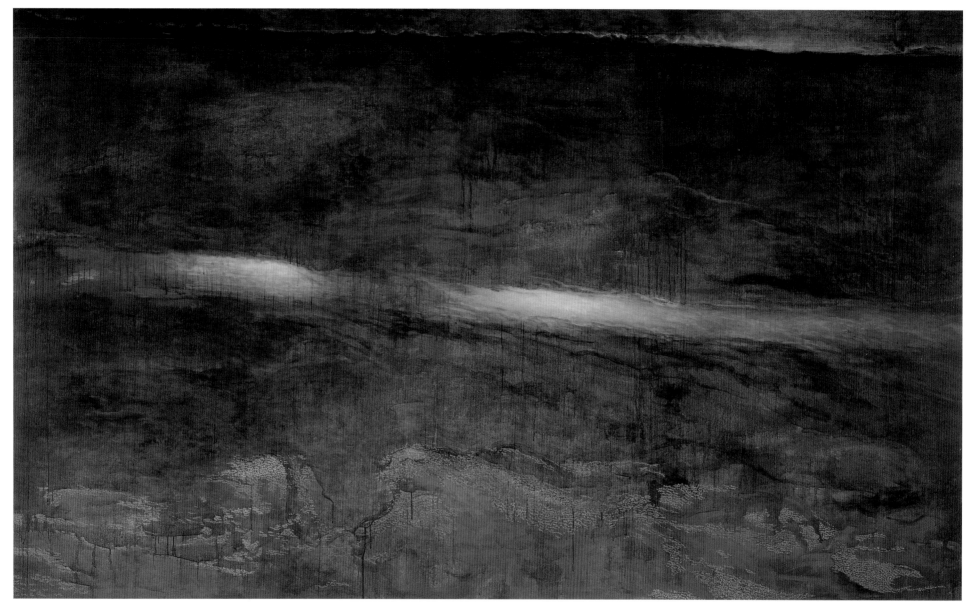

Plate 74. *Galisteo (Creek, New Mexico)*, 2001.
Acrylic on unstretched canvas, 84 x 144.
Courtesy Mary Ryan Gallery, New York

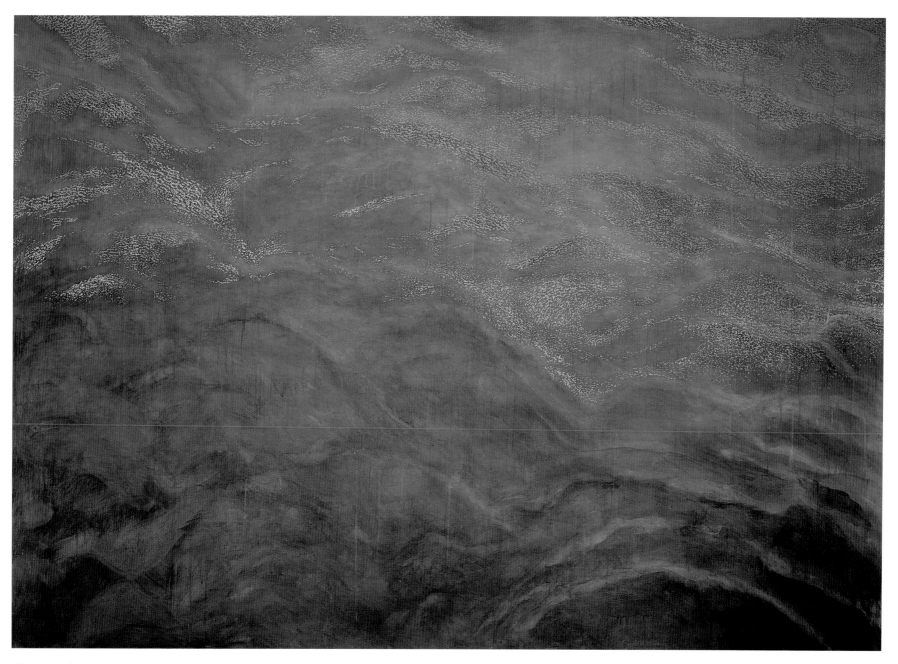

Plate 75. *Atlantic*, 2001.
Acrylic on unstretched canvas, 58 x 83 in.
Collection of Stroock & Stroock & Lavan, New York.

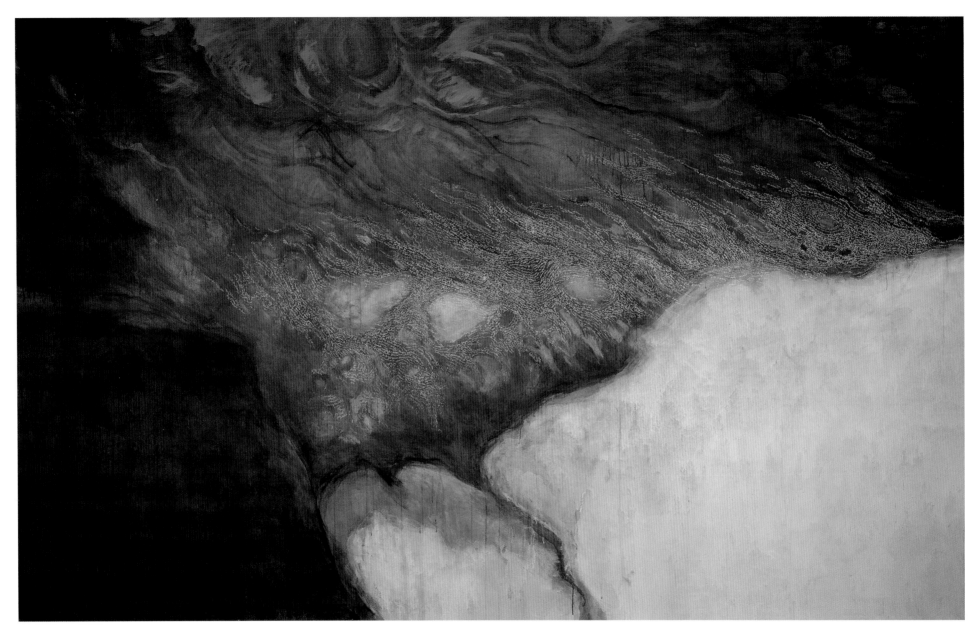

Plate 76. *Confluence of Two Rivers,* 2002–2003.
Acrylic on unstretched canvas, 80 x 130 in.
Courtesy Mary Ryan Gallery, New York.

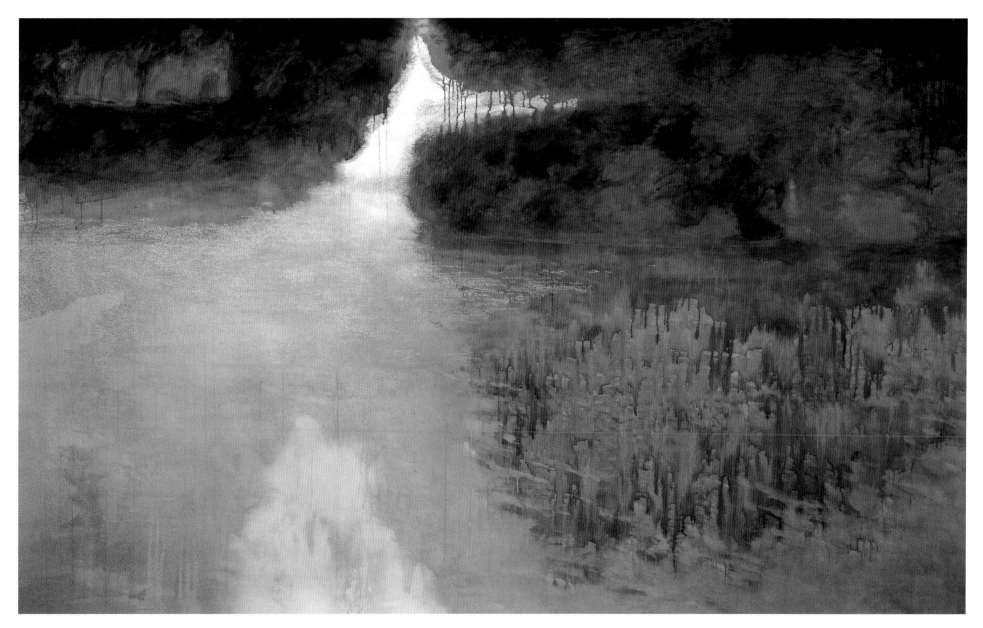

Plate 77. *Oxbow, Napa River,* 2002.
Acrylic on unstretched canvas, 72 x 118.
Courtesy Mary Ryan Gallery, New York.

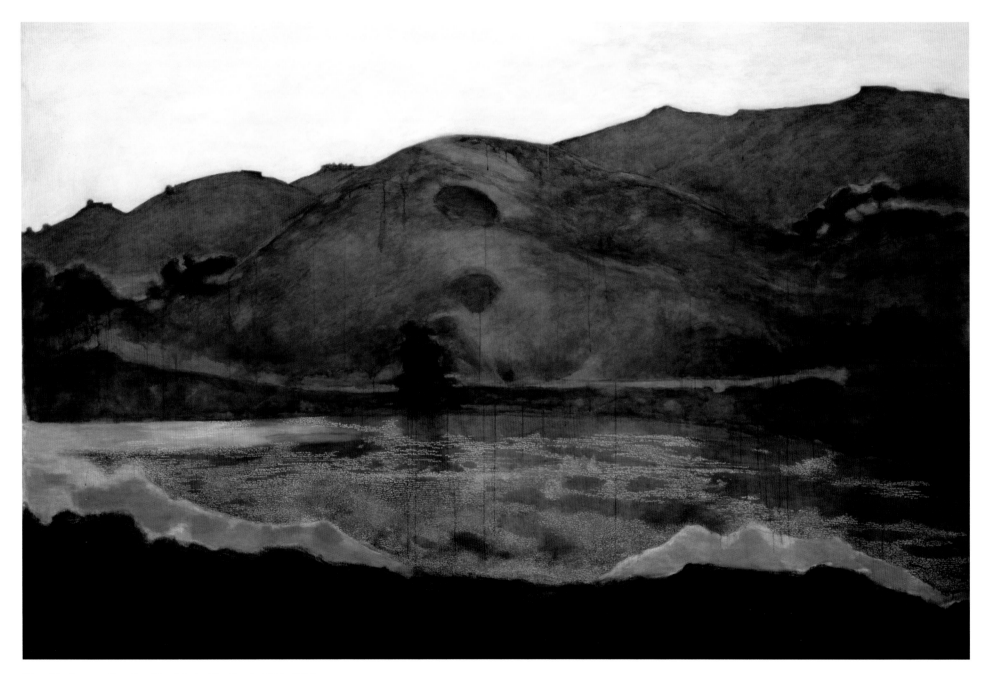

Plate 78. *Lagoon, Fort Cronkite, Marin Headlands,* 2002–2003.
Acrylic on unstretched canvas, 80 x 130 in.
Courtesy Mary Ryan Gallery, New York.

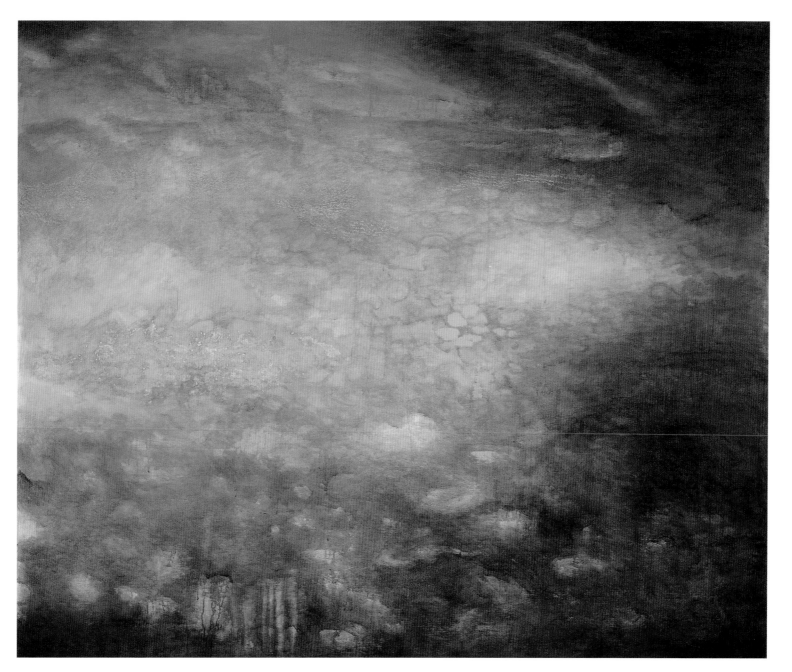

Plate 79. *Water's Edge, Charles River, Cambridge,* 2002.
Acrylic on unstretched canvas, 68 x 83 in.
Courtesy Mary Ryan Gallery, New York.

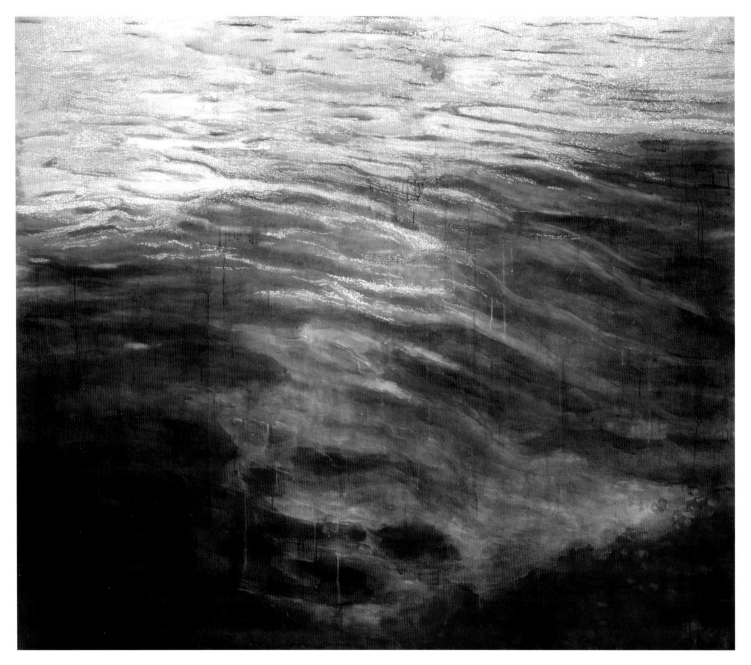

Plate 80. *Water's Edge II, Charles River, Cambridge,* 2003.
Acrylic on unstretched canvas, 69 x 79 in.
Courtesy Mary Ryan Gallery, New York.

Plate 82. *Lighthouse, Cornwall*, 2004.
Acrylic and ink on paper, 18 x 30 in.
Private collection.

Plate 81. *Untitled: Boat Series #2*, 1995.
Mixed media, 22 x 30 in.
The Minneapolis Institute of Arts.

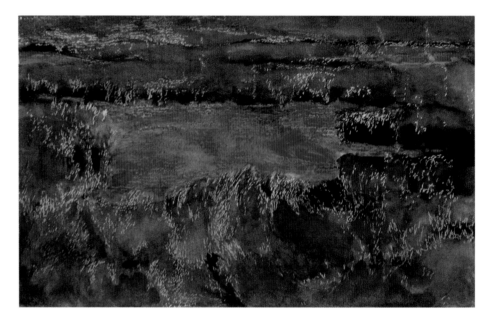

Plate 83. *Last Light,* 2004.
Acrylic and ink on paper, 19 x 30 in.
Courtesy Mary Ryan Gallery, New York.

Plate 84. *Lagoon,* 2004.
Acrylic and ink on paper, 18¹/₂ x 30 in.
Courtesy Mary Ryan Gallery, New York.

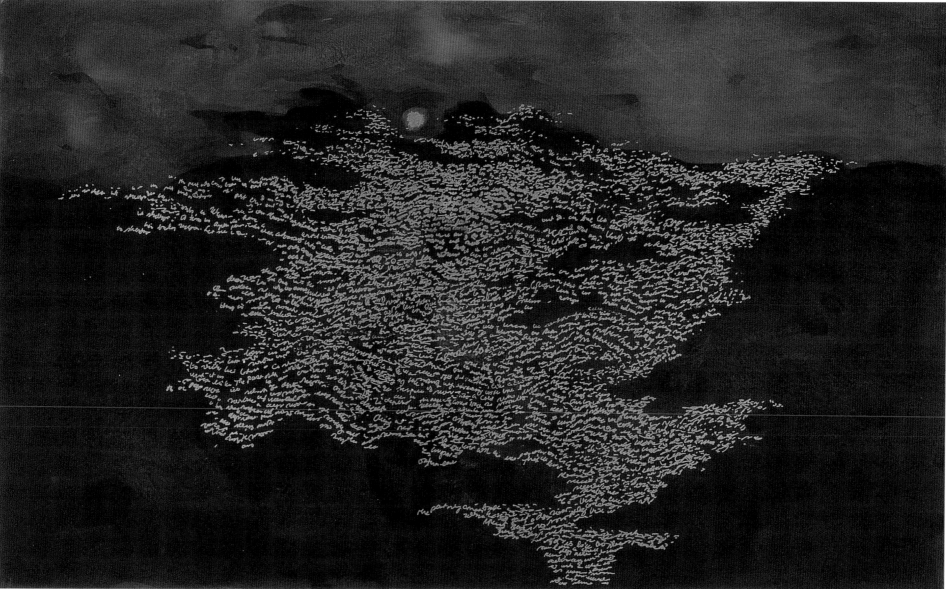

Plate 85. *Moonlight,* 2004.
Acrylic and ink on paper, 18 x 30 in.
Courtesy Mary Ryan Gallery, New York.

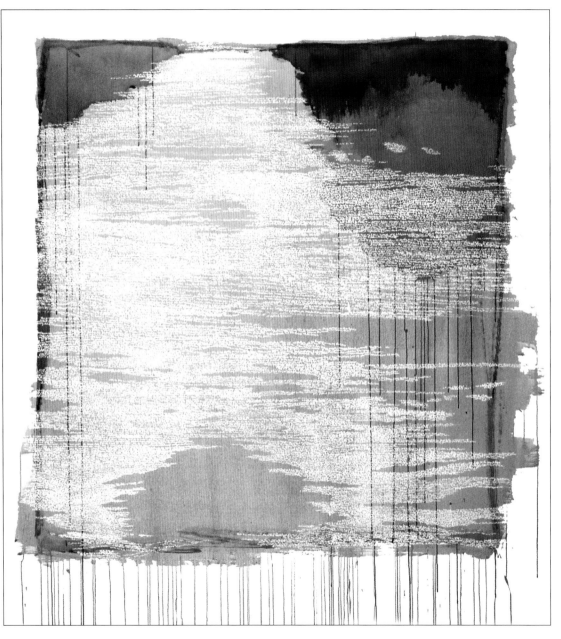

Plate 86. *This Is Not Landscape*, 2004.
Acrylic on unstretched canvas, 84 x 78 in.
Courtesy Mary Ryan Gallery, New York.

1924 June 9, born in Boston, Massachusetts, older child of Ralph and Alice Dick Stevens.

1940 Brother Stacey Dick Stevens dies at 15 of pneumonia.

1946 Graduates from the Massachusetts College of Art, Boston, with a fine arts certificate.

1947 Moves to New York City.

1948 Meets artist Rudolf Baranik at the Art Students Leagues. Marries Baranik June 5. In September, moves to Paris with Baranik, where he studies at the Académie Julian and the Académie Leger. Stevens works in her studio at home, with a short stint at the Académie Julian.

Son Steven Gregory Baranik born December 29.

1948–1951 Exhibits at the famed Salon D'Automne with Picasso and others. First solo show at Galerie Huit on the Left Bank. Paints landscapes, street scenes, and first political painting, *The Martinsville Seven.* Also shows at Salon de Mai and Salon des Jeunes Peintres.

Fall 1951, moves back to New York; settles in Queens.

1952–1954 Holds jobs at the Museum of Modern Art in the publicity department and at a market research firm. Takes two courses, at Queens College and Long Island University; awarded an MFA equivalency and qualifies for a teaching license from New York City Board of Education.

1955–1960 Exhibits paintings from Paris at Galerie Moderne, New York. Lives in Westchester, New York.

1958 Receives the New England Annual Landscape Prize, Silvermine Guild, CT.

1960–1969 Active in political art circles; develops friendships with Carl Andre, Leon Golub, Nancy Spero, Jack Sonenberg, Phoebe Helman, and Irving Petlin. Forms Artists and Writers Against the Vietnam War.

1961 Exhibits new paintings at Roland De Aenelle Gallery, New York.

1961–1996 Teaches at School of Visual Arts, New York. Also co-teaches art seminars at Queens College for several years. Meets co-teacher Leslie Epstein.

1962 Moves with Baranik to Riverside Drive in Manhattan when Steven attends the High School of Music and Art.

1963 Exhibits *Freedom Riders* paintings at Roko Gallery in New York; preface for catalog signed by Martin Luther King Jr.

1967–1968 Moves to a loft at 97 Wooster Street in Soho and lives there with Baranik until 1996.

1967–1976 Makes *Big Daddy* paintings, a series of social protest paintings involving themes that grew out of the Vietnam War and the beginnings of the feminist movement.

1968 First exhibits at the National Academy and Institute of Arts and Letters in New York and receives the National Institute of Arts and Letters Childe Hassam Purchase Award in 1968, 1969, and 1975.

1971 Receives the first of ten fellowships from the MacDowell Colony, Peterborough, NH.

1972 Exhibits in American Women Artists show, GEDOK, Kunsthaus, Hamburg, Germany, sponsored by a feminist organization of which Kathe Kollwitz was a founder. Receives second MacDowell Colony Fellowship.

1973 Lawrence Alloway writes the catalog essay for Stevens' first museum exhibition at the Herbert F. Johnson Museum, Cornell University, Ithaca, NY.

1974 Receives NYSCA CAPS Award in Graphics and third MacDowell Colony Fellowship.

1975 The first of four solo shows at the Lerner Heller Gallery in New York. *Big Daddy* paintings exhibited with catalog essay written by Lucy Lippard. Lippard becomes a friend and political and feminist co-worker. Subsequent shows in 1976, 1978, and 1981. Receives fourth MacDowell Colony Fellowship. Also receives her fourth National Institute of Arts and Letters Award.

1976 Founding member of *Heresies, a Feminist Publication on Art and Politics,* created by a collective of women artists and writers, including Lucy Lippard, Pat Steir, Joan Snyder, Joyce Kozloff, Harmony Hammond, Mary Miss, Miriam Schapiro, and Mary Beth Edelson, many of whom became close friends.

1977–1981 Paints a series of life-size group portraits of artists and writers, including *The Artist's Studio (After Courbet), Soho Women Artists,* and *Mysteries and Politics.* Begins friendship with artist Benny Andrews, of whom she paints three portraits. Receives her fifth MacDowell Colony Fellowship.

1977 January, first issue of *Heresies* appears in January. Her first major essay, "My Work and My Working-Class Father," is published in *Working It Out,* Pantheon Books. Her critical writing and poetry are published in numerous publications from this point on.

1977–1984 Paints *Ordinary/Extraordinary,* a series based on the life and words of Rosa Luxemburg juxtaposed with images and words of Stevens' mother Alice Stevens.

1978 Receives the LINE Association Grant for Artists' Books.

1980 Exhibits in international survey issue: *Social Strategies by Women Artists* held at the Institute of Contemporary Art in London, curated by Lucy Lippard. Gives lecture series in several universities in England.

Exhibits with Adrian Piper, Hans Haacke, Rudolf Baranik, Leon Golub, Nancy Spero, Vito Acconci, and Martha Rosler in *Art of Conscience: The Last Decade,* Wright State University, Ohio, curated by Donald Kuspit.

Exhibits in International Feminist Art at the Gemeentemuseum, The Hague, Netherlands.

Publishes artist's book, *Ordinary/Extraordinary,* with the LINE Grant.

1981 Son Steven Baranik commits suicide October 16. Receives sixth MacDowell Colony Fellowship.

1982 With Rudolf Baranik publishes a book of Steven's photographs, Burning Horses.

May–June, travels for 2 weeks to Cuba with a group led by Ana Mendieta, organized by Circulo de Cultura Cubana. Others include Rudolf Baranik, Carl Andre, Vivian Browne, and Irene Wheeler. Receives seventh MacDowell Colony Fellowship.

1983　Receives a National Endowment for the Arts Grant in Painting.

1984–1985　Solo exhibitions of *Ordinary/Extraordinary* at Clark University, Worcester, MA. Boston University Art Gallery organizes her first traveling exhibition, curated by Patricia Hills.

1985–1986　Receives MacDowell Colony Fellowship.

Awarded a John Simon Guggenheim Memorial Foundation Fellowship.

1986　Steven's mother, Alice, dies in February.

Involved with a group that includes Rudolf Baranik and Arnold Belkin to send an exhibition of painting by American artists to Cuba. Exhibition first shows at the Museo Universitario El Chopo, Mexico City, and then travels to the Casa de la Obra Pia, Havana, Cuba. Travels to Cuba for exhibition opening.

Publishes twelve poems in *Fire Over Water,* an anthology edited by Reese Williams for Tanam Press.

1987　Receives MacDowell Colony Fellowship.

1988　*One Plus or Minus One,* a solo installation at the new Museum of Contemporary Art in New York, curated by William Olander.

Travels to Ireland to install a version of *One Plus or Minus One* at the Orchard Gallery in Derry, Northern Ireland.

1988–1989　Spends a year as a fellow at the Bunting Institute at Radcliffe College, Cambridge, MA. Paints *Alice in the Garden,* a 30 foot long multipaneled painting which is publicly exhibited.

1990　Visiting Artist, State University of California, Long Beach. Begins *Women, Words and Water,* a series of paintings, drawings and later lithographs published by Tamarind and RCIPP at Rutgers University.

Recipient of Women's Caucus for Art Honor Award for Outstanding Achievement in the Visual Arts, held at the annual College Art Association Meeting, New York. Patricia Mathews presents the award with a statement that begins: "We honor you, May Stevens, for your commitment to an engaged art and for the humanity through which you create it."

1990–1991　Makes the Burning Horses collages in response to the death of her son; exhibits them in a joint exhibition *Crossings,* with Civia Rosenberg, at the DeCordova Museum in Lincoln, MA.

1993　Teaches summer school at Skowhegan School of Painting and Sculpture, Maine.

1994　Exhibits her paintings with Baranik's paintings in a two-person show, *Existential/Political,* Exit Art Gallery, New York. Co-publishes with Baranik *In Words* in conjunction with the exhibition. *In Words* includes an argument with Baranik called "(Not) Coming to Terms" and other writings by both.

Moves to Church Street.

Spends summer with Baranik in Taos, NM, funded by the Wurlitzer Foundation.

1995　Solo show at the Orchard Gallery in Derry, Northern Ireland.

Included in a group show at Mary Ryan Gallery, New York; followed by solo shows in 1996, 1997, 1999, 2001, 2003, 2005. Spends part of summer with Baranik at Lucy Lippard's house in Galisteo, NM.

1996　Solo exhibition *Sea of Words and Related Works* at the University Art Museum, Albuquerque, NM.

Spends summer with Baranik at Lippard's house and paints in Harmony Hammond's studio in Galisteo, NM. Buys house in Santa Fe; moves in December.

1997　Receives award from the Massachusetts College of Art as Alumna of the Year. Visiting artist at the Vermont Studio Center, Johnson.

Gives the first annual lecture in the "Fear and Desire" series by women in the arts at the College of Santa Fe, New Mexico. Later Speakers include Carrie Mae Weems, Barbara Kruger, Leslie Marmon Silko, and Guerrilla Girls.

Travels to Vilnius, Lithuania, with Rudolf Baranik for his retrospective exhibition.

1998　Rudolf Baranik dies of heart failure March 6.

Completes new studio in Santa Fe. Exhibits *Tic-Tac-Toe* at Lew Allen Contemporary in Santa Fe.

1999　Solo exhibition of paintings, *Images of Women Near and Far,* at the Museum of Fine Arts, Boston, curated by Barbara Stern Shapiro.

Included in Invitation Exhibition of Paintings and Sculpture at the American Academy of Arts and Letters, New York.

Receives The Hassam, Speicher, Betts and Symons Purchase Prize from the American Academy of Fine Arts and Letters.

2000　February 28, awarded the "Distinguished Artist Award for Lifetime Achievement" by the College Art Association at its annual meeting.

Visiting artist at Oxbow, in Napa, CA.

2001　Residency at Project Space, Headlands Center for the Arts, Sausalito, CA, funded by the Andy Warhol Foundation Award.

Receives College Art Association Distinguished Artist Award for Lifetime Achievement "as an artist, poet, social activist and teacher."

2003　Inducted into the National Academy of Design. For diploma painting donates *The Artist with Benny Andrews.*

2004　Receives Edwin Palmer Memorial Prize for Painting from National Academy of Design.

2005　Visiting artist at the Vermont Studio School.

2005–2006　Traveling exhibition, *The Water Remembers: Recent Paintings by May Stevens, 1990–2004,* organized by the Springfield Art Museum, Columbia, MO, which opens at the Minneapolis Institute of Art, and travels to the National Museum of Women in the Arts, Washington, DC, and the Springfield Art Museum.

PUBLISHED WRITINGS BY MAY STEVENS

"The Artist's Voice." *National Academy of Design Spring Bulletin* 20, no. 1 (2004).

"'In Her Own Words: Soho Women Artists." *Women in the Arts* 21 (Fall 2003), pp. 14–15.

"(Not) Coming to Terms," with Rudolf Baranik. In *Exit Art— The First World.* New York: Privately printed, 1994.

"The White Paper." In *Art & Academe: A Journal for the Humanities and Sciences in the Education of Artists,* ed. Mark Salmon and Robert Milgrom. New York: Visual Arts Press, 1993.

"Whose Agenda? False Dichotomies on an Uneven Ground." *M/E/A/N/I/N/G* #10 (1991).

"Mourning and Militancy." *M/E/A/N/I/N/G* #5 (1989).

"Ordinary Extraordinary." In *Between Women,* ed. Carol Ascher, Louise DiSalvo, and Sara Ruddick. Boston: Beacon Press, 1984.

"Looking Backward in Order to Look Forward: Memories of a Racist Girlhood." *Heresies* 15 (1982).

"Ordinary Extraordinary." *Artist's Book.* New York: Privately printed, 1980.

"May Stevens on Jane Cooper on Rosa Luxemburg." In *Voices of Women: 3 on 3 on 3,* ed. Cynthia Navaretta. New York: Midmarch Associates, 1980.

"Taking Art to the Revolution." *Heresies* 9 (1980), pp. 40–43.

"Class." *Conditions: Six* 2, no. 3 (Summer 1980).

"Radical Art: Theory and Practice." Proceedings of the "Marxism and Art" Caucus. Los Angeles: College Art Association, January 1978.

"My Work and My Working-Class Father." In *Working It Out,* ed. Sara Ruddick and Pamela Daniels. New York: Pantheon Books, 1977.

"Eva Hesse by Lucy Lippard." *Women Artists Newsletter* (1977).

"Art and Class." *The Fox 3* (1976).

"Painters Reply." *Artforum* 14 (September 1975), p. 26.

MONOGRAPHS AND ONE-PERSON EXHIBITION CATALOGS/BROCHURES

May Stevens: Images of Women Near and Far. Interview by Barbara Stern Shapiro. Exhibition catalog. New York: Mary Ryan Gallery, published on occasion of Museum of Fine Arts, Boston, exhibition, 1999.

May Stevens: Images of Women Near and Far. Text by Barbara Stern Shapiro. Exhibition brochure. Boston: Museum of Fine Arts, 1999.

Baranik, Rudolf. *Random Notes on a Persistent Icon.* New York: Bee Sting Press, 1997.

May Stevens: Sea of Words. Essay by Moira Roth. Exhibition brochure. Boulder: CU Art Galleries, University of Colorado at Boulder, 1993.

Rosa, Alice: May Stevens Ordinary, Extraordinary. Melissa Dabakis and Janis Bell, eds. Essays by Melissa Dabakis, Janis Bell, and Reese Williams; poem by May Stevens. Exhibition catalog. Gambier, OH: Olin Gallery, Kenyon College, 1988.

One Plus or Minus One. Essay by William Olander. Exhibition brochure. New York: The New Museum of Contemporary Art, 1988.

May Stevens: One Plus or Minus One. Essays by Declan McGonagle, May Stevens, and Rudolf Baranik. Exhibition catalog. Derry, N. Ireland: The Orchard Gallery, 1988.

May Stevens: Ordinary/Extraordinary, A Summation. Preface by Patricia Hills; Donald Kuspit, "May Stevens Within the Self's Heroic and Unheroic Past"; Lucy Lippard, "Masses and Meetings"; Moira Roth, "Visions and Re-Visions: Rosa Luxemburg and the Artist's Mother"; and Lisa Tickner, "May Stevens." Exhibition catalog. Boston: Boston University Art Gallery, 1984.

Mysteries and Politics by May Stevens. Essay by Folke T. Kihlstedt. Exhibition brochure. Lancaster, PA: Dana Room Gallery, Franklin and Marshall College, 1979.

May Stevens. Essay by Patricia Hills. Exhibition brochure. Richmond, VA: Marsh Gallery, University of Richmond, 1977.

May Stevens: Big Daddy 1967–75. Essay by Lucy R. Lippard. Exhibition catalog. New York: Lerner-Heller Gallery, 1975.

May Stevens. Essay by Lawrence Alloway. Exhibition catalog. Ithaca, NY: Herbert F. Johnson Museum of Art, Cornell University, 1973.

King, Martin Luther Jr. Preface in *Freedom Riders.* Exhibition brochure. Roko Gallery, New York, 1963.

ARTICLES, ENCYCLOPEDIA ENTRIES, AND REVIEWS

Kanou, Britta. "May Stevens: Soho Women Artists." In *Women Artists: Works from the National Museum of Women in the Arts,* ed. Nancy G. Heller. Washington, DC: National Museum of Women in the Arts in association with Rizzoli, International, 2000.

Lefingwell, Edward. "May Stevens at Mary Ryan." *Art in America* 91 (October 2003), p. 134.

Dannatt, Adrian. "Like Music or Nature or the Sea." (Artist Interview), *The Art Newspaper* 13 (March 2003), p. 29.

"May Stevens." *The New Yorker* (February 17, 24, 2003).

Glueck, Grace. "May Stevens 'Rivers and Other Bodies of Water'." *The New York Times,* June 1, 2001.

Murdoch, Robert. "May Stevens: Mary Ryan." *ARTnews* 98 (October 1999), p. 190.

Carvalho, Denise. "Spotlight: May Stevens." *Flash Art* 32 (Summer 1999), p. 128.

Shulman, Ken. "A Crusader Who Lets Her Heroes Be Human." *The New York Times,* June 27, 1999.

Temin, Christine. "Personal and Political, Stevens' Work Gives Presence to Women." *The Boston Sunday Globe,* June 20, 1999.

Temin, Christine. "Perspectives." *The Boston Globe,* May 5, 1999.

Craven, David. "Sniper's Nest: Where a Love of Art Meets a Passion for Politics." *El Palacio: The Museum of New Mexico Magazine* (Summer–Fall 1998), pp. 40–45, 50–51.

Johnson, Ken. "May Stevens." *The New York Times,* November 21, 1997.

Anonymous. "Artist Honored." Quincy (Mass.) *Patriot Ledger,* May 24, 1997.

Braff, Phyllis. "The Feminine Image in Its Many Facets in the 20th Century." *The New York Times,* April 6, 1997.

Hills, Patricia. "May Stevens." In Delia Gaze, ed., *Dictionary of Women Artists.* Vol. 2. London: Fitzroy Dearborn, 1997.

Wei, Lilly. "May Stevens at Mary Ryan." *Art in America* 84 (November 1996), p. 109.

Craven, David. "Stevens' Works are Powerful, Yet Temperate." *The Albuquerque Tribune,* April 19, 1996.

Pulkka, Wesley. "Review: May Stevens." *Albuquerque Journal,* April 7, 1996.

Hills, Patricia. "May Stevens: Painting History as Lived Feminist Experience." In *Redefining American History Painting,* eds. Patricia M. Burnham and Lucretia Giese. New York: Cambridge University Press, 1995.

Rosenberg, Judith Pierce. "Art and Motherhood: A Profile of Painter May Stevens." *Sojourner: The Women's Forum* (May 1993).

Hayden, Niki. "May Stevens Blends Art, Language and Politics." *The Sunday Camera,* January 17, 1993.

Stapen, Nancy. "Two Bunting Artists' Searing Exploration of Self and Society." *The Boston Globe,* May 22, 1992.

Campbell, Sharon. "Review of Greenville County Museum of Art Exhibition of May Stevens: Paintings." *Art Papers* (November–December 1991).

Tarlow, Lois. "Profile: May Stevens." (Artist Interview), *Art New England* 12 (February 1991), pp. 7–9.

Hess, Elizabeth. "Herstory." *The Village Voice,* March 13, 1990.

Hills, Patricia. "May Stevens: The Canal and the Garden." *Art New England* 10 (July–August 1989), p. 30.

Jacobsen, Carol. "Two Lives: Ordinary Extraordinary." *Art in America* 77 (February 1989), pp. 152–157.

Jacobsen, Carol. "May Stevens." *New Art Examiner* 15 (June 1988).

Jacobsen, Carol. "May Stevens." *High Performance,* no. 44 (Winter 1988).

Withers, Josephine. "Re-visioning our Foremothers: Reflections on the Ordinary/Extraordinary Art of May Stevens." *Feminist Studies* 13 (Fall 1987).

Mathews, Patricia. "A Dialogue of Silence: May Stevens' Ordinary/Extraordinary, 1977–1986." *Art Criticism* 3, no. 2 (Summer 1987).

Steyn, Juliet. "The Other America, an Interview with May Stevens." *Fires* (London) (Spring 1987).

Parada, Esther. "Woman's Vision Extends the Map of Memory." *Michigan Quarterly Review* (Winter 1987).

Weisberg, Ruth. "Two Women Juxtaposed." *Artweek* 16 (May 11, 1985), p. 1.

Knight, Christopher. "She Paints of Politics and Power." *Los Angeles Herald Examiner,* April 12, 1985.

Heartney, Eleanor. "May Stevens." *New Art Examiner* 12 (April 1985).

Weisberg, Ruth. "Art Couples 1: Rudolf Baranik and May Stevens." In *Art Couples* 1. Exhibition catalog. P.S. 1, New York: October 1982.

Phillips, Deborah. "Definitely Not for Framing." *ARTnews* 80 (December 1981), pp. 62–67.

Liebman, Lisa. "May Stevens at Lerner-Heller." *Art in America* 69 (November 1981).

Tickner, Lisa. "Ordinary/Extraordinary." *Block 5* (London) (Fall 1981).

Larson, Kay. "May Stevens." *New York Magazine,* March 23, 1981.

Glueck, Grace. "May Stevens." *The New York Times,* March 20,1981.

Larson, Kay. "Art People." *The New York Times,* April 24, 1981.

Cooper, Emmanuel. "Extending Visual Art Boundaries." *Morning Star* (London), December 5, 1980.

Richards, Margaret. "Social Exposures." *Tribune* (London), December 5, 1980.

Roth, Moira. "Visions and Revisions, Rosa Luxemburg and the Artist's Mother." *Artforum* 19 (November 1980), pp. 36–39.

Kingsley, April. "Visions and Revisions." *Village Voice,* January 15, 1979.

Larson, Kay. "May Stevens." *ARTnews* 78 (January 1979), p. 151.

Wallach, Alan. "May Stevens: On the Stage of History." *Arts* 53 (November 1978), pp. 150–151.

Kuspit, Donald. "May Stevens at Lerner-Heller." *Art in America* 65 (March 1978), pp. 117–118.

Moore, Alan. "May Stevens." *Artforum* 15 (Summer 1977).

Wooster, Ann-Sargent. "May Stevens." *ARTnews* 75 (December 1976).

Kramer, Hilton. "May Stevens." *The New York Times,* March 22, 1975.

Nemser, Cindy. "Conversations with May Stevens," *The Feminist Art Journal* 3 (Winter 1974–1975), p. 6.

Neugroschel, Joachim. "May Stevens." *Artforum* 10 (December 1971), pp. 78–81.

SELECTED GROUP EXHIBITION CATALOGS/ BROCHURES AND GENERAL LITERATURE

Bennett, Mary. *Insight Out: Reversing Vandalism.* Santa Fe, NM: Center for Contemporary Arts, 2004.

Isaak, Jo Anna. *H₂0.* Exhibition catalog. Geneva, NH: Wobart & William Smith Colleges Press, 2002.

Taylor, Simon and Natalie Ng, curators. *Personal and Political: The Women's Art Movement, 1969–1975.* Exhibition catalog. East Hampton, NY: Guild Hall Museum, 2002.

Chassman, Gary Miles, ed. *In the Spirit of Martin: The Living Legacy of Dr. Martin Luther King Jr.* New York: Chadwick Communications, 2001.

Hills, Patricia. *Modern Art in the USA: Issues and Controversies of the 20th Century.* Upper Saddle River, NJ: Prentice-Hall, 2001. Includes excerpts from May Stevens, "Taking Art to the Revolution," *Heresies* 9 (1980).

Robinson, Hilary, ed. *Feminism—Art—Theory.* Oxford, UK: Blackwell Publishers, 2001. Includes excerpts from May Stevens, "Taking Art to the Revolution," *Heresies* 9 (1980).

Kuspit, Donald. *The Rebirth of Painting in the Later Twentieth Century.* Cambridge, UK: Cambridge University Press, 2000.

Frascina, Francis. *Art, Politics and Dissent: Aspects of the Art Left in Sixties America.* Manchester, UK: Manchester University Press, 1999.

Frankel, David, ed. *Sniper's Nest: Art That Has Lived with Lucy R. Lippard.* Great Barrington, MA: Bard College, 1996.

Isaak, Jo Anna. *Feminism and Contemporary Art: The Revolutionary Power of Women's Laughter.* New York: Routledge, 1996.

Blum, Paul von. *Other Voices, Other Visions,* Lanham, MD: University Press of America, 1995.

Kahn, Robyn, ed. *Time Capsule: A Concise Encyclopedia by Women Artists.* New York: The Creative Time, 1995.

Rosenberg, Judith Pierce. *Creative Conflicts: Artists and Writers Talk About Motherhood.* California: Papier Maché, 1995.

Sterling, Susan Fisher. *Women Artists: The National Museum of Women in the Arts.* New York: Abbeville Press, c. 1995.

Broude, Norma and Mary D. Garrard. *The Power of Feminist Art: The American Movement of the 1970s, History and Impact.* New York: Harry N. Abrams, 1994.

Frueh, Joanna, Cassandra Langer and Arlene Raven, eds. *New Feminist Criticism: Art–Identity–Action.* New York: Harper Collins, 1993.

Jahoda, Susan E. and May Stevens, curators; Elizabeth Hynes, Susan E. Jahoda, and May Stevens, eds. *This Is My Body: This Is My Blood.* Amherst, MA: Herter Art Gallery, University of Massachusetts, 1992.

Tuttle, Lisa. *Encyclopedia of Feminism.* London: Arrow Books, 1991.

Thomas, C. David, ed. *As Seen by Both Sides: American and Vietnamese Artists Look at the War.* Exhibition catalog. Boston: Indochina Arts Project and the William Joiner Foundation, 1991.

Lippard, Lucy R. *A Different War.* Exhibition catalog. Bellingham, WA: Whatcom Museum of History and Art, and Seattle: Real Comet Press, 1990.

Mathews, Patricia. "Feminist Art Criticism." *Art Criticism* 5 (1989).

Kuspit, Donald. "Crowding the Picture: Notes on American Activist Art Today." *Artforum International* 26 (May 1988), pp. 111–117.

Raven, Arlene, Cassandra Langer, and Joanna Freuh. *Feminist Art Criticism: An Anthology.* Ann Arbor, MI: UMI Research Press, 1988.

Parker, Rosika and Griselda Pollock, eds. *Framing Feminism: Art and the Women's Movement 1970–1985.* London: Pandora, 1987.

Robinson, Hillary, ed. *Visibly Female: Feminism and Art Today, an Anthology.* London: Camden Press, 1987.

Stich, Sidra. *Made in U.S.A. An Americanization in Modern Art, the '50s & '60s.* Exhibition catalog. Berkeley: University of California Press, 1987.

Walker, John A. *Rosa Luxemburg and Karl Liebnecht: Revolution, Remembrance, Representation.* Exhibition catalog. London: Pentonville Gallery, 1986.

Lippard, Lucy R. *Get the Message? A Decade of Art for Social Change.* New York: E. P. Dutton, 1984.

Rubinstein, Charlotte Streifer. *American Women Artists.* New York: Avon Publishers, 1982.

Foner, Moe, ed. *Images of Labor.* Exhibition catalog. Preface by Joan Mondale, introduction by Irving Howe. Princeton, NJ: A Bread and Roses Book, The Pilgrim Press, 1981.

Greyson, John. "Women Artists' Books." *Fuse* (May–June 1981).

Kuspit, Donald B. "Art of Conscience: The Last Decade," in *Art of Conscience: The Last Decade.* Exhibition catalog. Dayton, OH: Wright State University, 1981.

Selz, Peter. *Art in Our Times: A Pictorial History, 1890–1980.* New York: Harry N. Abrams, 1981.

Munro, Eleanor. *Originals: American Women Artists.* New York: Simon & Schuster, 1979.

Lippard, Lucy R. "Caring: Five Political Artists." *Studio International* (London), (March 1977).

Alloway, Lawrence. "Women's Art in the 70s." *Art in America* (March 1976).

Alloway, Lawrence. "Art." *The Nation* (February 1976).

Lippard, Lucy R. *From the Center.* New York: E. P. Dutton, 1976.

Moroski, Stefan. "Neofeminism w Sztuce." *Sztuca* (Warsaw), 1976.

Andrews, Benny and Rudolf Baranik, eds. *Attica Book* by the Black Emergency Cultural Coalition and Artists and Writers Protest Against the War in Vietnam. South Hackensack, NJ: Custom Communications Systems, c. 1972.

Schwartz, Therese. "The Politicalization of the Avant-Garde." *Art in America* (November–December 1971).

SELECTED PUBLIC COLLECTIONS

Allen Memorial Art Museum, Oberlin, OH

Allentown Museum of Art, Allentown, PA

Ball State University Museum, OH

Binghamton University Art Museum, Binghamton, NY

Brooklyn Museum, Brooklyn

The Cleveland Museum of Art, Cleveland

DeCordova Museum and Sculpture Park, Lincoln, MA

Department of State, Washington, DC

Dulin Gallery of Art, Knoxville, TN

Everson Museum, Syracuse, NY

FMSS/GC/TS Bank Program, Washington, DC

Hallmark Cards, Inc., Kansas City, MO

Hampton Institute Museum, Hampton, VA

The Harwood Museum of Art, Taos, NM

Herbert F. Johnson Museum, Cornell University, Ithaca, NY

Hunter Museum of American Art, Chattanooga, TN

Jersey City Museum, Jersey City, NJ

Jacksonville Art Museum, Jacksonville, FL

Joslyn Art Museum, Omaha

Knoxville Museum of Art, Knoxville, TN

Lyman Allyn Art Museum, New London, CT

The Marion Koogler McNay Art Museum, San Antonio, TX

McCormick Place Center Art Collection, Chicago

The Metropolitan Museum of Art, New York

Metropolitan Pier and Exposition Authority, Chicago

The Minneapolis Institute of Arts, Minneapolis

Museum of Contemporary Art, Los Angeles

Museum of Fine Arts, Boston

Museum of Modern Art, New York

Nassau Museum of Art, Roslyn Harbor, NY

The National Museum of Women in the Arts, Washington, DC

Ohio State University, School of Visual Arts, Columbus, OH

Palmer Museum of Art, University Park, PA

Queens College Museum, Flushing, NY

San Francisco Museum of Modern Art, San Francisco

Schenectady Museum, NY

School of Visual Arts, New York

Syracuse University Art Collection, Syracuse, NY

Thomas Crane Public Library, Quincy, MA

University of Arizona Museum of Art, Tucson

University of Miami, Miami

University of Wisconsin at Menomonie, WI

Washington University, St. Louis, MO

Whitney Museum of American Art, New York

Wichita State University Museum, WI

Plate 87. *Kill Books,* 2004.
Mixed media, collages.
Courtesy Mary Ryan Gallery, New York.

SOLO EXHIBITIONS

2005–2006 *The Water Remembers: Paintings and Works on Paper from 1990–2005.* Organized by the Springfield Art Museum, Springfield, MO and traveling to The Minneapolis Institute of Arts (June 11–July 31, 2005); the National Museum of Women in the Arts, Washington, DC (October 12, 2005–January 5, 2006); and the Springfield Art Museum, MO (September 15–November 12, 2006)

2005 *Alice and Rosa Paintings and Drawings, 1982–2001,* Mary Ryan Gallery, New York

2003 *Deep River,* new paintings and works on paper, Mary Ryan Gallery, New York

2001 Headlands Center for the Arts, Sausalito, CA

Rivers and Other Bodies of Water, Mary Ryan Gallery, New York (begun in 2000)

1999 *Images of Women: Near and Far,* Museum of Fine Arts, Boston.

1998 *Tic·Tac·Toe,* Lew Allen Contemporary, Santa Fe

1997 *Big Daddy: 1968–1976,* selected paintings, drawings and prints, Mary Ryan Gallery, New York

1996 *Ordinary/Extraordinary; Tic·Tac·Toe; Her Boats,* selected paintings and drawings, first solo exhibition at Mary Ryan Gallery, New York

Sea of Words and Related Works, University Art Museum, University of New Mexico, Albuquerque

1994 *Existential/Political: Rudolf Baranik and May Stevens,* joint one-person shows, Exit Art, New York

1993 *Sea of Words,* Colorado University Art Galleries, University of Colorado, Boulder

1991 Herter Gallery, University of Massachusetts, Amherst

Selves, Greenville County Art Museum, Greenville, SC

1990 University Art Museum, California State University at Long Beach

1989 *The Canal and the Garden,* Bunting Institute, Radcliffe College, Cambridge, MA

1988 *One Plus or Minus One,* New Museum of Contemporary Art, New York

Special Project, Orchard Gallery, Derry, Northern Ireland

Rosa, Alice: May Stevens Ordinary, Extraordinary, Olin Gallery, Kenyon College, Gambier, OH

New Works from Ordinary/Extraordinary, Real Art Ways, Hartford, CT

1985 *Ordinary/Extraordinary, A Summation 1977–1984,* organized by the Boston University Art Gallery, traveled to University of Maryland, College Park, and Frederick S. Wight Gallery, University of California, Los Angeles

1982 *Ordinary/Extraordinary,* Clark University, Worcester, MA

1981 Lerner-Heller Gallery, New York

1979 *Mysteries and Politics,* Franklin and Marshall College, Lancaster, PA

Rosa Luxemburg Series, C Space, New York; Texas Tech University, Lubbock

1978 *Three History Paintings,* Lerner-Heller Gallery, New York

1977 Pelham von Stoffler Gallery, Houston, TX

1976 *New Realist Work,* Lerner-Heller Gallery, New York

1975 *Selections Big Daddy 1968–1975,* Lerner-Heller Gallery, New York

Recent Paintings, University of Wisconsin, Menomonie

1974 Women Artist Series Year 4, Douglass College, New Brunswick, NJ

Soho 20, New York

Bienville Gallery, New Orleans

1973 Herbert F. Johnson Museum, Cornell University, Ithaca, NY

1971 Terry Dintenfass Gallery, New York

1968 Roko Gallery, New York

Ball State University Museum, Muncie, IN

1963 *Freedom Riders: Paintings by May Stevens,* Roko Gallery, New York

1961 Roland de Aenlle Gallery, New York

1955 Galerie Moderne, New York

1948–1951 Galerie Huit, Paris

SELECTED GROUP EXHIBITIONS

2004 *Insight Out,* The Center for Contemporary Arts, Santa Fe

Eight Artists Portfolio Premiere, Harwood Museum, Taos

The 179th Annual: An Invitational Exhibition of Contemporary American Art, National Academy

2002–2004 *In the Spirit of Martin: The Living Legacy of Dr. Martin Luther King, Jr.* Traveling to Charles H. Wright Museum of African American History, Detroit; Delaware Art Museum, Wilmington; Missouri Historical Society, St Louis; Brooklyn Museum; Brooks Museum of Art, Memphis, TN; Montgomery Museum of Fine Arts, Montgomery, AL

2003 Group Exhibition Video Project "Censorious" by Carol Jacobsen, Shaun Bangert, Ceres Gallery, New York

Insomnia: Landscapes of the Night, National Museum of Women in the Arts, Washington, DC

2002–2003 *H₂O,* traveling exhibition to Houghton House Gallery, Hobart and William Smith Colleges, Geneva, NY; Western Gallery, Western Washington University, Bellingham; Elaine L. Jacob Gallery, Wayne State University, Detroit; Danese Gallery, New York

2002 *Personal and Political: Women Artists of the Eighties,* Guild Hall Museum, East Hampton, NY

Text and Textile: Words and Weaving in Contemporary Art, Deutsche Bank, New York

A Century on Paper: Prints by Art Students League Artists 1901–2001, UBS Paine Webber Art Gallery, New York

Daily Terrors, Santa Fe Art Institute

2001 *Highlights from the Collection: Social Conflicts in American Art,* Jersey City Museum, Jersey City

Twentieth-Century Reflections and Impressions, Mary Ryan Gallery, New York

2000 *The End: An Independent Vision of the History of Contemporary Art,* EXIT ART, New York

1999 *Print Publisher Spotlight,* Barbara Karkow Gallery, Boston

Invitational Exhibition of Painting & Sculpture, The American Academy of Arts and Letters, New York

MUMIA 911: National Day of Art, 1199, New York

Spectrum 1999, Hunter Museum of American Art, Chattanooga, TN

1998 *Recent Prints,* Mary Ryan Gallery, New York

1997–2000 *Crossing the Threshold,* traveling exhibition organized by Steinbaum Krauss Gallery, New York, which traveled to fourteen different museums and galleries

1997 *Fear & Desire,* Cline LewAllen Contemporary, Santa Fe

Feminine Image, Nassau County Museum of Art, Roslyn Harbor, NY

Civil Progress: Images of Black America, Mary Ryan Gallery, New York

1996 *Consensus and Conflict: The Flag in American Art,* Whitney Museum of American Art at Champion, Stamford, CT

Mary H. Dana Women Artists Series 25th Year Retrospective, Mason Gross School of the Arts Galleries, New Brunswick, NJ

1995–1998 *Sniper's Nest: Art That Has Lived with Lucy R. Lippard,* Center for Curatorial Studies, Bard College, Annandale-on-Hudson, NY; Museum of Fine Arts, Santa Fe

1995–1996 *Voices of Conscience: Then and Now,* ACA Galleries, New York

1995 *Elementum,* Mary Ryan Gallery, New York

Artists of the MacDowell Colony, Krasdale Gallery, White Plains, NY

Honoring Vivian E. Browne, Adobe Krow Archives, Bakersfield, CA

Generations, Gwenda Jay Gallery, Chicago

Handprints & Notations, Lizardi/Harp Gallery, Los Angeles

Temporarily Possessed: The Semi-Permanent Collection, The New Museum of Contemporary Art, New York

Death Penalty—Loss of Conscience, Visual Arts Gallery, SUNY, Purchase, NY

ACA Galleries, New York

1994 *Voicing Today's Visions: Articulate,* Mary Delahoyd Gallery, New York

Social Violence, Kutztown University, Kutztown, PA

1993 *Return of the Cadavre Equis,* The Drawing Center, New York

Establishing the Legacy, National Museum of Women in the Arts, Washington, DC

1992 *This Is My Body, This Is My Blood,* Herter Gallery, University of Massachusetts, Amherst

Recent Acquisitions: Selections from the Permanent Collection, DeCordova Museum and Sculpture Park, Lincoln, MA

Paintings from the Permanent Collection, Museum School, Museum of Fine Arts, Boston

1991 *Designing Women,* Rutgers University, Mason Gross School of the Arts, New Brunswick, NJ

Crossings: A Collaboration between Civia Rosenberg and May Stevens, DeCordova Museum and Sculpture Park, Lincoln, MA

History: Truth or Consequences, San Francisco State University Art Gallery

Show of Strength, Ann Plumb Gallery, New York

1990 *Contemporary Women: Works on Paper,* Carnegie Museum of Art, Pittsburgh, PA

Rudolf Baranik and May Stevens, Angel's Gate, San Pedro, CA

With a Message, Women's Studio Workshop, Rosendale, New York

Art and the Law, American Association of Law Libraries and the American Bar Association, Minneapolis and Chicago

Women's Caucus for Art, Newark Museum, NJ

1989 *Concrete Utopias,* Kunsthalle, Düsseldorf

Mothers of Invention, Hobart and William Smith Colleges, Geneva, NY (tour)

Lines of Vision: Drawings by Contemporary Women, Blum-Helman Gallery, New York, traveled by United States Information Agency

As Seen by Both Sides, Indochina Arts Project, traveled to the United States and Vietnam

Decade of the Eighties, Western Carolina University, Cullowhee, NC

Abstraction as Landscape, Gallery Urban, New York

A Different War: Vietnam in Art, Whatcom Museum of History and Art, Bellingham, WA (tour)

1988 *Committed to Print, 1960 to Present,* Museum of Modern Art, New York

Alice, and Look Who Else, Through the Looking Glass, Bernice Steinbaum Gallery, New York (tour)

American Herstory: Women and the U.S. Constitution, Atlanta College of Art Gallery, Atlanta, GA

Vietnam and Artists' Perspectives, San Jose Museum, San Jose, CA

The Social Club, Exit Art, New York

1987 *Artists' Mothers: Portraits and Homages,* Heckscher Museum, Huntington, NY; traveled to National Portrait Gallery, Washington, DC

Made in USA: Art from the '50s and '60s, University Art Museum, Berkeley, CA

Concrete Crisis: Urban Images of the '80s, Exit Art, New York

Connections Project/Conexus, Museum of Contemporary Hispanic Art, New York; Museum of Contemporary Art, São Paulo

Images of Power, Rockland Center for the Arts, New York

Women's Autobiographical Artist's Books, University of Wisconsin, Milwaukee

1986 *Rosa Luxemburg and Karl Liebknecht: Revolution, Remembrance, Representation,* Pentonville Gallery, London

The Law and Order Show, Barbara Gladstone Gallery, New York

Feminist Photo-Graphics, Hunter College, New York

Art in the Community—Community Art?, Maidstone College of Art, London

Letters, The Clocktower, New York

Homage to Ana Mendieta, Zeus Trabia Gallery, New York

Por Encima Del Bloqueo, Casa de la Obra Pia, Havana

En Camino a Cuba, Museo Universitario del Chopo, Mexico City

1985 *The Other America,* Royal Festival Hall, London

Photo-Synthesis, One Penn Plaza, New York

Adornments, Bernice Steinbaum Gallery, New York

Latitudes of Time, City Gallery, New York

American Women in Art: Works on Paper, United Nations International Conference on Women, Nairobi, Kenya

1984 *Tradition and Conflict, 1963–1973,* The Studio Museum in Harlem, New York

1 + 1 = 2, Bernice Steinbaum Gallery, New York; Boca Raton Museum, Boca Raton, FL

1983 *Exchange of Sources: Expanding Powers,* California State College at Stanislaus, Turlock

Portraits on a Human Scale, Whitney Museum of American Art, New York

Issues and Images, Emerson Gallery, Hamilton College, Clinton, NY

1982 *Text/Picture Notes,* Visual Studies Workshop, Rochester, NY

Indiana-New York Connection, Snite Museum of Art, University of Notre Dame, IN

4 Art and Photography Portfolios, City Gallery, New York

Beyond Aesthetics, Henry Street Settlement House, New York

Window Work, Mason Gross School of the Arts, Rutgers University, New Brunswick, NJ

Sense and Sensibility, Midland Group, Nottingham, England

Art Couples 1: May Stevens and Rudolf Baranik, P.S. 1, New York

1981 *Ikon/Logos. Word as Image,* Alternative Museum, New York

Window Work, Printed Matter, New York

The Page as Alternative Space, Franklin Furnace, New York

Artists by Artists, Whitney Museum of American Art, New York

Images of Labor, District 1199 Headquarters, New York (circulated by Smithsonian Institution)

1980 *Issue: Social Strategies by Women Artists,* Institute of Contemporary Art, London

Art of Conscience: The Last Decade, Wright State University, Dayton, OH; circulated by Ohio State Council on the Arts

International Feminist Art, Gemeentemuseum, The Hague, Netherlands

Political Commentary in Contemporary Art, State University of New York at Potsdam and at Binghamton

1979 *Drawing Invitational,* University Art Gallery, Creighton University, Omaha, NE; University of Mississippi, Oxford

1978 *Painting and Sculpture Today,* Indianapolis Museum of Art, Indianapolis, IN

New York Now, Wordworks, San Jose, CA

Master Drawings, University Art Gallery, Creighton University, Omaha, NE

1977 *Dotty Attie/May Stevens Drawings,* Manhattanville College, Purchase, NY

Strong Works, Artemisia Gallery, Chicago

Ten Years Ten Downtown, P.S. 1, New York

Ten Years Ten Downtown Documentation, 112 Green Street, New York

Consciousness and Content, Brooklyn Museum, Brooklyn, NY

1976 *An American Symbol,* Minneapolis Institute of Arts

The American Flag in the Art of Our Country, Allentown Art Museum, Allentown

A Patriotic Show, Lerner-Heller Gallery, New York; Wright State University, Dayton, OH; University of Connecticut, Storrs

Color, Light and Image, Women's Interart Center, New York

Three American Realists: Neel, Sleigh, Stevens, Everson Museum of Art, Syracuse, NY

1975 *Sons and Others: Women Artists See Men,* Queens Museum, New York

Paintings Eligible for Purchase under the Childe Hassam Fund (purchase), American Academy of Arts and Letters, New York

1974 *Watergate,* Speglat AV Ameicanska Konstnarer, Galerie Borjeson, Malmo, Sweden

1973 *Women Choose Women,* New York Cultural Center, New York

Drawings 1973, Minnesota Museum of Art, St. Paul

Voices of Alarm, Lerner-Heller Gallery, New York; Moravian College, Bethlehem, PA

Print Exhibition, California Palace of the Legion of Honor, San Francisco

1972 *Eighteenth National Print Exhibition,* Brooklyn Museum, Brooklyn, NY

American Women Artists Show, Gedok, Kunsthaus, Hamburg

1971 *The Permanent Collection: Women Artists,* Whitney Museum of American Art, New York

Collage of Indignation II, New York Cultural Center and Hundred Acres Gallery, New York

1970 *Ten Downtown Loft Exhibition,* New York

Paintings Eligible for Purchase under the Childe Hassam Fund (purchase), American Academy of Arts and Letters, New York

Women Artists from the Permanent Collection, Whitney Museum of American Art, New York

Recent Acquisitions, The Whitney Museum of American Art, New York

Shakespeare Festival Public Theater, New York

Soho Artist Festival, New York

1969 *Paintings Eligible for Purchase under the Childe Hassam Fund (purchase),* American Academy of Arts and Letters, New York

Drawings, Terry Dintenfass Gallery, New York

Art/Peace Event, Shakespeare Festival Public Theater, New York

1968 *Paintings Eligible for Purchase under the Childe Hassam Fund (purchase),* American Academy of Arts and Letters, New York

1967 *Collage of Indignation,* Loeb Student Center, New York University, New York

1966 *The Peace Tower,* Los Angeles

Landscapes, Visual Arts Gallery, New York

New York '66, Hampton Institute, Hampton, VA

1965 *65 Self-Portraits,* Visual Arts Gallery, New York

1964 *159th Annual Exhibition,* Pennsylvania Academy of the Fine Arts, Philadelphia

Exhibition of Paintings, The National Institute of Arts and Letters, New York

1962 *Commemoration of 65th Birthday of Siqueiros,* ACA Gallery, New York

1961 *The Figure Then and Now,* Roland de Aenlle Gallery, New York

1959 *24th Annual Midyear Show,* Butler Institute of American Art, Youngstown, OH

Hudson River Museum, Yonkers, New York

1958 *Ninth Annual New England Exhibition,* Silvermine Guild, CT

1957 *May Stevens,* ACA Gallery, New York

1951 Salon d'Automne, Paris

Salon des Femmes Peintres, Paris

Salon des Jeunes Peintres, Paris

Salon de Mai, Paris

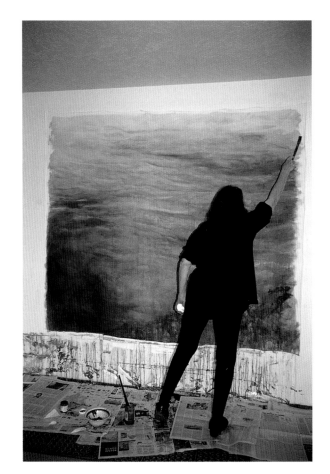

Mary Stevens painting *Water's Edge,* 2002.
Photograph © Virginia Lee Lierz.